THE PROPER DECORATION OF BOOK COVERS

THE LIFE AND WORK OF ALICE C. MORSE

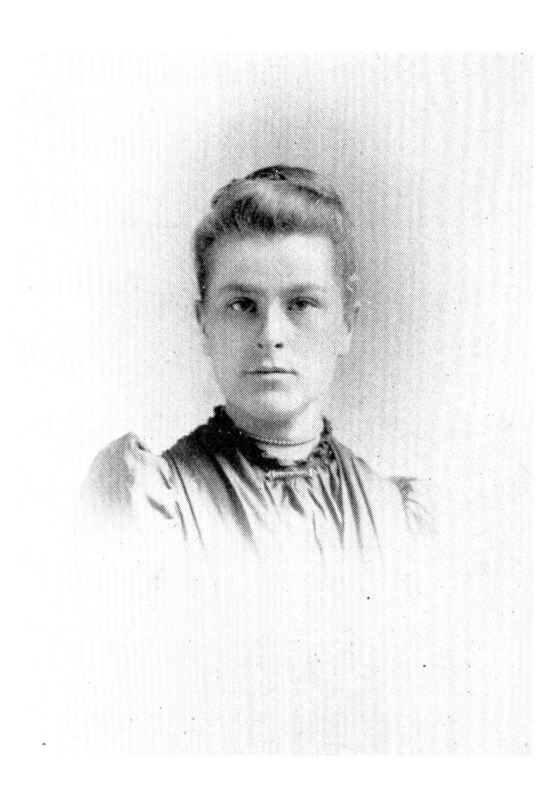

THE PROPER DECORATION OF BOOK COVERS

THE LIFE AND WORK OF Alice C. Morse

by MINDELL DUBANSKY

With Essays by Alice Cooney Frelinghuysen

and Josephine M. Dunn

THE GROLIER CLUB OF NEW YORK · MMVIII

Published to accompany exhibitions at the Grolier Club, New York City, January 23 through March 7;

and at the University of Scranton, Hope Horn Gallery, April 4 through May 2, 2008

Production of this book was made possible in part by the generous support of

Peck Stacpoole Foundation

Furthermore: a program of the J.M. Kaplan Fund

Lackawanna Historical Society

ISBN: 0-910672-74-1

CONTENTS

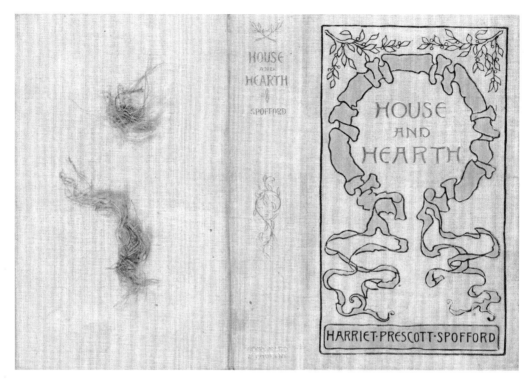

FIG. 1. Morse's cover (front and back) for *House and Hearth* (91-3) as found in the Metropolitan Museum of Art in 1997.

INTRODUCTION

Mindell Dubansky, *Preservation Librarian, Thomas J. Watson Library, The Metropolitan Museum of Art*

> *... even in this age of machinery, and the endless publication of cheaply bound books, very charming and artistic cover effects are within the realm of the cultivated and enterprising publisher.*
>
> ALICE C. MORSE

I discovered Alice Cordelia Morse (1863–1961) in 1997 in a storage room of the Metropolitan Museum of Art's Department of Drawings and Prints. There I stumbled across a print box containing an uncataloged collection of fifty-eight covers. Several calligraphic labels also in the box read "Designed and Presented by Miss Alice C. Morse." These suggested that at some point the covers had been mounted in an exhibition. Cover fronts and backs were fitted with twine loops that would have enabled mounting and displaying of both the spines and front covers (fig. 1). Morse had inscribed most of the covers with her name, address, an identification number, and a dedication to her long-time companion, Leä (Leah) M. Heath. The covers exemplified three types: covers removed from bound books, covers that had never been bound (such as proof covers produced during production or made by publishers for exhibition), and there was one bound book containing duplicate copies of one text bound inside the cover of another title.

As a collector and enthusiast of nineteenth-century publishers' bindings, I was familiar with several of the covers in the box, even though I had never heard of Alice C. Morse. I was also aware of the potential importance of the fifty-eight book covers in light of the current interest in both women designers and publishers' bindings from the late nineteenth century. Consequently, I brought Morse's book covers to my office in the conservation lab in the Thomas J. Watson Library, the museum's principal research library. I also contacted Alice Cooney Frelinghuysen, a curator in the museum's Department of American Decorative Arts. Together, we began to describe and conserve the collection.

Alice Frelinghuysen introduced me to Morse through her chapter on women illustrators in *Art and Handicraft in the Woman's Building of the World's Columbian Exposition*, and through an interview with Morse published in *Art Interchange* in 1894.[1] The publications made her views clear on what it meant to be a professional woman in general and in the field of book cover design in particular. They also provided technical information on how she developed her designs.

From a handwritten note also in the print box, I learned that the book covers had been transferred from the museum's library in 1956. In an effort to determine how and when, I examined the museum's old bulletins and annual reports, starting in 1924, when I knew there had been a major exhibition of rare books at the museum.[2] I found a note in the *Bulletin of the Metropolitan Museum of Art* for 1924 stating, "The Library has received an unusual gift of fifty-eight book covers from the designer, Miss Alice C. Morse. These have been placed on exhibition in the Library, where they should prove of great usefulness to book-cover designers."[3] An earlier report of the Library Committee to the Executive Committee states that Morse had given the book covers to the library between mid-November and mid-December 1923.[4]

Until my rediscovery of Morse's book-cover collection, details of her life were scarce, and only about twenty-five book cover designs had been attributed to her.[5] The boon of finding fifty-eight covers inspired further research. I began to trace Morse's life and to locate her cover designs among extant published books, in order to verify that the exhibition covers Morse gave the museum were equivalent

to them. I soon found additional covers that had not been previously attributed to Morse. As a result, over eighty book-cover designs by Morse, as well as many binding variants and adaptations have been identified. I have also culled information on Morse's life from various sources, including her will, the Metropolitan Museum of Art Archives, and Morse's Teacher's Record Card from the Scranton Public Schools, a résumé of sorts that meticulously records her educational and professional accomplishments.[6]

Finding published books that matched Morse's text-less book covers proved exceedingly difficult. I was able to locate a number of them in libraries, but discovered that many had been rebound. Working from book covers only, I had no dates of publication or edition; and if the spines were blank, as several were, I also had no names of publishers. Popular books by well-known authors such as Charles Reade, Donald Grant Mitchell, William Shakespeare, and Elizabeth Cleghorn Gaskell presented other problems, as they were frequently reprinted during Morse's active period and many book covers needed to be examined to determine those with Morse's designs. I soon realized that if interest in Morse was to be revived, I would need to compile my own collection of books designed by her, as well as supplementary materials.

In 1999, I published an introductory article on Morse in *The Gazette of the Grolier Club*.[7] The article included a biography and photographs of several of Morse's book covers. Since then, I have visited Scranton, PA and can offer additional biographical details on Morse's life, thanks to assistance from the Lackawanna Historical Society, and the late William Heath of Scranton, who was researching the genealogy of Leah Heath (1861–1912).[8] I can also now present descriptions and illustrations of every book-cover design represented in Morse's collection at the Metropolitan Museum of Art, as well as many other designs discovered after the Grolier Club article of 1999. These designs include: published books; advertising posters for books; and several designs found in periodicals for china painting, needlework and other decorative objects. Unfortunately, none of Morse's original drawings for book covers or other original artwork have been located. My hopes for this book are threefold: that it will lay a foundation for further investigation into Morse's life and work, that it will enable libraries and collectors to more easily identify books in their collections designed by Morse, and that it will encourage bibliophiles to build new collections of Morse's body of work. These hopes are already being realized at the Metropolitan Museum of Art, where Morse's book covers are now cataloged as works of art, with each cover design assigned an individual accession number.[9]

Morse grew up in a middle-class family during a period of emerging opportunities for women. These opportunities arose as a response to the state of women after the Civil War, which left thousands of single or widowed women impoverished, with no means of support and no training by which they could earn a living.[10] In response to this situation, social reformers of both sexes worked tirelessly to create institutions that provided educational and professional support for women, as well as opportunities to showcase and market their skills. These initiatives included the Woman's Art School of Cooper Union for the Advancement of Science and Art, the New York Society of Decorative Art, and the Woman's Building at the World's Columbian Exposition (Chicago, 1893). Morse was active in all of these, a talented, determined young woman who took full advantage of new opportunities opening to women to develop a career as an independent designer at a time when art and design were male-dominated endeavors.

In 1885, two years after graduating from Cooper Union, Morse took a position at Tiffany & Company as a designer and painter of stained glass.[11] Around this time, progressive American publishers began to commission artist-designers to design the covers of commercial books, rather than assigning the work to die-makers and engravers, as was customary.[12] Morse grew interested in the emerging field of book-cover design while still at Tiffany & Company. Perhaps in part due to her experience there, she developed an impressive ability to interpret nature motifs and historical ornament.[13] On leaving Tiffany & Company in 1889, Morse resumed her education at the Woman's Art School while also work-

ing as an independent designer.[14] She soon rose to the forefront of the first generation of artists to design commercially produced books. Throughout the 1890s, she was mentioned in articles and exhibition catalogs along with Sarah Wyman Whitman and Margaret Armstrong, designers whose works are well known today. Morse experimented with both historic and modern styles and created appropriate designs for many subjects. The scope of the books she designed is vast, and includes literature for adults and children, drama, novels, poetry, travel, self-help and pet care. Regardless of subject, Morse designed each book cover with equal care and elegance. Yet, identifying Morse's designs can be difficult, as so few were signed. Edna Harris, in 1899 aptly expressed the joy and frustration I and others experienced in the course of our research:

> It is a fascinating thing, this dressing up of books, and a good one. It is too bad we don't often know the designer; while the knowledge might not add to our appreciation, it would be gratifying at times, and we want him to know how we enjoy his work, or, perhaps, disapprove it.[15]

Alice C. Morse was one of the more prolific and versatile designers of the late nineteenth century, and although her fame has diminished, her work is familiar to those bibliophiles attuned to the beauty of artist-designed publishers' bindings of the 1890s. I have enjoyed studying her life and artistic environment in New York City and Scranton. While I have gathered much information on Morse's life, I am sure that more remains to be found, and there is much more work to be done in defining her style and exploring her aesthetic. For now, I introduce Alice C. Morse, designer of book covers, textile patterns and stained glass, artist, and drawing instructor—truly "a woman of the century."

"A WOMAN OF THE CENTURY":
A BIOGRAPHY OF ALICE C. MORSE

Alice Cordelia Morse (fig. 2) was born on June 1, 1863 in Hammondsville, Jefferson County, Ohio, the daughter of Joseph and Ruth Perkins Morse.[16] She had a brother, Joseph Morse, Jr., and a sister, Mary Morse (Fancher).[17] Early in her life, Morse's family moved to the Williamsburg section of Brooklyn, in New York City.[18] We know very little about this period of her life beyond the short biography by Frances Willard and Mary Livermore in 1894. They relate that Morse was "sent to school at the age of five years" and "took her first lesson in an evening class started by the Christian Endeavor Society of Dr. Eggleston's Church." The authors also relate that Morse's early drawings failed to reveal any "flash of inspiration" or "genius in her first attempt to immortalize a model."[19] Morse, however, did find her promise as an artist and applied to one of the premier art schools in New York City to launch her artistic career.

THE WOMAN'S ART SCHOOL AT COOPER UNION

After her early education in Brooklyn, Morse received an undergraduate education in art and design at the Woman's Art School of the Cooper Union for the Advancement of Science and Art in downtown Manhattan.[20] At the time, it was one of few art schools in the city open to women. Morse, of middle-class background, was probably ambitious to gain the skills required to support herself as an artisan-designer. She selected an exceptional school deeply committed to educating men and women of all classes, especially the working class. Cooper Union's primary mission was to endow students with a level of skill high enough to ensure both a satisfying lifetime occupation and financial independence.

Classes strove to meet not only the needs of students, but also the needs of businesses that would employ them. By offering classes and lectures throughout the day and week, Cooper Union made it possible for students to attend classes while employed. Equally important, tuition was waived for students who could furnish proof of their inability to pay and need to earn a living. Morse was likely one of these students. When Morse attended, men and women were segregated into different art programs with slightly different courses. Men also received training in drafting and technical drawing, which the women did not. Although men's and women's subjects of study varied, the professors and instruction in both programs were of equally high caliber.[21]

An undergraduate from 1879 through 1883, Morse specialized in drawing, and returned to Cooper Union to take post-graduate art classes from 1889 to 1891.[22] Competition among students for admission was fierce. Of the six hundred applicants who applied with Morse in 1879, for example, only 292 were admitted to study a curriculum directed by Susan N. Carter.[23] Convinced that women could earn their own living and that they possessed more ability in the applied arts than men, Carter trained women for honorable, useful work. By 1891, Morse's graduation year, Carter and an Advisory Council of nineteen women philanthropists, businesswomen, social

FIG. 2. Alice C. Morse c. 1893 (from Willard and Livermore, p. 523).

10 ALICE C. MORSE

activists, and artists, were planning programs in addition to administering the school. Members of the council included women from the Hewitt and Cooper families; Candace Wheeler, who later supervised Morse in the Woman's Building of the World's Columbian Exposition; artist Jeanette Meyer Thurber, Wheeler's sister-in-law; Helena de Kay Gilder, thought to be the designer of the famous peacock-feather binding on Richard Watson Gilder's *The New Day* (see fig. 7 in Frelinghuysen essay); and Mrs. Burton N. Harrison, an author for whose books Morse later designed covers (92-3; and 93-1).[24]

The final decades of the nineteenth century were a productive time for the Woman's Art School. During Morse's time there it grew in enrollment, physical size, and course offerings. By the late 1880s, classes had been added in china painting, clay modeling, pen-and-ink drawing, and design. The design classes were funded through the generosity of Louis Prang and Company of Boston, the most prolific and influential publisher of American chromolithographs. By 1891, enrollment exceeded four hundred students.[25] Courses were being offered free in the morning and at cost in the afternoon in five departments: Drawing (including design), Painting, Photography, Wood Engraving, and Teaching. In 1879, Morse could have studied with any or all of a number of proficient teachers. Painting was taught by R. Swain Gifford; Life Drawing by S. A. Douglas Volk; Photo-color and Photo-crayon Drawing by Carl Hecker; Normal Drawing by Miss C. E. Powers; Art History by William H. Goodyear; and Engraving by Miss Charlotte Cogswell. [26]

To supplement student education and stimulate employment opportunities, the socially connected members of the Advisory Council developed programs introducing students to New York City's prominent artists and businessmen. One program was an ongoing series of Saturday-evening lectures that could have easily brought Morse into contact with artists such as Louis C. Tiffany, J. Alden Weir, Thomas Eakins, Charles A. Vanderhoof, and R. Swain Gifford.[27] To help students support themselves and relieve the financial burden education imposed on their families, Cooper Union also solicited work for students from local businesses. In this way, students honed their skills while earning money; and manufacturers identified potential employees while benefiting from an inexpensive student labor force. In fact, commercial firms competed for graduates of Cooper Union. Tiffany & Company hired many students in glass decoration and interior design, and other establishments engaged students as illustrators, book-cover designers, teachers, school and arts administrators, photographers, engravers, and designers of decorative objects for the home.[28]

After completing her undergraduate work, Morse continued to study art while embarking on her career as a designer. In 1883, she attended a summer program at Alfred College in Alfred, New York. A year later, she studied art with skilled interior designer and stained glasswork master John La Farge.[29] She also studied with the firm of Louis C. Tiffany & Company, and was employed by his glass studio from 1885 to 1889.[30] Although few company records survive from this period, the recent book *A New Light on Tiffany: Clara Driscoll and the Tiffany Girls*, provides some perspective on what Morse's working life at Tiffany & Company might have been like.[31] Morse's working years correspond with the early employment period of Clara Driscoll and her sister Josephine, as well as that of Agnes Northrop, Tiffany & Company's best-known female designer; and designers Anne Van Derlip and possibly Dora Wheeler, Candace Wheeler's daughter.[32] At the time, Tiffany & Company's focus was on manufacturing leaded-glass windows and interior decoration. The women's department was small and employed only unmarried or widowed women. Clara Driscoll herself left the firm to be married in 1889.

Louis C. Tiffany appreciated female designers and was accustomed to working with them. He thought that women had a good eye for color and design; and because they lacked professional training in stained glass and looked to him as a mentor, he was easily able to impress his personal artistic vision upon his women employees.[33] As a stained-glass designer for Tiffany & Company, Morse would have been involved in many processes and worked collaboratively with other women artisans. Her day-

to-day tasks probably consisted of making rough sketches, colored presentation drawings, full-sized cartoons, and drawings from which the glasscutters could work. As a member of the women's department, she could also have been involved in selecting, painting, and cutting glass.[34]

Morse learned much about design as an employee of Tiffany & Company, but later said the work had been tiring and, in the end, not to her liking. Leaving Tiffany & Company's employ, she returned to Cooper Union and enrolled in postgraduate courses. In an 1894 interview for *Art Interchange*, Morse reveals her desire to prepare for a career as a book-cover designer:

> I was compelled to take up book-cover work through having competed with three other girls for some book-covers about five years ago. I won two out of three competitions. At that time I had been four years with the Tiffany Glass Co. designing windows; but growing tired of the long hours, and wishing to have time to myself for other work, I left them and turned my attention to book-covers, combining it with stained-glass work.[35]

Morse's change in medium from stained glass to book-cover design was not as extraordinary as it might first have appeared to be, as she herself explained:

> All the applied arts are more or less alike, but I think book-covers resemble glass (stained) more than, say, wall-paper or silk, in that you have a complete design in a given space, whereas wall-paper and silks repeat indefinitely.[36]

Whether any of Morse's stained-glass designs were executed is unknown, and although a window in Brooklyn's Beecher Memorial Church is mentioned in Willard and Livermore's biographical entry on Morse, it has yet to be identified.[37]

During Morse's final year at Cooper Union, the *New York Times* reported her winning the "Frederick A. Lane, Robert C. Goodhue, and Trustees Silver Medal" for "Drawing from Life," a full-figure.[38] Also winning a bronze medal in life drawing that year was Miss Minna Brown, who later illustrated *The Lovable Crank*, published by Dodd, Mead with a cover designed by Morse in 1898 (98-5).[39] Morse had also obtained some commissions for book cover designs from prominent New York publishers such as Scribner's, Harper's, Putnam's, and Dodd, Mead. Susan N. Carter proudly refers to Morse's success, although without identifying her by name, in the Cooper Union *Annual Report* of 1892, when she notes:

> A young woman reports $280 earned by making designs for book covers for Scribner's, Harper's and others. Among dainty designs exhibited at the recent display of the Aldine Club, Miss M's book covers are much admired; and she also showed lovely work at the Architectural League Exhibition last winter.[40]

Morse was already achieving success as an independent woman artist, realizing Cooper Union's highest goals for its women students. It is hardly surprising that she soon drew the attention of New York State's Board of Women Managers, then in the process of planning exhibits for the Woman's Building at the forthcoming World's Columbian Exposition.

THE WOMAN'S BUILDING AT THE WORLD'S COLUMBIAN EXPOSITION

It is not known how Morse came to participate in planning activities for the Woman's Building of the World's Columbian Exposition, which was held in Chicago from May through October of 1893. She was already known as a designer to members of the New York Board of Women Managers, and was surely known to artist and social reformer Candace Wheeler, director of the Bureau of Applied Arts. Wheeler was charged with interior decoration of the Woman's Building and organizing the applied-arts exhibits from New York State.[41] In promoting Morse's participation, Wheeler would have also been promoting Cooper Union.

The Board of Women Managers along with thousands of women across the nation, was working to create exhibitions demonstrating the contributions of women to art, industry, sciences, social reforms, and philanthropic work. Many women hoped the exhibits would contribute to winning voting rights and new job opportunities for women. Morse's contribution was substantial. As chairman of the Sub-

Committee on Book-Covers, Wood Engraving, and Illustration of the Board of Women Managers, she presented her own work and the work of other woman artists in the Woman's Building Library.[42] In the Applied Arts Exhibit on view in the library, Morse created a small exhibition comprising eleven of her book covers. She was awarded a diploma and a medal for her work, the medal being the highest award possible for a personal exhibition at the exposition.[43]

Morse also wrote a chapter titled "Women Illustrators" for *Art and Handicraft in the Woman's Building* (Attrib. 93-3), the official handbook to the Woman's Building.[44] Always outspoken and an expert at self-promotion, she illustrated the chapter with six photographs of her own book covers. These included *The Chevalier of Pensieri-Vani* (92-2); *The Chatelaine of La Trinité* (92-1); *Old Ways and New* (92-4); *The Alhambra* (92-8); *Scenes from the Life of Christ* (92-7); and *The Conquest of Granada* (93-2).[45] While the binding of the handbook is unsigned, its appearance suggests Morse might have designed it. I also attribute to Morse the design for the six-volume Distaff Series (Attrib. 93-2).[46] Published by Harper and sold in the Woman's Building Library, the Distaff Series reflected the full scope of the achievements of the women writers represented in the Library. Each volume contained writing on a particular subject. The contributions were gleaned from periodical literature and compiled and edited by a prominent woman in the field. Candace Wheeler, editor of *Household Art,* notes in her introduction for the Distaff Series that it was also typeset, printed, and designed by women.[47]

In 1893, Frances Willard and Mary Livermore, both eminent activists for women's suffrage, education, and the Temperance movement, published *A Woman of the Century: Fourteen Hundred-Seventy Biographical Sketches Accompanied by Portraits of Leading American Women in All Walks of Life* (Chicago: C. W. Moulton, 1893). The collection was intended to celebrate the accomplishments of American women for the 400th anniversary of the discovery of America. Willard and Livermore saw their biographies as "a rosary of achievement." They covered women of all ages and interests, including philanthropy, social services, and the arts. The book also contains the only known photograph of Alice C. Morse. Looking quietly lively, she was about thirty at the time. A glimpse into Morse's character was given by the authors in the concluding sentence of their entry:

> [Alice] is a very clear, original thinker, with an earnestness relieved by a piquant sense of humor, a fine critical estimate of literary style and a directness of purpose and energy which promise well for her future career.[48]

Subsequent events did not disprove Willard's and Livermore's optimistic assessment of Morse's future.

THE NEW YORK SOCIETY OF DECORATIVE ART

The year 1893 was an active one for Morse. In addition to her work for the Woman's Building and her independent career as a book-cover designer, she was also employed as a designer for the New York Society of Decorative Art.[49] Candace Wheeler was also associated with this organization, having founded it in 1877. Motivated by some of the same goals that directed her efforts on the Advisory Board of Cooper Union, she envisioned the society as an organization dedicated to helping American women artists and artisans obtain training and employment.

This was a time when many women were in desperate financial need, with few acceptable employment opportunities open to them. The heavy competition for places in training programs like the Woman's Art School left many eager, talented girls without any hope of advancement. The society sought solutions to these problems. Its threefold mission sponsored courses for women in art needlework and related crafts; provided a venue for the sale and marketing of high-quality decorative goods made by women (although work by men was also accepted); and improved the quality of household decorations through exhibitions and lectures. The society also provided a showroom where women could sell their work at a ten-percent commission.

A large, diverse group of members were attracted to the society throughout the 1870s and 1880s: artists, collectors, and connoisseurs. Members shared a commitment to broadening career opportunities for women and expanding their cultural influence through the decorative arts. Wheeler assembled a design committee of distinguished artists who regularly met to draft and criticize new art-needlework designs. Two of Morse's former teachers and employers were on the committee: Louis C. Tiffany and John La Farge.[50] Designs appraised as best were given to society students for sewing. Morse's role was most likely as a creator of needlework designs to be distributed to students and women for implementation. Her involvement with the society is noted in her Scranton Public Schools Teacher's Record Card, and in a small book of needlework designs, *Corticelli Home Needlework*. In this 1898 publication by the Nonotuck Silk Company, the title page lists Morse as one of five editors and credits her with having been a designer for the society. Two charming embroidery designs by Morse are included in this book (see figs. 8A and 8B in Frelinghuysen essay).[51]

Morse continued designing for the Society until 1895. Although she increasingly focused on book covers, she continued to publish designs for decorative and useful objects that could be copied by talented women and sold at women's exchanges and decorative arts societies around the country, or made by women to decorate their own homes or as gifts to family and friends. A number of Morse's designs for china painting, embroidery, wood carving and pyrography (wood burning), were published in the popular serial *Art Amateur*, of 1897.[52]

DESIGNING BOOK COVERS

Morse was a major competitor in the field of artist-designed book covers throughout the 1890s, during which time she created a large number of covers for many of New York City's eminent publishers. In the chapter she wrote for *Art and Handicraft in the Woman's Building* (Attrib. 93-3), Morse shared her thoughts on the design of book covers. Her comments are worth printing here *in toto*:

> [Book-cover design] . . . has received a great impetus in the last five or six years. Until that time there was practically no attention paid to the proper decoration of book covers. Even the best publishers, except, perhaps, on those rare occasions when an expensive volume was to be issued, were guilty of offering the most preposterous inconsistencies to their patrons. A publisher was quite likely to bring out, let us say, a volume of critical essays with a bunch of daisies thrown across the cover, with a careless disregard of all rules of balance and composition. Among books of a higher character, it was a common thing to find an illustration extracted from the contents of the volume and reproduced on the cover. We hardly know to what to attribute the general revolt among the publishers and the public against this puerile perversion of the art of binding. Perhaps the establishment of such clubs as the Grolier and Aldine has had more to do with the reform in this matter than anything else. Through frequent exhibitions, the members of these clubs have been able to study, and better still, to put before the public, the treasures of private collectors. It was inevitable that the contrast between the beauty of treatment and design seen in the Grolier, Derome, and kindred styles, and the entire absence of these qualities in the current publication, should be strongly felt. The effect of this influence has been such that publishers have come to realize that a salable book must have an attractive cover. It is not expedient to have hand-tooled leather and such other expensive bits of handicraft as we have inherited from the bibliophiles of the sixteenth and seventeenth centuries, but even in this age of machinery, and the endless publication of cheaply bound books, very charming and artistic cover effects are within the reach of the cultivated and enterprising publisher.
>
> Book-cover work presents a wide field, ranging from the thoroughly formal conventional sixteenth-century cover to something appropriate for the so-called railroad novel. It is there that the illustrator's 'ingenuity and invention' is called into play. It is not enough to have a pretty extensive knowledge of historic ornament; she must be able to extract from a book its central idea, and reduce through, if possible, to some tangible form permitting a conventional treatment. She must not outrage any true standards of design, yet she should be able to suggest to the casual observer, in a symbolic way, the contents of the volume. Women seem to have a remarkable facility for designing. Their intuitive sense of decoration, their feeling for beauty of line and harmony of color, insures them a high degree of success. Another consideration is the necessity of rigid, exact treatment of details, uncertain or even suggestive drawing is out of place in cover ornamentation.[53]

Morse's remarks give us valuable insight into the life of a working designer at the outset of this new era in book design. Her statements confirm what has long been believed: that the establishment of organizations to promote the arts pertaining to the production of books, in particular the Grolier Club (founded 1884) and the Aldine Club (founded 1890), created unique opportunities for artists and designers to study superior examples of contemporary and antiquarian fine printing and bookbinding from many countries.[54]

Bookshops too, exhibited rare and historic books. On November 12, 1894, Charles Scribner's Sons opened an exhibition of the best works of famous fine bookbinders. Among them were French binders Trautz-Bauzonnet, Chambolle-Duru and Marius Michel; British binders, the Doves Bindery (T. J. Cobden Sanderson), Sarah Prideaux and Zaehnsdorf; and American binders Blackwell, Bradstreet's, and Stikeman.[55] Exposure to historic materials and fine bookbindings such as these significantly influenced modern publishers and the work of Morse and her fellow-designers.

From designs identified to date, we know Morse produced no fewer than eighty published book covers between 1887 and 1905; and more will surely be discovered to expand the list I have compiled. Publishers who commissioned designs by Morse are listed in a table at the back of this book (Index IV), organized by year of publication, number of designs per year, and designs per publisher per year. The table shows that Morse's first known cover was designed for Charles Scribner's Sons in 1887. Four covers followed for Harper & Brothers in 1899. From 1890 to 1894, Morse designed no fewer than forty-eight covers and added as clients the Century Company, Dodd, Mead & Company, G. P. Putnam's Sons, and Longmans, Green and Co.

No covers were found for 1895, possibly because Morse was still occupied with her work for the Society of Decorative Art and was planning an extended trip to Europe.[56] In 1896, identified work resumes with seven books published for Dodd, Mead & Company and Charles Scribner's Sons. From 1897, the number of Morse's commissions diminishes each year; however, her work appears on books by new clients George H. Richmond & Company, and the International Association of Newspapers and Authors.

From this point to the end of her career as a book-cover designer, Morse's primary publisher is Dodd, Mead & Company. At the turn of the twentieth century, Dodd, Mead was transitioning from antiquarian bookselling to publishing contemporary books.[57] A shared appreciation of antiquarian books obviously made Morse the ideal designer for the up-and-coming publisher, and she designed some of her most beautiful and unusual covers for them. Two advertising posters Morse designed for the company have been identified: for George Gissing's *The Paying Guest* (95P-1), and Ian Maclaren's *Kate Carnegie* (96P-1).[58] Morse's earliest designs for Dodd, Mead are for books in series. These include the Giunta Series (90-1), the At the Ghost Hour Series (94-5), and the Portia Series (91-2). From 1896 through 1897, twelve designs for the company have been identified, all signed by Morse. These lovely designs are, with one exception, for individual titles.

Morse's reputation as an articulate, popular, reputable designer made her the ideal subject of an article on book-cover design for an 1894 issue of *Art Interchange*. In an interview that also included a conversation with fellow-designer Margaret Armstrong, Morse discussed her perspective on modern book-cover design, again providing valuable insight into her experience and vision.[59] In the article, Morse reveals that her first commission for Harper's was a design for the Odd Number Series published in 1889 (89-4). She recalled that although the design appeared to be a simple one, it had been a challenging task, but with a successful outcome. In consequence, Morse continued to receive commissions from Harper's and other publishers. This gave her the confidence to launch a career in book-cover design, supplemented by stained-glass and other related design work. Morse lists the qualifications necessary to be a successful book-cover designer:

. . . first, ingenuity because you must invent an idea from your manuscript capable of being converted into a fitting design; second, a strong sense of balance and composition; third, a knowledge of historic ornament. The cover ought to suggest the contents of the volume.

Morse advised that book-cover designs be taken from "the period in which the story is written," that "a love story should be dainty," and that "essays require something dignified and severe." The full text of Morse's interview in "The Designing of Book-Covers," *Art Interchange* (1894) is given in the appendix.

Throughout her career, Morse's commissions included book-cover designs—and occasionally illustrations—for books on every subject, by both famous and lesser-known authors. She designed covers for novels, drama, poetry, literature, art history, travel, instructional manuals, women's health and home issues, children's stories, and even pet care. Popular contemporary authors whose books were designed by Morse included Amelia Barr, Lafcadio Hearn, William Dean Howells, Thomas Nelson Page, and Oscar Wilde. Considered by her publishers to be a tasteful and dependable designer, Morse was often charged with designing covers for expensive publications and holiday books. An example of the former is Charles Seward Webb's *California and Alaska and Over the Canadian Pacific Railway* (90-7). It is a gold-stamped, full-leather binding that was issued in a limited edition of 500 copies and sold for the princely sum of $25.00.[60] Morse also designed a cover for the 1891 holiday edition of *Wordsworth's Sonnets* (91-9) for Harper & Brothers. Although the custom of the time was to not identify unmarried ladies by name in the press, Morse was acknowledged in *Publisher's Weekly* for this design:

> Every Christmas the house illustrates something with drawings by Abbey or Alfred Parsons for a fine gift volume. Last year Parsons did the cover and the publishers were not satisfied. This year "Wordsworth's Sonnets" was the choice and Parsons did the pictures, but Miss Morse—her name slipped from the point of the pencil—was called upon to supply the quiet green and gold binding. [61]

Morse's proud publishers often submitted her original designs and sample book covers to exhibitions of applied arts and book arts in New York City. These were held fairly regularly between 1889 and 1895 at the Aldine Club, an organization whose members consisted of important publishers, authors and artists; the Grolier Club, whose membership included collectors of rare and beautiful books; and the New York Architectural League, which held annual exhibitions of the fine and applied, or decorative, arts.[62] Although it must have been very gratifying for Morse to have her work on view at the Aldine and Grolier exhibits, it was most remarkable to have been included in the exhibitions of the Architectural League, which were broader in scope. The Architectural League brought together men of kindred pursuits "in close and friendly relations" in order to change centuries of segregation in the arts, by adhering to the philosophy that no permanent achievement in one branch of art was possible without corresponding developments in other areas. In these annual exhibitions, Morse's designs and covers were exhibited together with paintings, sculpture, architectural drawings, prints, embroideries, rugs, silver and other works of art and design.[63] Although members of all three organizations were men, examples of work by women artists were welcome and women were invited to attend exhibitions as visitors.

The exhibition Commercial Bookbindings, held at the Grolier Club in April 1894, was probably the most important and influential display of contemporary book cover designs during this time. It presented a comprehensive survey of modern American and European artist-designed publishers' bindings. In addition to the examples of contemporary book covers, it featured a selection of brass stamps and original drawings, and a retrospective display of covers produced since 1850, illustrating improvements in recent book design. Works by women designers such as Alice C. Morse, Sarah Wyman Whitman, Margaret Armstrong, and a Miss Guiney were shown alongside the work of prominent male designers. In the modest essay accompanying the exhibition, the anonymous author specifically complimented Morse's designs for *Sweet Bells Out of Tune* (93-1), *The Odd Number* (89-4), *Marse Chan* (92-12), and Stevenson's *Ballads* (90-8). [64] A review in *Publisher's Weekly* lists the impressive group of artists and designers who were included in this exhibition:

Among the artists whose work is represented in the collection are Miss Guiney, Miss Alice C. Morse, Miss Margaret Armstrong, Stanford White, George Wharton Edwards, Harold B. Sherwin, George Fletcher Babb, Walter Greenough, Edwin Abbey, Elisha Vedder, Howard Pyle, W. H. Gibson, F. Hopkinson Smith, Reginald Birch, and Otto Taospern.[65]

Also in 1894, Morse's book-cover design for Stevenson's *Ballads* was featured in a woman's guide, *The House and Home: A Practical Book*, which introduced her as an excellent example of the successful woman designer.[66] In P. G. Hubert Jr.'s chapter titled "Occupations for Women," the field of book-cover design was recommended as a viable occupation for women.[67] The author buttressed his point by printing color illustrations of two woman-produced book covers: Morse's Stevenson's *Ballads*; and *Songs About Life, Love and Death*, designed by Margaret Armstrong (fig. 3).[68] Hubert also reported that since few professional careers were open to women, the number of women artists exceeded demand. He wrote that almost 1,333 women were designers earning annual incomes from $1,000 to $1,500 in New York City alone.[69]

Morse had only two substantial competitors during most of her career: designers Sarah Wyman Whitman (1824–1904), and Margaret Armstrong (1867–1944).[70] De-

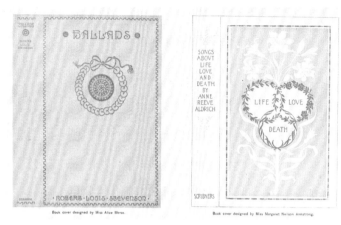

FIG. 3. Book covers designed by Morse and Armstrong in *House and Home. A Practical Book*, 1894: vol. 1, p. 9.

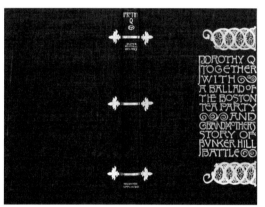

FIG. 4. Sarah Whitman's design for Oliver Wendell Holmes' *Dorothy Q* (1893), with a design inspired by medieval bookbinding.

sign and publishing communities considered the three women to be foremost among their generation of designers. Morse recognized their talents in the chapter she wrote in *Art and Handicraft in the Woman's Building*:

> Mrs. Sarah W. Whitman of Boston and Margaret N. Armstrong have taken a firm hold on the publishers and won recognition from the public, by their appropriate, tasteful, well-studied book decoration.

The editor, Maude Howe Elliott, followed with this footnote:

> Miss Alice C. Morse, the writer of this paper, has made a wide reputation by her excellent and serious work in the designing of book covers. —Ed.[71]

Sarah Whitman's designs had begun to appear in 1884 on books designed for Boston's Houghton Mifflin Company and her designs continue through 1917.[72] Today, Whitman is credited for having been the first professional artist, male or female, to design book covers on a regular basis.[73] She was also a pioneer in women's education, and, like Morse and Armstrong, a painter and designer of stained glass.[74] Whitman's beautiful, understated book covers were often bound with spine and boards in two contrasting colors of cloth. Minimally decorated with the title and author's name, her designs were sometimes ornamented by an elegant but simple stamped motif.[75] Whitman's designs, like Morse's, were often influenced by historic bookbindings. While Morse appears to have been inspired by the highly decorative bookbindings of the Renaissance, Whitman's work was more influenced by medieval bind-

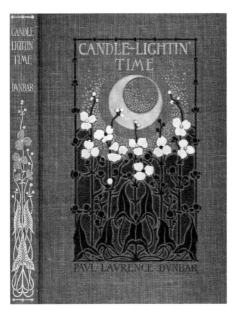

FIG. 5. Margaret Armstrong's design for Paul Dunbar's *Candle-Lightin' Time* (1901) with photographs by the Hampton Institute Camera Club, published by Dodd Mead, and similar to Morse's design on *Poems of Cabin and Field* (1899).

ings, in which the structural elements, such as cords and clasps, are the dominant aesthetic features (fig. 4).[76] Whitman was also the first book cover designer to develop her own hand-drawn alphabet, rustic sans serif letterforms in the Arts and Crafts style.[77] During the early years of her career, when most of her book covers were unsigned, this distinctive alphabet served as her signature. Occasionally other designers, including Morse, borrowed Whitman's alphabet, and her distinctive lettering can be seen in Morse's *Landscape Gardening* (91-10) and *Kerrigan's Quality* (94-4). On both covers we see a rendition of Whitman's "A" as a flattened top surmounted by a bar; an "E" with the bar set high; and a "K" with a flattened bowl set very high.

Margaret Armstrong, active from 1890 through 1940, was the youngest of the three woman-designers and an extremely talented illustrator.[78] She was prolific, having created over three hundred covers, and hundreds, if not thousands, of illustrations during this period, and she sometimes collaborated with her artist-sister Helen Maitland Armstrong (b. 1869).[79] Armstrong was employed by many of the same publishers as Morse, including Dodd, Mead; Harper's; Putnam's; and Scribner's.[80] She designed book covers for many of Morse's authors as well, including Paul Dunbar, Thomas Nelson Page, Harold Frederic, Marion Harland, Donald Grant Mitchell, W. H. Bishop, and Washington Irving[81] (fig. 5). Morse's and Armstrong's designs were similar and, as a result, Morse's work has occasionally been misattributed to Armstrong. An example of this can be seen in the *Art Interchange* article, where Morse's cover for *The Chevalier of Pensieri-Vani* (92-2) is attributed to Armstrong.[82] A bold and colorful Art Nouveau style characterized Armstrong's style, and she was known for the hand-drawn alphabets she had developed.[83] Also a noted botanical illustrator, she embellished her cover designs with flowers and plant forms. Given the beauty of their design, Armstrong's books have always been very popular and collectible.

Morse's approach to design differed from that of Whitman and Armstrong, who had characteristic styles of drawing and recognizable color palettes. Whitman and Armstrong were also wealthy women who could afford to select their commissions, whereas Morse needed to work for her living. Ironically, of the three designers, the one who depended most upon her craft to provide a viable means of support—Morse—created designs more varied, eclectic, and even more risky, than those of her competitors. Yet Morse appears to have enjoyed working and experimenting in many styles, while constantly adapting her designs both to complement each book's theme and appeal to the widest audience.[84] She evidently appreciated the individuality of each book and structured her designs uniquely to reflect their themes, as is obvious in the very different covers Morse designed for *The Chatelaine of La Trinité* (92-1) and *Our Home Pets* (94-9).[85] Adept at rendering both ornamental and naturalistic forms, Morse was equally comfortable producing historical styles of drawing, as illustrated by the sixteenth-century style fanfare design for *California and Alaska and Over the Canadian Pacific Railway* (90-7), as well as with modern styles of drawing, as in the pictorial design for *Yellow Pine Basin* (97-8).

Although Morse was designing book covers as early as 1887, signed designs have not been noted until 1894. According to Charles Gullans, designer's monograms, in general are rarely seen before 1893.[86] The volumes of the "At the Ghost Hour Series" (94-5) are the first books I've seen where Morse received credit on the title page for her work as designer. From the two titles examined, it appears that the same illustrations were reused throughout the series, and most of these were signed "AM" or "Alice

Morse." It is unclear whether the book covers are signed, because the faded nature of the design and the poor condition of the copies make this difficult to confirm. After the At the Ghost Hour Series, Morse's signed covers are not seen again until 1896 when they appear stamped with her initials, "A M". An example of this can be seen on the back cover of *Majesty of Man* (96-1). The following year, Morse began to sign with a conjoined "AM" monogram, as seen on *Dariel* (97-2). After this, she consistently used this style of monogram unless separate initials better suited a particular design, as in *A Doctor of the Old School* (97-6) (fig. 6).

FIG. 6. Morse's monograms from *Majesty of Man* (96-1), *Dariel* (97-2), and *A Doctor of the Old School* (97-6).

As Morse's designs became better known, she began to receive commissions from publishers to design advertising posters and to "decorate" texts. Three known book-advertising posters designed by Morse exist: *The Paying Guest* (95P-1), and *Kate Carnegie* (96P-1) published by Dodd, Mead; and *Emma Lou: Her Book* (96P-2), published by Henry Holt & Co. Occasionally, Morse produced vignettes, title pages, and decorative borders for books, and received credit for some of them, in some such form as: "Decorations by Alice C. Morse." She probably designed borders and decorative endpapers for other books, but unsigned designs cannot be attributed to her with certainty. Only five books with illustrated title pages, page borders, and vignettes known to be by Morse exist: *Poems of Cabin and Field* (99-2), and Dodd, Mead's four-volume At the Ghost Hour Series (94-5).

Demand for cover designs subsided as publishers and the public became infatuated with illustrated paper book-jackets. Charles Gullans and John Espey present evidence from the trade literature of the time suggesting that 1908 or 1909 was the last year that readers and bibliophiles saw extensive use of decorated cloth on novels.[87] New and less expensive technologies were being developed to replace the beautiful, but expensive, gold-stamped covers such as those designed by Morse and her colleagues. Publishers discovered that color illustrations printed on paper could be used both on the jacket and front cover of books, thereby eliminating the need to manufacture expensive stamping plates. This stylistic and technological change in book-cover production may explain in part why Morse began to prepare for a career change by 1895.

MORSE AS EDUCATOR IN SCRANTON, PENNSYLVANIA

Morse relates that she spent five months in France in 1895, studying painting and the French language.[88] In 1896, at the age of thirty-three, she enrolled in a two-year management training course at the Normal School of Pratt Institute, New York City, which offered a program specializing in teacher education.[89] Normal schools were precursors of today's teaching colleges, and mostly female students were enrolled in them, since teaching remained one of the few careers deemed suitable for single women.

After graduating from Pratt Institute in 1897, Morse moved to Scranton, Pennsylvania, to accept the position of supervisor in the city's public school system. Although it may seem surprising that Morse would leave career and home in New York City for Scranton, this Pennsylvania city was the coal capital of the world in the 1890s, and possessed quite a wealthy community. The teaching position Morse accepted offered financial stability, which she did not enjoy as an independent designer in New York City. Some evidence suggests that Morse's sister and other family members might have been living in the Scranton area about this time, but this is by no means certain.[90] If true, having family already established in Scranton might have encouraged Morse's move. In her first position as supervisor of Art and Drawing for elementary grade schools, Morse would have directed the efforts of approximately thirty elementary-school teachers, and planned the art curriculum as well.[91] After two years, Morse advanced to the position of supervisor of Art and Drawing for high schools and worked out of Central High School, which had opened in 1896.[92] In 1917, Morse earned her final promotion, as district supervisor,

which made her head of all drawing departments at the grade-school and high-school levels. She retained this position until her retirement in September of 1923.[93]

While living in Scranton, Morse boarded in the home of Leah M. Heath (1861–1912) at 1024 Scranton Avenue.[94] During the early twentieth century, it was not socially acceptable for single women to live alone. Most single, working women either lived with family, as Morse did in New York City, or in boarding houses. From 1901 until soon after Heath's death, Morse shared a home with Heath and two other boarders: J. J. Cosgrove and the Reverend Valentine Ambrosene. Morse and her landlady became close companions, a type of bond typical of its time and place. The tone of Heath's 1912 obituary in the local newspaper, the *Tribune-Republican,* suggests that the community accepted Morse's relationship with Heath.

Morse and Heath had many interests in common. Both were educators at Central High School and shared a deep appreciation of the arts. Heath's obituary described her as having been a much-loved high school teacher of literature and rhetoric for seventeen years.[95] "Last representative of one of the oldest families in the city," she was considered an authority on the Old Masters and owned a large collection of photogravures of masterpieces that she exhibited at her home to graduating classes at the end of each academic year.[96] Heath undoubtedly appreciated Morse's book cover designs, and many of the covers donated by Morse to the Metropolitan Museum of Art in 1923 are inscribed as gifts from Morse to Heath.[97] The *Tribune-Republican* obituary refers to Morse's care of and loyalty to her companion:

> Miss Heath had been suffering from heart trouble for the last four years. Last Saturday, she sustained an attack … from which she never rallied into complete consciousness. With her through these last hours was her devoted friend and companion, Miss Alice Morse, also of the High school faculty.[98]

After Heath's death, Morse moved frequently within Scranton.[99] During summer vacations, she pursued her interest in art and languages by taking courses at Harvard University, the Rhode Island School of Design, and the Atkinson School in New York City. She also traveled abroad to paint and visit art galleries in Holland, Belgium, France, and Italy.[100] In September 1923, Morse retired from teaching after twenty-five years as a drawing supervisor.[101]

MORSE RETURNS TO NEW YORK CITY

Shortly after her retirement, Morse returned to New York City and set up housekeeping with her widowed sister Mary in an apartment at 606 West 116th Street on Manhattan's Upper West Side.[102] In November of the year of her return, Morse "announced her presence" by donating a set of her book covers to the Metropolitan Museum Library. As an announcement in "Library Notes" in the *Bulletin of The Metropolitan Museum of Art* acknowledged:

> The Library has received an unusual gift of fifty-eight book covers from the designer, Miss Alice C. Morse. These have been placed on exhibition in the Library, where they should prove of great usefulness to book-cover designers.[103]

At the close of this small exhibition, the book covers were relegated to the stacks, remaining uncataloged until 1956, when they were transferred to the Print Department. There, they remained virtually inaccessible until their rediscovery in 1997.[104] Neither Morse nor her two siblings had children, and Morse herself moved on to other career challenges during her long life. These circumstances, combined with the inaccessibility of an important archive of her work, apparently explain the lack of published information on Alice C. Morse as a designer.

Little is known of Morse after her return to New York City, and most of what we do know comes from a deposition taken from Morse's friend of thirty years, Augusta C. Wagner. Dated September 18, 1961 and filed with Morse's will, the document relates that Wagner had become acquainted with Morse

through friendship with her sister Mary Morse Fancher. Morse was living with Mary in New York City in 1924 when Wagner moved into the same building that the Morse sisters inhabited at 606 West 116th Street. Together, the three women attended theater, opera, musicals, and other cultural events. According to Wagner, Mary Fancher probably died in Scranton in 1937, after which Wagner continued her close friendship with Morse until the designer's death on July 15, 1961.[105] Morse died at the age of 99 in the Bronx's St. Barnabas Hospital where she had been a long-term patient.[106]

Morse bequeathed approximately $20,000 in assets to friends, cousins, and New York social and cultural institutions. Among them were the New York Metropolitan Opera Guild, for which a fund was created in Mary Morse Fancher's name; to the Memorial Hospital for the treatment of cancer and allied diseases for which a fund was created in her parents' names; to the Trudeau Sanitorium at Saranac Lake, for which a fund was created in her brother's name; and to St. Barnabas Hospital, where she died.[107] Alice Morse's will concludes with a poignant request:

> I direct that my body be cremated with the least possible expense—a wooden box which the undertaker will provide after a doctor has declared me dead. The ashes are to be put in a simple box and delivered to Mrs. John S. Littell [Morse's cousin], who will dispose of the ashes where she finds a lovely view. I want not services or music or flowers except a bunch of violets placed in my hand.[108]

Morse's directions reveal her love of beauty and nature as well as her sense of practicality. In the language of flowers, violets signify virtue, modesty, and affection. In the practical world of the nineteenth century, Morse might have purchased nosegays of violets to ward off the pungent odors of the streets of New York City. In making this request, was Morse perhaps thinking of her early years as a young and promising New York designer? We will never know. What we do know is that she had a long and full life as a talented and successful designer; a well-trained and capable art teacher; an artist committed to self-education and the pursuit of knowledge; and, ultimately, a generous benefactor to the Metropolitan Museum of Art, which preserves her book-cover designs in trust for us all.

A NEW DAY: WOMEN BOOK-COVER DESIGNERS AND THE AESTHETIC AND ARTS AND CRAFTS MOVEMENTS

Alice Cooney Frelinghuysen

Anthony W. and Lulu C. Wang Curator of American Decorative Arts,
The Metropolitan Museum of Art

The Aesthetic movement of the late nineteenth century was an all-pervasive design force that transformed the field of decorative arts. Its impact on publishers' bindings is a clear example. This essay grew out of work on *In Pursuit of Beauty: Americans and the Aesthetic Movement,* an exhibition at the Metropolitan Museum of Art in 1986 and the first serious study of the movement in America. In the course of my research the serendipitous finding of an article in the popular decorative arts journal *Art Interchange* (1894) introduced me to the subject of publisher's binding and the women who executed them, notably Sarah Wyman Whitman, Margaret N. Armstrong, and Alice C. Morse. That all three were involved in one way or another in the designing or making of stained glass further piqued my interest. Mindell Dubansky's discovery in the Metropolitan Museum's Department of Drawings and Prints a little over a decade later of the large collection of book covers associated with Alice C. Morse further demonstrated the significance of the work of these talented women.

Traditionally the study of book arts has been segregated from the study of other decorative arts, the former primarily the realm of librarians and the latter of decorative arts historians and curators. This essay attempts to bridge that divide and to build upon earlier scholarship that first recognized their roles in this new artistic endeavor. It also focuses on the specific intersection of women involved in the design of bindings and stained glass. The relationship of women who undertook the design of publishers' bindings and of those who worked in various genre in the decorative arts during the last decades of the nineteenth century is significant; these female decorative artists, like Morse, Whitman, and Armstrong, were the embodiment of the Aesthetic and Arts and Crafts movements which sought to impart art to all aspects of daily life, in the design of the furnishings and finishes of their homes, the beautification of their dishes, and even the embellishment of the volumes they would read. They were art practitioners in the largest sense of the word, making art, making designs for others to craft, working in diverse media, and involving themselves in circles of other artists.

Publishers' bindings heralded many of the important design principles of the Aesthetic movement. Conventionalized natural ornament replaced earlier naturalistic narrative scenes in painstaking, gold-stamped compositions, the new designs embracing design tenets promulgated by such influential British designers as Owen Jones in his *Grammar of Ornament* (1856), and Christopher Dresser in his *Principles of Design* (1873), as well as the published designs of Bruce J. Talbert and William Morris, who promoted design reform based on a geometricized depiction of nature, where flowers and plants were reduced to their essential geometric form. The palette of book cloth blossomed in a variety of hues and shades; it, too, responded to the range of tertiary colors characteristic of the Aesthetic movement with its muted grays, blues, and greens, favored by other decorative artists of the period. Some bindings have a distinctly refined appearance, in lighter and more delicate tones of cream and pearly gray, lending a more feminine quality.

Finally, the parallel extends even to the moral motives of the Arts and Crafts movement whereby its goal, as promoted by William Morris, was to bring art into the realm of everyday life. Publishers' bindings fulfilled this laudable moral value perhaps better than any other medium: they brought good design to consumers of mass-produced books. Alice C. Morse, an early pioneer in this field, expressed such

Arts and Crafts ideals in her essay "Women Illustrators" published in 1893 as a companion to the exhibits in the Woman's Building at the World's Columbian Exposition in Chicago. She wrote: "It is not expedient to have hand-tooled leather and such other expensive bits of handcraft as we have inherited from the bibliophiles of the sixteenth and seventeenth centuries, but even in this age of machinery, and the endless publication of cheaply bound books, very charming and artistic cover effects are within the reach of the cultivated and enterprising publisher."[109] The following year Sarah Wyman Whitman, one of the luminaries in publishers' binding design, echoed the sentiment in a lecture to the Boston Art Students' Association, when she urged her students to "think how to apply elements of design to these cheaply sold books; to put the touch of art on this thing that is going to be produced at a level price."[110]

Women's role in the decorative arts has been the subject of scholarly inquiry for nearly three decades.[111] More recently, the subject of women designers of publishers' bindings has received greater attention than ever over the past two decades, resulting in important contributions to that field in first recognizing women's roles in this new artistic endeavor.[112] It should be noted that book arts were not solely the province of women during the period of the Aesthetic movement. At its peak, such artists as John La Farge, Stanford White, and Elihu Vedder each participated in one aspect or another of the art of the book. La Farge's notable contributions were his original illustrations based on Japanese designs for Alfred Lord Tennyson's *Enoch Arden* (1865). Stanford White was one of several American artists who contributed to the design of *A Book of the Tile Club* (1886): the decorative endpapers were designed by George Maynard; the cover design of gold on white cloth by Augustus Saint-Gaudens, as well as the title page; and the Riverside pressmark created by Elihu Vedder. Vedder's greatest contribution to book design, however, was his *Rubaiyat of Omar Khayyam* (1883–84). Vedder designed the entire book, selecting the paper and typeface, and designing the highly charged and dynamic binding stamped in gold.[113]

The last quarter of the nineteenth century was significant for interest in the decorative arts, for the integration of art into nearly every medium, and for the rising prominence of women in the field of decorative arts design and fabrication. The study of women in the Aesthetic movement and the Arts and Crafts movement has acknowledged the more traditionally feminine realms such as china painting and needlework, and indeed these materials were portals by which women might enter the field of design. In cities across the country, design schools were founded to provide practical training for female students in the field of industrial arts, with the goals of developing marketable talents and skill sets. One such advocate of design training for women was Candace Wheeler, one of the founders of the New York Society of Decorative Art in 1877. The following decades in New York City alone saw the establishment of Pratt Institute, the Cooper Union, the Institute for Artist-Artisans, the New-York School of Applied Design, and the Metropolitan Museum of Art School, all of which fostered art educational opportunities for women.[114]

Book-cover design was part of the curriculum of many of these schools, and at the New-York School of Applied Art, the subject was taught at least for several years in the early 1890s by Henry L. Parkhurst, who was working at the same time for Tiffany Glass and Decorating Company.[115] That the professional instructor in book-cover design was a member of the staff of the Tiffany firm underscores the connections and affinities between the discipline of book-cover design and stained glass.

Helena de Kay (1848–1916) was arguably the first woman designer of publishers' bindings, creating an exquisite yet spare gold-stamped peacock-feather design on a deep blue ground for a

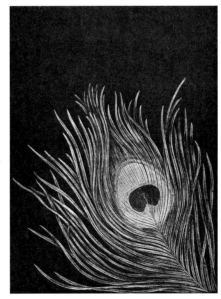

FIG. 7. *The New Day: A Poem in Songs and Sonnets.* (New York: Scribner, Armstrong, and Company, 1876). Richard Watson Gilder. Book cover designed by Helena de Kay. Gold peacock feather on blue cloth over beveled boards. 17.8 x 13.5 cm.

collection of poems by her husband, Richard Watson Gilder, entitled *The New Day,* dating to 1876 (fig. 7). De Kay exemplifies the new role of women in art and design. Her first formal art training took place at the Cooper Union School of Design for Women as early as 1867–68.[116] She was not only a pioneer in book-cover design, but with her husband formed part of the circle of artists who were at the forefront of the cultural awakening that characterizes much of the late nineteenth century. She was also clearly aware of the revolutionary changes that were taking place in stained glass at the same time. De Kay studied painting, for example, under John La Farge, whose innovative developments in the use of opalescent glass beginning in the late 1870s completely changed the look of the stained-glass medium. La Farge even presented de Kay and Gilder a window he made in honor of their tenth anniversary in 1883.[117] Louis Comfort Tiffany (1848–1933), who with La Farge continued to experiment and develop a new look for leaded-glass windows, may also have been an important force in de Kay's life. Her brother, Charles de Kay, was an impassioned art critic, who later authored anonymously the monograph commissioned by Tiffany in 1912 (published in 1914), as well as numerous articles on Tiffany's Long Island country estate, Laurelton Hall.[118] She developed familial ties to Tiffany when their son Rodman Gilder married Tiffany's daughter Louise in 1911.

Helena de Kay paved the way for the three principal women designers of publishers' bindings: Alice C. Morse, Sarah Wyman Whitman, and Margaret N. Armstrong. All three crossed disciplines in book-cover and stained-glass design, a phenomenon that had a significant impact on their work. Close associations between artists, designers, and literary figures characterize this period, and that intermingling applied particularly to these designers of decorative bindings and to stained-glass artists.

There are significant stylistic affinities between the designs of stained glass and book covers. Both rely on strong outline. For stained-glass artists, a reliance on outline is imposed by the leading necessary to hold the individual cut pieces of glass together. Book designers, in turn, work with die stamping. Both techniques result in bold outlines that divide broad areas of color, generating a related, albeit rather different, graphic style. Morse herself acknowledged another similarity between the two mediums, noting that, "All the applied arts are more or less alike, but I think book-covers resemble glass (stained) more than, say, wall-paper or silks, in that you have a complete design in a given space whereas wall-paper and silks repeat indefinitely."[119]

As this publication and accompanying exhibition demonstrate, Alice C. Morse had a successful career designing book covers for at least sixteen years. Like many women of the period, Morse pursued several decorative media, including the traditional feminine spheres of china painting and needlework. Some of her designs for painting on china and glass were published in 1897 in *Art Amateur,* one of the proliferating art magazines that published practical advice on the decorative arts.[120] The following year, she published some of her needlework designs in a manual devoted to needle arts published by the Nonotuck Silk Company (figs. 8A and 8B).[121] Morse's training and career, in addition to the success she enjoyed in the publishing world, link her to the other two primary binding designers, Whitman and Armstrong. Like them, Morse's career intersected with stained glass, and would have an important influence on her formative work.

Morse studied at the Woman's Art School at Cooper Union which was a fertile training ground for women interested in developing a talent into a marketable career in the arts. She received critical instruction in art and design, and first became exposed to stained glass there when she "studied and painted with great assiduity" under the supervision of John La Farge.[122] Following her graduation, Morse submitted to Louis C. Tiffany and Company, one of the earliest corporations of the acclaimed stained-glass artist, "a study of a head, painted on glass," and was hired to "paint glass and study designing, and accomplished much in the time devoted to her work there."[123] In doing so, she joined a small coterie of talented women involved in stained-glass work.[124]

During the 1880s, the period when Morse would have been involved with Tiffany, a number of

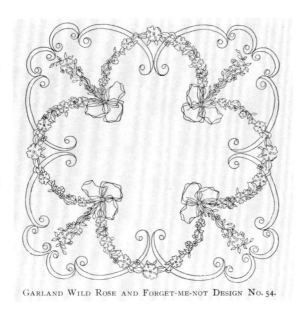

GARLAND WILD ROSE AND FORGET-ME-NOT DESIGN NO. 54.

GARLAND PHOTOGRAPH FRAME
DESIGN NO. 62.

women are known to have worked designing windows for Tiffany for a brief duration, including Anne Van Derlip Weston, Lydia Emmett, and Dora Wheeler. Morse would also have known Agnes Northrop, who may have had a particular influence on Morse's work. Northrop also began at the Tiffany Glass Company in the mid-1880s, and developed a specialty in floral and landscape window designs. Her early work, in particular, reveals a highly decorative style.

Like many women designers at Tiffany's workrooms, Morse had a relatively short-lived tenure with the firm. Most left because they became engaged and were married, and Tiffany never employed married women. Morse left for reasons of quality of life. She apparently felt that the working conditions were too rigorous or too restrictive. She declared that she had "been four years with the Tiffany Glass Co. designing windows; but growing tired of the long hours, and wishing to have time to myself for other work, I left them and turned my attention to book-covers, combining it with stained-glass work."[125] Although Morse clearly enjoyed some success in stained glass, no examples of her work in that medium have yet been identified, leaving lingering speculation as to the relationship of her windows to her work in book-cover design.

Sarah Wyman Whitman (1853–1904), one of Alice Morse's primary competitors, can be considered a true aesthete. She made her career and reputation as the leading designer of publishers' bindings in Boston, creating covers in the mid 1880s, and by 1887 becoming virtually the house designer for the publishing firm Houghton Mifflin, a relationship which would endure nearly twenty-five years.[126] She is even credited with creating her own distinctive lettering style. The range of Whitman's decorative work is suggested in 1893 by the notice of an exhibition of her work at the Avery Galleries in Boston, announced by one critic as: the work of "Mrs. Henry Whitman, of Boston, in oil, pastel and watercolors, designs for book covers and stained glass, that show a more varied and excellent artistic equipment than is usual, even among the most clever young women artists...."[127]

Whitman's interest in stained glass was most assuredly inspired by John La Farge, a member of the artistic circles in Boston during the late nineteenth century. La Farge had been at work on the extensive decorations and stained glass for Trinity Church there, an ambitious enterprise, where it has been suggested Whitman assisted in the decorative work.[128] Whitman admired La Farge's novel stained glass as well, for its decorative value and the jewel-like qualities of its glass. Whitman fully embraced this genre of decorative work, eventually establishing her own stained-glass workshop, the Lily Glass Works, at 184 Boylston Street in Boston. In her work, traditional gender roles were reversed. As a book-cover designer, she produced designs that were executed by others, male and female; and in her stained-glass

studio, her designs were realized by skilled glass-cutters and glaziers. This was a reversal of more traditional roles, such as those at the Grueby Pottery (also of Boston), for example, where the women decorated pottery vases designed by men.

Whitman was an influential figure in the burgeoning Arts and Crafts movement in Boston, and a driving force and founding member of the Boston Society of Arts and Crafts, established in 1897. In addition, she led a noted salon in the brahmin city, one that attracted eminent literary figures and artists. Whitman was also part of the artistic circle there that included Celia Thaxter, and she designed covers for Thaxter's books.[129] Thaxter, a poet who, like Whitman, was most closely linked to literary circles, embraced the decorative arts herself by taking up both china painting and needlework, both most closely associated with women's roles.

Whitman's stained glass embraced ideals that occupied other stained-glass artists working in an Arts and Crafts mode, creating highly decorative patterns based on natural plant forms in a rigidly conventionalized and stylized manner and giving a majority of the panel over to transparent colorless glass. This in turn related to the stained-glass designs of such practitioners as George Washington Maher, Purcell and Elmslie, and even Frank Lloyd Wright, in their reliance on transparent glass panes and highly geometricized natural forms. The graphic quality and simplicity of Whitman's windows echoed the subtle and elegant designs of her book covers; the linearity of the leading is transposed to colored or metallic stamping on delicately colored book cloth.

By comparison to work by other designers, some of Whitman's window designs bear the closest relationship to her designs for book covers. Windows she had made to decorate a classroom in the Fogg Memorial Building at Berwick Academy in South Berwick, Maine, exhibit the same exceedingly graphic quality of her book covers. With a predominance of transparent glass divided in long vertical areas, they are crowned with titles set in stylized scrolled frames, reminiscent of book titles. Even more compelling, Whitman translated one of her book-cover designs of a delicate leafy wreath, seen in several variations on book covers—Sarah Orne Jewett's *Betty Leicester's Christmas* (fig. 9) (Houghton Mifflin, 1890) or William

FIG. 9. *Betty Leicester's Christmas.* (Boston: Houghton Mifflin Company, 1899). Sarah Orne Jewett. Binding designed by Sarah Wyman Whitman. Black, pink, yellow, green, and blue on white calico-grain cloth. 20 x 14 cm.

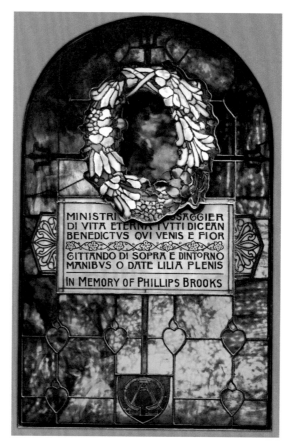

FIG. 10. Design attributed to Sarah Wyman Whitman, Phillips Brooks Memorial Window. Leaded glass. Groton School, Groton, Massachusetts.

FIG. 11. *The Queen's Twin.* (Boston: Houghton Mifflin Company, 1899). Sarah Orne Jewett. Binding designed by Sarah Wyman Whitman. Gold on green cloth. 18 x 12 cm.

FIG. 13. *The White Shield.* (New York: G.P. Putnam's Sons, 1912). Myrtle Reed. Binding designed by Margaret Armstrong. Purple, white, and gold on lavender cloth. 20.5 x 13.6 cm.

FIG. 12. Design attributed to Margaret Armstrong, Maitland Armstrong & Company, *George and Mary Morris Memorial Window*, ca. 1914. Leaded glass. St. Margaret's Episcopal Church, Green Cove Springs, Florida.

Dean Howells's *Venetian Life* (Houghton Mifflin, 1900)—into at least two window designs. One, dating to about 1897, memorializes Civil War soldiers in a window commissioned by Whitman's close friend Sarah Orne Jewett, also for Berwick Academy, in Jewett's home town. The other was a memorial to Phillips Brooks, rector of Trinity Church, Boston, for whom Whitman designed other windows, and it was installed in Groton School, Massachusetts (fig. 10). The Groton window features additional motifs characteristically found on Whitman's bindings, including her signature flaming heart (fig. 11). Even the decorative flourish dividing the Latin text of the inscription panel resembles her designs for endpapers that appear on the Howells book as well as on William Wordsworth's *Pastorals, Lyrics, and Sonnets* (Houghton Mifflin, 1890). Both windows exhibit Whitman's trademark font in their leaded inscriptions. The delicacy and attenuation of the linear designs in leaded glass echoes many of her known book designs with their spare graceful patterns.

Margaret N. Armstrong (1867–1944) is the third of the principal women book-cover designers of the late-nineteenth and early-twentieth centuries, joining Sarah Whitman and Alice Morse. Like Whitman and Morse, she developed her talent and achieved significant success and recognition, with an oeuvre in book design of over 270 covers in a career spanning more than thirty years.[130] Like Whitman and Morse, Armstrong was involved in decorative work that extended beyond book design, and she, too, tried her hand at stained-glass design. Margaret's father, David Maitland Armstrong enjoyed a successful career in stained glass, working for both John La Farge and Louis Comfort Tiffany. Similarly, Armstrong enjoyed fruitful associations garnered in the intellectual and cultural milieu of her city, New York, where her father's home and studio became the center of gatherings that included such influential artists as Stanford White, Elihu Vedder, and William Merritt Chase. Armstrong studied painting but turned to decorative work, inspired, as was her sister Helen, by Christmas cards designed by Vedder, which thus turned their hands and talents to that line of work. Their father's stained-glass career had a dominant effect, and Helen Armstrong had the important role of delineating and painting the figures, a specialty within stained-glass design. Margaret's specialty was in the more decorative arena of stylized floral design, and although surrounded by stained-glass work, she rarely designed windows herself. One exception is the highly-decorative, stylized bouquet of white lilies translated in a stained glass window for the Morris Memorial dating to about 1914 at St. Margaret's Episcopal Church in Green Cove Springs, Florida (fig. 12).[131] In its tight linear design, rigid symmetrical composition, and floral motifs, the Morris window shows the compositional influence of Armstrong's established work in book-cover design. The prominently featured lilies are characteristic of the distinctive, stylized floral imagery on her book covers, such as the design for Myrtle Reed's *The White Shield* (G. P. Putnam's Sons, 1912) (fig. 13), completed only two years prior to the lily window. The verticality of the design and the rendering of the lilies for the window relate closely in form and style to the book cover.

The design of publishers' bindings represents one of the best examples of the upheaval in the arts that began with the Aesthetic movement and continued through the Arts and Crafts movement. A craft which, like making stained-glass windows, had changed little since the middle ages, book-cover design gave new opportunities for women artists, and in the proliferation of such bindings, for the first time, it brought art quite literally into the hands of thousands of consumers. Beginning with Helena de Kay, it was the dawn of a new day, that matured and flourished under the leadership of her talented successors, Alice Morse, Sarah Wyman Whitman, and Margaret Armstrong. These women, who were trained in the new techniques of stained glass, sought to expand their new way of thinking and then applied it to the discipline of book-cover design. These years signaled the shift from artisan die-stamper to the independent designer, whose artistic work would then be executed by the craftsman. The work of these three women was a subtle, but significant reminder of the Aesthetic movement's primary aim to beautify everyday articles.

ALICE MORSE IN SCRANTON, 1897–1923

Josephine Dunn, Ph. D., *Associate Professor, Director, History Department, University of Scranton*

In 1897, designer Alice Cordelia Morse (1863–1961) left New York City for a smaller, industrial, and culturally nascent city in the mountains of northeastern Pennsylvania. One hundred and eighteen miles away, she spent the next twenty-six years of her professional life in Scranton, which proudly proclaimed itself "Anthracite Capital of the World." Although an industrial city, Scranton was also a young American city in formation: confident, proud, prosperous and ambitious. Entrepreneurial ventures touted by Scranton's early historians, and hearty prophecies of great destiny annually printed in Scranton's newspapers could be marshaled to describe Morse's new home.[132] But Morse's artistic and teaching life had little to do with commercial destiny and civic factionalism. Her life was now embedded in a career traditionally prescribed suitable for the talents of women. Hence, this essay briefly engages the history of local art and artists, the realities of the early Scranton school system, and regional women's history, in order to create a frame for the new life Morse created for herself.

When Morse arrived in Scranton there was no art school, public art gallery, or museum that provided visual stimuli or attracted artists to a vital cultural center. Later, the Everhart Museum of Natural History, Science and Art would be donated to the city by local physician and naturalist, Isaiah F. Everhart in 1908.[133] That year, the local newspaper enthusiastically opined the birth of a new epoch for the city, "a new line of scientific, educational and uplifting work among our people of today and generations to come."[134] In many ways, these ambitions were realized, but initial dedication of the museum as a center for natural history and science impeded the site's development as an art museum.

The Everhart Museum was the gift of a single citizen whose primary interests were ornithological and scientific, and Dr. Everhart's original vision for Scranton entailed construction of three separate buildings in Nay Aug Park. He financed the first, dedicated to his life-long interest in natural history, and only later were material artifacts, historical and cultural documents donated to the museum.[135] The first director and curator of the museum were appointed in 1912 and directed their efforts exclusively to classification of Dr. Everhart's highly valued natural-history specimens.[136] Formation of a serious art collection moved slowly. Not until the death of local artist John Willard Raught (1857–1931), donation of a selection of his paintings, and installation of a permanent memorial exhibition in his honor, did the notion of a *bona fide* art museum take root.[137]

John W. Raught's life and ambition were closely tied to the New York City art world that Morse had left, and she undoubtedly knew his work.[138] The last will and testament penned by Morse's colleague and companion Leah M. Heath bequeathed paintings by Raught to two close friends: Katherine Winton Murray (*Old Normandy Houses*, 1887) and Nellie Richards Paterson (*The Roadway*).[139] Both images were hanging in Heath's and Morse's shared home when the former died on June 13, 1912 and Morse, as executrix of Heath's estate, effected their disposal.

Morse had opportunities to view Raught's work in New York City, and in Scranton's Connell Building after 1899. He was a popular artist who produced portraits of local gentry, countryside landscapes, and Scranton city views, all easily sold to a wide class of citizenry. Scrantonians appreciated Raught's academic and European training reflected in the Barbizon-style of his Breton and Pennsylvania landscapes.[140] In October of 1911, however, Raught premiered an extraordinary exhibition of twelve paintings of "Anthracite Coal Breakers" in the Robertson Art Rooms of the Connell Building.[141] These large, moody and romanticized paintings of industrial coal breakers and collieries were commissioned or owned by prosperous local businessmen whose fortunes had been built on the anthracite industry.

Four years later, a large exhibition comprising sixty-four of Raught's works was sponsored by the Century Club.[142] It is difficult to imagine Morse ignoring either exhibition.

The only local artist of any stature comparable to Raught and active in northeastern Pennsylvania was Honesdale native Jennie Augusta Brownscombe (1856–1936).[143] Brownscombe worked professionally from a number of studios in America and abroad (New York, Pennsylvania, London, and Rome), and like Raught, mounted exhibitions in her local studio. A portraitist when the occasion demanded, Brownscombe was primarily known for paintings of historical narratives and idyllic scenes. Intelligent and educated, like Morse, she was as assiduous in historical research of her narratives as Morse was in allying historicity to the design of her book covers.[144] Whether Morse and Brownscombe knew one another remains uncertain, but both women shared the commendation of Frances E. Willard and Mary A. Livermore in their dictionary of 1,470 biographies of "leading American women."[145]

Early twentieth-century Scranton boasted local portrait artists and women illustrators who enjoyed successful careers. Highly-regarded fashion illustrator Alice Seipp came to Scranton in 1916 when the International Correspondence School opened the Woman's Institute of Domestic Arts and Sciences under the direction of Mary Brooks Picken.[146] Sarah Farley-Allan (1879–1923) of nearby Jermyn was an illustrator of talent who designed book covers for local trade journals and organizations, as well as advertisements and pen and ink drawings for the *Scranton Times*.[147] Portraitists John Evans, P. W. Costello, and W. B. Sandorhazi were painting and exhibiting images of Scranton's leading figures, while from nearby Wilkes-Barre, Bear Creek native Edith Reynolds was traveling regularly to New York City to study with Robert Henri at the Art Students League.[148] Most of Scranton's artists exhibited independently without benefit of museum or gallery, staging three-day or one-week displays during certain hours of the day.[149] Additionally, works of art by nationally-celebrated artists were also exhibited in windows and showrooms of Scranton's leading commercial establishments.[150]

Well-heeled Scrantonians were collecting art, and while few private collections were finding their way into the Everhart Museum, many were being made accessible to public audiences in a variety of ways.[151] Fifty-five paintings owned by local coal operator and banker James G. Shepherd were lent for exhibition in 1913 to the Lotos Club of New York City.[152] Raught's patron, John Law Robertson, opened his collection to public viewing, presenting work by Frederick Church, George Inness, Charles Lazar, and John Sartain in the Art Rooms of the Connell Building.[153] Bequests were also bringing art into public spaces at institutions other than the Everhart Museum; for example, O. S. Johnson's bequest to the YWCA was used in this way.[154]

Morse essentially constructed an art world for herself in Scranton. As a teacher, she taught, supervised drawing instructors, and designed art curricula. As an artist, she spent her summers studying art abroad or taking postgraduate courses at schools like Harvard University and the Rhode Island School of Design. Her summers offered the welcome boon of unencumbered time for study and travel and this, coupled with a regular salary, made her artistic life stable, productive, and relatively free from administrative deadlines for three to four months out of the year.[155] Probably Morse returned often to New York City to visit museums, art schools, and galleries, as many Scrantonians do today. Finally, her private life was enriched by colleague, teacher, and kindred art spirit Leah M. Heath, who had as great a passion for the arts as did Morse.[156] Morse boarded sixteen years with Heath and undoubtedly participated in the end-of-the year exhibition of art masterpieces that the latter staged annually for Central High School's graduating seniors.[157]

Describing the reality of Morse's teaching career is a complex endeavor, and documentation is scant.[158] Her official "Teacher's Record," however, offers an important lead, documenting her steady progress from "Supervisor of Drawing, Grade Schools" (1897), to "Supervisor of Drawing, Scranton High School" (1899), and finally to "Head of the Drawing Department" at Central High School" in 1917.[159] The

sequence of promotions attests to Morse's proficiency and skill in designing a well-regarded curriculum, and suggests leadership and administrative competence as well. While the "Record" enumerates Morse's career benchmarks and commitment to continuing self-education, it does not reveal the quotidian realities of her professional life. The profession of school teacher in early twentieth-century Scranton was still in formation.

One year before Morse's arrival in Scranton, the city's only high school had been rebuilt on its original site, and teachers were being hired to staff the inaugural faculty.[160] Among the new teachers hired for September 1896 was Dalton-born, Scranton High School graduate Leah M. Heath, who was appointed to head the English Department at her *alma mater*.[161] In 1897, Morse also became a member of the high-school faculty. As a graduate of Pratt Institute's Normal School, Morse exemplified the quality of teacher that Superintendent of Lackawanna County School Districts J. C. Taylor had been advocating as early as 1893.[162] By comparison, Heath's pedagogical training comprised study at Philadelphia's School of Elocution and the Boston School of Expressions, and teaching positions at the Conservatory of Music in Cincinnati, Ohio (elocution), and at a high school in Fall River, Massachusetts (elocution and gymnastics).[163] Although much less experienced a teacher than Heath, Morse at the outset of her teaching career had greater job security at a critical time when new certification standards were being set and state educational codes were being implemented. It seems that Morse's and Heath's intertwined professional careers were subject to considerable change during the years preceding Heath's sudden death in 1912.

An issue of paramount concern for Morse and Heath was changing guidelines for teacher recertification. In Scranton of 1912, it was strongly hinted that conflict over certification guidelines occasioned Leah Heath's premature death on the eve of her examination in rhetoric and English literature. Readers of the *Tribune-Republican* on June 13, 1912 learned that Heath collapsed at the conclusion of the busy academic year due to:

> …nervous strain resulting from worry over the humiliation of the necessity of taking an examination in subjects that Miss Heath had been teaching in the Central High School for seventeen years.[164]

Heath was holding a teaching certificate no longer recognized by the state, and was certainly aware that she did not possess the pedagogical training of her Normal School-educated colleagues. This must have been an economically destabilizing situation for her as, indeed, it would have been for any unmarried woman without family and living on her own income. Heath's death in 1913 spared her the poverty that de-certification threatened, since her demise also anticipated, by thirty-three days, state institution of a teachers' retirement fund.[165]

Heath's death was a great personal loss to Morse. On a practical level, it precipitated a peripatetic living situation for Morse, who moved from one Scranton residence to another for the next twelve years.[166] Beyond Heath's Will, which documents a change in executrix, and favors Morse's appointment over a married female cousin, no record has been found indicating the precise tenor of Morse's and Heath's friendship. Nested in the language of the resolution drafted by Central High School faculty to honor Leah Heath's life is a statement about colleague-friends such as Morse:

> . . . [Heath's] place in the regard of her associates and pupils is high and secure; her devotion to her task was boundless; in her field of labor she toiled with unflagging zeal and brought forth fruits a hundredfold. She had a wide and deep knowledge of the best that has been thought and said and done in the world; joined with this was a taste that was sure and fine, and a power of expression which made her most incidental criticism illuminating. Her burdens seemed greater than her strength, but now the brave struggle being over, doubts are ended and she enjoys the beatific vision.
>
> Our sympathy goes out to all her friends and especially to our sorrowing colleagues whom ties more near than those of blood bound in closest friendship to her we mourn.[167]

Morse assuredly was one of Heath's "colleagues whom ties more near than those of blood bound in

closest friendship." In fact, to Morse, "devoted friend," fell the duty of scattering Heath's ashes in the Neshaminy Creek waters that had also received her parents' dust.[168]

Morse was spared Heath's trauma of re-certification because of her strong educational background, but she was to face her own challenges in 1904. Until that year, Scranton High School was sole purveyor of high school education in Scranton. Afterwards, two new high schools opened in response to a city-wide clamor for more "practical education." Technical High School and the William T. Smith Manual Training School both offered alternative curricula more vocational than classical in substance. Subjects like Drawing continued to be taught at Central High School, but the focus shifted to "fine art" rather than "mechanical" or "applied arts." Smith Manual Training School, in fact, offered courses—pattern, embroidery design and leather-tooling—that would have appealed to Morse as a "once-upon-a-time" book cover designer.[169] Nevertheless, Morse chose to remain at Scranton, now Central, High School, her vision directed to "fine art," which she taught, studied, and produced.[170]

Was Morse engaged by initiatives sponsored by Scranton women lobbying for civic improvement, child labor reform, better working conditions for factory-women and girls, and women's suffrage in the period 1900–1920? To date, only one document offers an answer, but it places Morse squarely in company with Scranton's most energetic women reformers. In 1919–20, Morse was listed as a member of the all-woman College Club.[171] As such, she enjoyed the company of politically-active women, whose collective club-voice substituted for the franchise they received in 1920. Morse's fellow club members included honorary member Louisa Hunt Dimmick, President of the City Improvement Association;[172] Esther Sinn, president of the local chapter of the American Playground Association;[173] Edith Wallbridge Carr, moving force behind creation of the American Library Association, President of the State Library Association, and personal friend of the first Librarian of Congress, Richard R. Bowker;[174] and Anna Calista Clarke, M.D., Day Nursery administrator and co-founder of the Lackawanna County Equal Suffrage League in 1913.[175] Morse also knew Caroline Patterson Sickler, founder of Scranton's first Parent-Teacher Association, who instituted the first radio broadcasts on women's issues by a federated woman's club district through Wilkes-Barre's radio station WRAX.[176]

The story of art, pedagogy, and women in Scranton remains to be written, but Alice Morse's career is an instructive touchstone. Morse left Scranton before the crash of 1929, but had witnessed the riveting state suffrage convention hosted by Scranton clubwomen in 1914; the celebration of the city's semi-centennial in 1916; the city-wide relief efforts during World War I; the flu epidemic of 1918; and passage of the 18th and 19th Amendments, in 1919 and 1920. And, for twenty-six years in Scranton and under Morse's *aegis*, Scranton's youth had discovered ideas, received inspiration, and acquired knowledge on art and culture that was not provided by their local museum.

The precise contours of Alice Morse's life in Scranton are faint. Her decision to remain in Scranton after Leah Heath's death was probably dictated more by necessity than by personal or career satisfaction. Having earned economic freedom through her teacher's pension by 1923, Morse left immediately for New York City. Upon arrival, she donated her personal collection of self-designed book-covers to the Metropolitan Museum of Art, thus fulfilling Heath's testamentary request that any remains of her estate be donated to the Metropolitan Museum and an acquisitions fund be established bearing her name. As it happened, Heath's estate did not yield the desired surplus in funds, but Morse's donation of books, many of which are inscribed to Leah, secured for both the stature of benefactor to the Metropolitan Museum of Art.

DESIGNS BY ALICE C. MORSE

INTERPRETING MORSE'S BOOK-COVER DESIGNS

The new idea of the artist-designed commercial book cover took hold in the American publishing industry in the late 1880s and remained the prominent style of book-cover design for almost twenty years. Although the field continued to attract many designers throughout this period, Sarah Wyman Whitman, Alice C. Morse, and Margaret Armstrong were among the earliest and most successful.[177] Since the late nineteenth century, Morse's work has not been as well known as that of her contemporaries. This is due in part to the fact that although Morse began designing covers in 1887, she did not begin signing them until 1894. Morse's eclectic approach to design makes it difficult to identify her work, which is not defined by any particular style. It is expected that close study of the covers presented in this book will help readers discover consistencies in Morse's approach to design.

Evident in all of Morse's designs is a thorough understanding of historic ornament and an expert ability to apply this ornament to book covers. Morse's early designs feature variations on classical ornament from Roman and Renaissance art, but she soon began to experiment with motifs from other cultures and periods of history, including Celtic, Arabic, Gothic, Rococo, Arts and Crafts, Art Nouveau, and pictorial styles. One device frequently used by Morse is the cartouche, a decorative frame for lettering, generally filling only a portion of the cover. She often centered a cartouche on a front cover and used variations of the motifs to decorate the spine. Three examples of what I refer to as Morse's "cartouche style" can be found on *Chevalier of Pensieri-Vani* (92-2), *Silhouettes of American Life* (92-10), and *Vain Fortune* (92-11).

Another approach in Morse's body of work consists of a bold, highly decorative design, which fills the entire cover, and I refer to these as "full-cover designs." They are orderly and symmetrical, but Morse's energetic style of drawing enlivens them to the extent that they sometimes appear to be moving or spinning on the cover. Striking examples of full-cover designs can be seen on *The Wrecker* (92-13), *A House in Bloomsbury* (94-7), and *Tattle-Tales of Cupid* (98-2). Examples of kinetic designs are *Chita: A Memory of Last Island* (89-2), and *Marse Chan* (92-12).

Fine bookbindings of the past were obviously a source of inspiration to Morse, and we know from her chapter "Women Illustrators" in *Art and Handicraft in the Woman's Building of the World's Columbian Exposition* (1893) that she was familiar with the work of famous craftsmen such as Derôme and the Grolier binders.[178] She undoubtedly saw fine, early bookbindings in exhibitions at bibliophilic clubs and antiquarian bookshops, and also took inspiration from pictures in books in the libraries at Cooper Union and Louis C. Tiffany & Company.[179] In the late 1880s, the Bibliothèque Nationale and the British Museum both published their collections of bindings in beautifully illustrated books. Morse most probably had access to these and other ornament books published for artists and designers. One of Morse's book covers may have been inspired by a plate in Owen Jones's *The Grammar of Ornament*. Her design for *The Alhambra* (92-8), bears a close resemblance to "Moresque Ornament from the Alhambra," No. 3, Pl. XLI.[180]

Considering the differences between the historic and modern bookbinding processes, it is surprising how well Morse's historic designs retain the feeling of a traditional hand-tooled book.[181] The decoration on a traditional hand-bound book was built up by the use of many small brass tools that were heated and pressed into the leather cover by hand; colors were applied with metal leaf, paint or leather onlays.[182] Morse needed to reinterpret these techniques for modern book design. This required her to draw a single design on paper using pen-and-ink and watercolor; the design would then be engraved onto brass dies and stamped onto cloth covers using a massive, heated press.

Several of Morse's historical designs were inspired by sixteenth-century European bindings. Some were based on strapwork and fanfare bindings.[183] In both styles, the covers consist of interwoven linear patterns, and the spaces thus formed are filled with delicate foliate details. *Summer Holidays* (89-1), *Two Years in the French West Indies* (90-3), and *Common Sense in the Household* (96-7) are reminiscent of early strapwork bindings (fig. 14); and *California and Alaska* (90-7) was designed in classic fanfare style (fig. 15). Morse was also occasionally inspired by French semé bindings.[184] In the semé style, the decoration consists of an overall pattern of many small dots or delicate flower-like motifs (fig. 16). Semé designs appear on the Giunta Series (90-1) and the New Edgewood Edition of works by Donald Grant Mitchell (93-4). Other historically-inspired book cover designs by Morse can be found on *Holland and Its People* (90-5), designed in armorial style, and incorporating the coat of arms of the Netherlands; *Curiosities of the American Stage* (91-7), which uses conventional ornaments and borders, including a French dentelle border; and *The Alhambra* (92-8), inspired by traditional Islamic binding design, defined by a central lozenge and corner ornaments in the arabesque style.[185]

Morse also found inspiration in the fashions of her own time, including the Arts and Crafts and Art Nouveau styles. Both developed in response to the Industrial Revolution and both aimed to elevate the level of the decorative arts through the application of the highest standards of craftsmanship and design of commonplace objects. The artist-designed book covers influenced by these styles and produced by contemporary British commercial publishers J. M. Dent, and Osgood, McIlvaine & Company, particularly impressed Morse.[186] Fellow-designer Sarah Wyman Whitman first made the Arts and Crafts style popular for use on commercial covers in America in the late 1880s.[187] Morse's *Landscape Gardening* (91-10) is very similar to many Whitman book covers designed in the Arts and Crafts style, for example, Oliver Wendell Holmes', *Before the Curfew and Other Poems,* published in 1888 (fig. 17).[188] Later, bolder versions of the Arts and Crafts style can be seen on Morse's covers on *A House in Bloomsbury* (94-7) and *Our Home Pets* (94-9). In 1896, we see Morse beginning to experiment with the Art Nouveau style on the cover of *The Majesty of Man* (96-1), one of her earliest signed book cover designs. Subtler versions of the Art Nouveau style were created for *A Knight of the Nets* (96-2), *A Lovable Crank* (98-5), *Poems of Cabin and Field* (99-2), and *My Lady's Slipper* (99-4), which has been compared to Whitman's earlier designs for Sarah Orne Jewett's *The Country of the Pointed Firs* (1897) (fig. 18), and for Helen Choate Prince's *At the Sign of the Silver Crescent* (1898) (fig. 19).[189] Occasionally, Morse designed book covers in the pictorial style, in which the design realistically illustrates the subject of the book. *Yellow Pine Basin* (97-8), *The Missing Prince* (97-3) and *I, Thou, and The Other One* (98-1) are examples of these covers in the pictorial style.

Lettering was another important element of Morse's designs. No single style of lettering emerges from her designs, but some alphabets are used repeatedly. At times Morse emulated Whitman's practice of drawing letters with their bowls and bars set very high, as on the cover of *Kerrigan's Quality* (94-4). On this cover Morse uses Whitman's signature letter A, with a flattened top surmounted by a bar; the letter R with vertically flattened bowls set high; and the letter E, also with its bar set high.[190] Morse frequently uses another lettering style, featuring san-serif letters with curved strokes terminating in an outward flare. This can be seen on the covers of *House and Hearth* (91-3), *Silhouettes of American Life* (92-10), and *A Manual of Mending and Repairing* (96-4). Conversely, she sometimes draws letters with strokes that curve dramatically inward, as seen on the covers of *A Rose of a Hundred Leaves* (91-1), and *Lord Arthur Saville's Crime* (91-4). In addition to these alphabets, Morse created many other styles, always integrating the letterforms beautifully into her designs. On occasion, commercial type was substituted for hand-drawn lettering. The use of type is most often seen on book-cover designs for series, where the lettering had to be changed for each title. Examples can be seen on the covers of The Odd Number Series (89-4), and Harper's Young People (New) Series (90-2), and on the monograph *The Majesty of Man* (96-1).

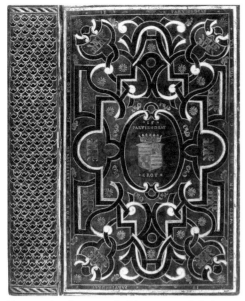

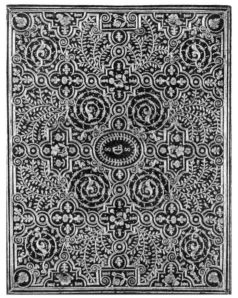

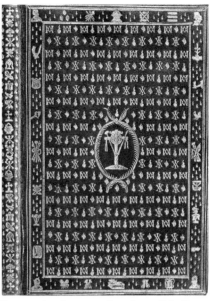

FIG. 14. A 16th-century Parisian strapwork design on silver-tooled binding for Philippe III with decorative elements similar to Morse's designs for *Summer Holidays* (89-1) and *Common Sense in the Household* (96-7). Richard de Wassebourg, *Antiquitez de Gaule* [Paris: François Girault], 1549. Morgan Library & Museum, New York. PML 15443, binding.

FIG. 15. A 16th-century French fanfare binding with a design similar to Morse's for *California and Alaska* (90-7). Guy de Faur, seigneur de Pibrac, *Ex Vidi Fabri Pibracij . . . tetrasticha.* Manuscript, written in Paris, 1594. Morgan Library & Museum, New York. MA 3108, binding, shown spine down.

FIG. 16. A 16th-century French semé binding, the type of design to have inspired Morse's designs on the Giunta Series (90-1) and The New Edgewood Edition of the Works of Donald Grant Mitchell (93-4). Prayer book. Manuscript written and illuminated in Tours, ca. 1500. Morgan Library & Museum, New York. M. 292, binding.

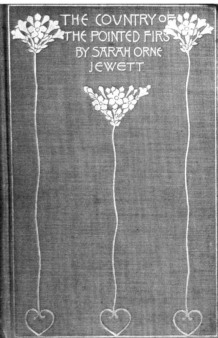

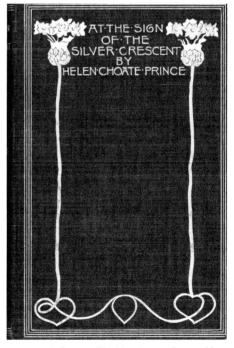

FIG. 17. *Before the Curfew and Other Poems* designed by Sarah Whitman. (Boston: Houghton Mifflin Company, 1888).

FIG. 18. *The Country of the Pointed Firs* designed by Sarah Whitman. (Boston: Houghton Mifflin Company, 1897).

FIG. 19. *At the Sign of the Silver Crescent* designed by Sarah Whitman. (Boston: Houghton Mifflin Company, 1898).

For each commission, Morse would present her publishers with two or three rough sketches. Once the publisher had chosen a design Morse prepared a finished colored drawing, specifying the colors of the design and the cloth. Depending on the cost and availability of materials, her choices would be accepted or modified. Once the design was approved, the cover would be put into production.[191] In order to understand the process by which Morse's designs were translated into book covers, it is necessary to know something about commercial book production in the 1890s.

Morse's books were bound using the efficient method of case binding, a commercial binding technique developed in the 1830s.[192] In case binding, then as now, the covers of books are manufactured separately from the text-blocks, usually with cloth as a covering material, but occasionally employing leather or paper. Each cover is constructed of two boards separated by a thin paper spine-piece, with spaces for hinging left on either side of the spine. Once these pieces are glued to the covering material, its edges are turned in over the boards. The covers may then be stamped or embossed with a design. Once the stamping is complete, the covers are attached to the text-blocks. The spine of a case binding is detached from the text-block, which is connected to its cover by the flanges of a fabric lining and the outer endleaves. This allows the book to open easily and lie flat. The case-binding structure is perfect for small, lightweight books, but does not provide good support for heavy or frequently used volumes, which explains the poor condition in which early publishers' bindings are often found today.

Morse's hand-drawn designs would be transferred, either by hand or mechanically, to one or more brass stamps made by an engraver or die-sinker. One plate was required for each color in the design. Once the plates were cut, the design would be stamped onto the book covers with a steam- or gas-heated stamping press. Each cover was set on the press, face-up. Gold and colored leaf or foils were laid onto the cover, and the head of the press raised up to stamp the design against the heated die. This process was repeated for each color in the design.[193] The creative use of stamping in Morse's work indicates that she had a thorough understanding of the techniques involved in the production of book covers, and it is possible that she collaborated with engravers to develop these varied and complex effects. Morse achieved beautiful and subtle results with the stamping technique, such as those in which the entire design is recessed into the cover. A number of Morse's covers are stamped only with gold, among them *Ballads* (90-8), *The Chevalier of Pensieri-Vani* (92-2) and *Kitty Alone* (94-3). Examples of covers combining stamping in both blind (without pigment) and gold are *Sweet Bells Out of Tune* (93-1) and *When All the Woods are Green* (94-2). In these the covers feature lovely blind-stamped designs, with lettering and small motifs in gold or in color.

Morse also made use of silver-stamping, as demonstrated in the designs of *The Chatelaine of La Trinité* (92-1), and *Under the Evening Lamp* (92-15). Because real silver tarnishes, a mixture of aluminum and palladium was used.[194] Morse combined up to three colors in some designs, usually in concert with gold or silver, and examples of this can be seen on the covers of The Gypsy Series (94-8), *Hilda Strafford* (97-4), and *The Conquest of Granada* (93-2).

Some of Morse's covers were not only stamped but also embossed. Embossing results in a design in relief, rather than one that is recessed into the cover, as with stamping.[195] Embossed designs, especially those in gilt, often have a sculptural quality, in which the gold catches the light with great effect. Examples of Morse's embossed covers are *Lyrics of Lowly Life* (96-3) and *Dariel* (97-2). There are also instances where the surface of the stamping die was intentionally given a texture, either to change the way that the gold leaf reflected light on the book cover, or to create matte or other textured effects. Examples of this technique can be found on the covers of *My Study Fire* (99-3), and *Charlotte Brontë and Her Circle* (96-6).

Since the early 1830s, the most commonly used covering material for publisher's bindings was bookcloth. The qualities of good bookcloth are impermeability to glue, dimensional stability, resistance to moisture, and a pleasing aesthetic. Bookcloth is manufactured from various grades and weaves

of plain cotton or linen fabric, treated to withstand the rigorous process of bookbinding and subsequent handling by readers. All bookcloth made in the late nineteenth century passed through various processes of bleaching, application of colored and clear starches, calendering (pressing between metal rollers to produce a smooth surface), and embossing. The finished appearance of the bookcloth was achieved through the creative application of some or all of these processes.[196] Most of the cloth used during the 1890s was referred to as "extra" cloth, defined by the fact that the coloring agents used were part of the starch mixtures that were applied only to the outside of the bleached white base cloth, leaving the back of the cloth in its natural state. The term "extra" may refer to the fact that the colored starches were applied in numerous coats to create a richly colored surface.[197]

Several trends in bookcloth can be observed in American publishers' bindings of the 1890s. It is common to see many variants of plain-weave cloths of all colors, some which appear to have a very solid, smooth surface. The smooth surface, sometimes referred to as "vellum" or enameled, was achieved through the application of many layers of colored starch and heavy calendering.[198] In other plain-weave cloths, the grain of the cloth shows through the starched surface. This effect was generally achieved through the scraping off of excess starch.[199] The opportunity to study Morse's unbound covers led to an unexpected discovery relating to this type of cloth.

Light colors and natural surfaces became fashionable in the 1890s, while darker colors associated with the Victorian period went out of fashion.[200] Publishers' dealt creatively (and economically) with this trend by recycling older cloths, reversing them to expose the lighter, more naturally-finished side of the fabric. Reversed cloth begins to appear in the late 1880s, and its use is significant because, while washable cloths were not common at the time, the reverse side of bookcloth was not affected by water.[201] Most of Morse's light-colored book covers were bound in reversed cloth, using the back of both plain-weave and old-fashioned ribbed cloths. To identify reversed cloth, one must look for uneven coloring, or feel for a ribbed surface. If the book is damaged or unbound, close inspection of the exposed cloth will make it easier to identify reversed cloth. Examples of reversed cloth on Morse's book covers include: *Seth's Brother's Wife* (87-1), *Summer Holidays* (89-1), *House and Hearth* (91-3), *Lord Arthur Savile's Crime* (91-4), *Landscape Gardening* (91-10), *Belhaven Tales* (92-3), *Old Ways and New* (92-4), *The Wrecker* (92-13), The Gypsy Series (94-8), and *The Majesty of Man* (96-1).

Publishers of the time experimented extensively with the colors of binding materials, and Morse's designs for series of literary works were often issued in two very different colors of bookcloth. Publishers must have felt that a choice of colors would induce buyers to purchase sets that most appealed to their personal aesthetic, resulting in higher sales. Series were usually produced in a white cloth, often with gold edges and floral printed endpapers, and a dark blue or green cloth with gold or uncut edges. Both the Harper's Odd Number Series (89-4) and Dodd, Mead's Giunta Series (90-1) are examples of this treatment. Monographs were also occasionally issued in several color variants. *Chita: A Memory of Last Island* (89-2) has been noted in two color variants, and *Ballads* (90-8), has been seen in three. Another style of binding used two different cloths in one design, one for the spine and another for the covers. *Landscape Gardening* (91-10) is the only example of this style identified in Morse's oeuvre to date.

In addition to bookcloth, publishers occasionally bound series and deluxe books in full leather. Four of Morse's designs were produced in full-leather bindings: *California and Alaska* (90-7), Wordsworth's *Sonnets* (91-9), the Ariel Edition of the Works of William Shakespeare (92-9), also issued in leather-look cloth, and *Writing to Rosina* (94-1). Another, more unusual covering technique was used for the At the Ghost Hour Series (94-5). The design appears to be a pale, ghost image on white cloth. This special effect was achieved through printing the design in strong colors on paper that was then covered with translucent, plain white cloth, so that the printed image appears subtly through it.

This brief introduction to Morse's creative approach is intended to help readers make distinctions among her designs, and facilitate comparisons between her designs and those of her contemporaries.

NOTES

[1] Maud Howe Elliott, ed., *Art and Handicraft in the Woman's Building of the World's Columbian Exposition, Chicago 1893* (Paris: Goupil; Chicago and New York: Rand McNally, 1894), 68–97; Gilson Willets, "The Designing of Book-Covers: Women Artists in the Field," *Art Interchange* (November 1894): 118–119.

[2] *Bulletin of the Metropolitan Museum of Art*, vol. 19 (1924): 114–121.

[3] Ibid., 23.

[4] In his report of the Library Committee to the Executive Committee, December 17th, 1923, the chairman, Edward D. Adams reports, "During the past month the Library has received an interesting gift from Miss Alice C. Morse consisting of fifty-eight book covers designed by herself. The book covers are now on exhibition in the Library."

[5] Early in my research, Vesta Lee Gordon informed me that Charles Gullans had identified twenty-five book covers as Morse's work. Thirteen titles are listed in Jean Peters, ed., *Collectible Books: Some New Paths* (New York and London: R. R. Bowker Company, 1979), 54.

[6] Alice C. Morse, will dated May 20, 1954, proved September 26, 1961, File P1394, Surrogate's Court, Bronx County, New York. Other information on Morse's life has been obtained from The Metropolitan Museum of Art Archives (New York, NY), from Morse's Scranton Public Schools Teacher's Record Card [1923?] (Teacher's Record Card) and in published works including Elliott, 68–79, Willets, 118–119, and in Frances Willard and Mary Livermore, editors, *A Woman of the Century: Fourteen Hundred-Seventy Biographical Sketches Accompanied by Portraits of Leading American Women in All Walks of Life* (Chicago: C. W. Moulton, 1893), 523.

[7] Mindell Dubansky, "The Proper Decoration of Book Covers," *Gazette of the Grolier Club*, no. 52, 2001: 60–78.

[8] Leah Heath's birth and death dates were taken from the personal notes of family member William Heath. Her birth year is confirmed by the federal census return of 1910.

[9] Morse's book covers may be viewed by appointment in the Department of Drawings and Prints. The Metropolitan Museum of Art accession numbers are listed at the end of this book, in the index headed: "Concordance of Metropolitan Museum of Art Accession Numbers and Catalog Entry Numbers" and within each entry.

[10] Amelia Peck and Carol Irish, *Candace Wheeler: The Art and Enterprise of American Design, 1875–1900.* (New York: The Metropolitan Museum of Art and Yale University Press, 2001): 26–27.

[11] Teacher's Record Card.

[12] Charles Gullans and John Espey, "American Trade Bindings and Their Designers, 1880–1915," in *Collectible Books: Some New Paths* (New York and London: R. R. Bowker Company, 1979), 34–36.

[13] Willets, 119.

[14] Teacher's Record Card.

[15] Edna Harris, "New Book Covers," *Brush and Pencil*, vol. 5, no. 3 (1899): 124.

[16] Teacher's Record Card. Most published sources do not agree on Morse's year of birth. Many cite 1862, perhaps following the lead of Frances Willard and Mary Livermore, 523. In a deposition from Morse's friend Augusta C. Wagner dated September 18, 1961, Wagner states that Morse was 101 years of age when she died in July 1961 (Alice C. Morse, will dated May 20, 1954). June 1, 1863 is the birthday written on Morse's Scranton Public Schools, Teacher's Record Card, and this is the source I generally use. The birth year 1863 is supported by the federal census returns of 1880, 1910, and 1930.

[17] Alice C. Morse, will, May 20, 1954.

[18] Willard and Livermore, 523.

[19] Ibid.

[20] Ibid.

[21] *Annual Report of the Trustees of the Cooper Union for the Advancement of Science and Art* (New York: 1879–83 and 1889–91). Each report includes a thorough description of the mission, programs, faculty and students.

[22] Teacher's Record Card.

[23] *Annual Report of the Trustees of the Cooper Union for the Advancement of Science and Art* (New York: 1879), 10.

[24] Ibid. (1891), "Advisory Council of the Woman's Art School," unpaged.

[25] Ibid. (1892), 12.

[26] Ibid. (1879), "Instructors in the Free School of Science and Art," unpaged.

[27] Ibid. (1890), R. Swain Gifford, J. Alden Weir and Charles A. Vanderhoof were listed in "Instructors in the Cooper Union Free Schools: Woman's Art School," unpaged.

[28] In each *Annual Report* for the Woman's Art School, Principal Susan N. Carter submitted to the Trustees a report that discussed the professional activities of the school's graduates.

[29] Teacher's Record Card.

[30] Ibid. At the time Morse worked for Tiffany Glass Co., it was located at 333–335 Fourth Avenue (now Park Avenue South), at Twenty-fifth Street.

[31] Martin Eidelberg, Nina Gray, and Margaret K. Hofer, *A New Light on Tiffany: Clara Driscoll and the Tiffany Girls* (New York: The New-York Historical Society; and London: D. Giles Limited, 2007), 16. The discovery of Clara Driscoll's correspondence has made it possible to document the day-to-day activities at the Tiffany studios and to attribute many designs to Clara Driscoll and others.

[32] Ibid., 14, 184–185.

[33] Ibid., 30.

[34] Ibid., 28–34.

[35] Willets, 119; cf., the full text of this important interview in the appendix.

[36] Ibid., 119.

[37] Willard and Livermore, 523. The church that Willard and Livermore identify is now the Greater Trinity Temple, Church of God in Christ. There are numerous small nineteenth-century flower garland windows in the church, but the main stained-glass window was replaced during the mid-twentieth century. It is not known if Morse designed the existing windows.

[38] "Cooper Union Graduates," *New York Times*, May 30, 1891; Willard and Livermore, 523.

[39] Cooper Union (1891), 76.

[40] Cooper Union (1892), 13.

[41] Peck and Irish, 65–66. "The Woman's Building at the World's Columbian Exposition, 1892–93," pages 63–71 provide a good introduction to the circumstances affecting Candace Wheeler and Alice C. Morse in relation to the Woman's Building.

[42] *Report of the Board of General Managers of the Exhibit of the State of New York, at the World's Columbian Exposition* (Albany: J. P. Lyon, 1892), 193.

[43] Morse's entries in the exhibition are described in *Report of the Board of General Managers,* 193.

[44] Elliott, 68–97.

[45] Ibid., 70, 74–75.

[46] Peck and Irish, 69–70.

[47] Ibid., 70.

[48] Ibid., 523.

[49] Teacher's Record Card.

[50] Peck and Irish, 27–38.

[51] *Corticelli Home Needlework: A Manual of Art Needlework, Embroidery and Knitting,* edited by Mrs. L. Barton Wilson, Mrs. Emma Haywood, Miss Alice C. Morse, Miss Elizabeth Moore Hallowell, and Mrs. Amalia Smith (Florence, Massachusetts: Nonotuck Silk Company, 1898): Design for a centerpiece or doily, The Garland Wild Rose and Forget-me-not Design No. 54, 30–31. Design for a photograph frame, Garland Photograph Frame Design No. 62, Colored Plate XXV, 73–74.

[52] Morse's designs appeared in *Art Amateur,* v. 36 (1897), no. 1 (design no. 1746 [repeat decoration for china, embroidery, or pyrography]); vol. 36, no. 2 (design nos. 1764–1767a, [*bonbonniére* decorations for candy dishes in the shape of spades, hearts, diamond, clubs]); and 1768 [china box-lid decoration]; vol. 37, no. 1 (design no. 1738 [carved wooden platter with fish motif]).

[53] Elliott, 73–75.

[54] Willets, 119.

[55] "Bookbindings at Scribners'," *The New York Times*, November 12, 1894.

[56] Teacher's Record Card.

[57] John T. Winterich, *The Grolier Club, 1884–1967* (New York: The Grolier Club, 1967), 7.

[58] Frederick R. Brandt, *Designed To Sell: Turn-of-the-Century American Posters in the Virginia Museum of Fine Arts* (Richmond, Virginia: Virginia Museum of Fine Arts, 1994), 75.

[59] Willets, 118–119.

[60] R. R. Bowker, ed., *American Catalogue 1890–1895,* (New York: Peter Smith, 1941), 472.

[61] Charles Gullans and John Espey (1979), 53–54; *Publisher's Weekly* (December 20, 1890): 990.

[62] Aldine Club, *Catalogue of an Exhibition of Oil and Water-Color Paintings Loaned by New-York Artists, Also of Modern Cloth and Leather Book-Covers and Original Designs Therefor, at The Aldine Club, from the Twenty-fifth to the Thirty-first of March, Inclusive,* (New York: The Aldine Club, 1892); (anonymous author), *Commercial Bookbindings: An Historical Sketch, with Some Mention of an Exhibition of Drawings, Covers, and Books, at the Grolier Club, April 5 to April 28, 1894* (New York: The Grolier Club, 1894); Architectural League of New York, *Catalogue of the Annual Exhibition of the Architectural League of New York* (New York: Architectural League of New York, 1889–1890, 1893–1895).

[63] Architectural League of New York (1899), "Introductory," unpaged.

[64] Grolier Club (1894), 114–15.

[65] "Commercial Bindings at the Grolier Club," *Publisher's Weekly* (No. 1160, April 21, 1894): 620.

[66] *The House and Home: A Practical Book* (New York: Charles Scribner's Sons, 1894), vol. 1, p. 9.

[67] Ibid., 7. Although book-cover design was viewed as a new occupation for women in 1894, women had worked in the binding trade for at least a century.

[68] Ibid., Anne Reeve Aldrich, *Songs About Life, Love and Death* (New York: Charles Scribner's Sons, 1892), p. 9.

[69] Ibid., 6–7.

[70] Charles Cullans and John Espey, *Margaret Armstrong and American Trade Bindings* (Los Angeles, California: University of California, Los Angeles, Research Libraries, Occasional Papers 6 (1991), 2.

[71] Elliott, 75.

[72] Sue Allen and Charles Gullans, "The New Generation: Sarah Whitman and Frank Hazen," *Decorated Cloth in America: Publisher's Bindings 1840–1910* (Los Angeles: University of California, Los Angeles Center for 17th- and 18th-Century Studies, William Andrews Clark Memorial Library, 1994), 95, n. 25; 74

[73] Ibid., 59.

[74] See Frelinghuysen essay.

[75] For example: Allen and Gullans, 65–72; Minsky, 10–11, 42.

[76] Ibid.

[77] Ibid.

[78] Gullans and Espey (1991), 132.

[79] Ibid., 14.

[80] Ibid., 134.

[81] Ibid., 69–107.

[82] Willets, 119.

[83] Gullans and Espey (1991), 24–25.

[84] Cf. Morse's statements in appendix.

85 Willets, 119.

86 Gullans and Espey (1979), 95 (note 25).

87 Ibid., 35.

88 Teacher's Record Card.

89 Ibid.

90 Alice C. Morse, probate proceeding, will of Alice C. Morse, dated September 26, 1961, File No. P1394, Surrogate's Court, Bronx County, New York. According to the federal census record of 1880, Morse's mother, Ruth P. Morse, was born in Pennsylvania, which makes it plausible that Morse may have had family there.

91 The role of an art supervisor was explained to me by staff at the Lackawanna Historical Society.

92 Teacher's Record Card. According to the "Lackawanna Junior College at Central Grand Opening Souvenir Booklet," which quotes the Central High School Yearbook of 1896 on page 23, the building opened its doors on September 2, 1896.

93 Teacher's Record Card.

94 Scranton City Directories, 1901–1912. The address, 1024 Scranton Ave., is inscribed on many of Morse's book covers at The Metropolitan Museum of Art.

95 Scranton Republican, June 13, 1912.

96 Ibid.

97 "Report of the Library to the Trustees . . . 1923"

98 Scranton Republican, June 13, 1912.

99 Michele Phillips Murphy, Reference Librarian, Albright Memorial Library, Scranton, traced Alice Morse's addresses in The Scranton City Directories of 1913, 1918, 1920, and 1923, which cite the following residences: 917 Mulberry Street; 320 Madison Avenue; 1102 Green Ridge Street; and 739 Jefferson Avenue.

100 Teacher's Record Card.

101 Ibid.

102 Alice C. Morse will dated May 20, 1954.

103 The Bulletin of The Metropolitan Museum of Art, vol. 19 (1923), p. 23.

104 The Department of Drawings and Prints is the largest curatorial department in the Metropolitan Museum of Art. The collection includes over one million drawings, prints, books, and ephemera. Cataloging the collection moved slowly before the computer age and, of necessity, the focus was on primary works of art. Alice Morse's book covers were never a point of focus. The new computerized cataloging procedures in The Museum System (TMS) have speeded up the process. Alice Morse's book covers were cataloged immediately after I brought them to the attention of the curator in charge of American books and prints.

105 Deposition of Augusta C. Wagner dated September 18, 1961; in Alice C. Morse, will dated May 20, 1954.

106 Alice C. Morse, will, May 20, 1954.

107 Ibid.

108 Ibid.

109 Alice C. Morse, "Women Illustrators," in Elliott, p. 94.

110 See Sarah Wyman Whitman, "Notes of an Informal Talk on Book Illustration, Inside and Out, Given before the Boston Art Students' Association, February 14, 1894" (Boston: Art Students' Association, 1894), p. 5, in Erica E. Hirshler, A Studio of Her Own: Women Artists in Boston, 1870–1940 (Boston, Massachusetts: Museum of Fine Arts, Boston, 2001), p. 42.

111 One of the first such studies was Anthea Callen's Women Artists of the Arts and Crafts Movement, 1870–1914 (New York: Pantheon Books, 1979); See also Peck and Irish; and Eidelberg, Gray, and Hofer.

112 See, for example, Nancy Finlay, Artists of the Book in Boston, 1890–1910 (Cambridge, Massachusetts: Department of Printing and Graphic Arts, The Houghton Library, Harvard College Library, 1985; Cullans and Espey, (1991); Charles Gullans, "The New Generation: Sarah Whitman and Frank Hazenburg," in Sue Allen and Charles Gullans, Decorative Cloth for America: Publishers Bindings, 1840–1910 (Los Angeles, California: William Andrews Clark Memorial Library, 1994), pp. 53–107; and Richard Minsky, American Decorated Publishers' Bindings, 1872–1929 (Stockport, New York: Richard Minsky, 2006). See also, "Publishers' Bindings Online," 1850–1930 (http://bindings.lib.va.edu).

113 For further discussion of American artists and the art of the book, especially those mentioned above, see Doreen Bolger Burke, "Painters and Sculptors in a Decorative Age," in Doreen Bolger Burke, Jonathan Freedman, Alice Cooney Frelinghuysen, et. al., In Pursuit of Beauty: Americans and the Aesthetic Movement (New York: The Metropolitan Museum of Art and Rizzoli, 1986), pp. 316–20.

114 Margaret K. Hofer presented much important information on the subject in her paper "Expanding Opportunities in Industrial Art: Schools of Design for Women in Turn of the Century New York," at a symposium at the New-York Historical Society, organized by Initiatives in Art and Culture, March 24, 2007.

115 "School of Applied Design," New York Times (December 22, 1892), p. 8; "Beautiful Work on Exhibition," New York Times (October 22, 1895), p. 5.

116 See Burke, Freedman, Frelinghuysen, et. al., p. 418.

117 The leaded-glass window to commemorate the Gilders' tenth wedding anniversary was later converted to a fire screen. The fire screen is in the collection of The Metropolitan Museum of Art (Acc. No. 2000.422).

118 [Charles de Kay] The Art-Work of Louis C. Tiffany (New York: Doubleday, 1914). The binding of the volume was designed by Tiffany.

119 Gilson Willets, "The Designing of Book-Covers," Art Interchange (November 1894), pp. 118–19.

120 Art Amateur, vol. 36, no. 1 (January 1897).

121 Corticelli Home Needlework.

122 Frances Willard and Mary Livermore, A Woman of the Century: Fourteen Hundred-Seventy Biographical Sketches of Leading American Women in All Walks of Life (Buffalo, New York: Charles Wells Moulton, 1893), p. 523. That Morse studied under La Farge was

confirmed in Morse's Teaching Record, Scranton, Pennsylvania. See Dubansky, this publication, p.11.

[123] Ibid.

[124] See Eidelberg, Gray, Hofer.

[125] Willets, pp. 118–19.

[126] For a full discussion of Whitman's binding designs, see Gullens, "The New Generation" (1994).

[127] "Art Gossip," *Art Interchange*, vol. 30 (Jan. 1893), p. 10.

[128] See Hirshler, p. 38.

[129] Whitman's design for Celia Thaxter's *An Island Garden* is among her most celebrated.

[130] According to Gullens, Armstrong's earliest binding designs date to 1890, and she continued to design bindings at least until 1920. She continued to design lettering for book covers for the next two decades.

[131] For a thorough discussion of the church and window as well as an illustration of the window, see Robert O. Jones, *D. Maitland Armstrong: American Stained Glass Master* (Tallahassee, Florida: Sentry Press, 1999), pp. 206–9.

[132] For example: Frederick Lyman Hitchcock, *History of Scranton and Its People*, 2 vols. (New York: Lewis Historical Publishing Co., 1914); Thomas Murphy, *Jubilee History Commemorative of the Fiftieth Anniversary of the Creation of Lackawanna County, Pennsylvania*, 2 vols. (Topeka and Indianapolis: Historical Publishing Co., 1928).

[133] *The Scranton Republican*, Sunday, 31 May, 1908, 3, col. 4; 6, col.3; and 7, cols. 4–6.

[134] Op. cit., Monday, 17 June 1912, 6, col. 1.

[135] Op. cit., Friday, 13 June 1913, 6, col. 1.

[136] Op. cit., Saturday, 8 June 1912, 4, col. 1.

[137] By 1913, newspapers were recounting the activities of director Dr. B. H. Warren and curator Prof. R. N. Davis who were assiduously installing natural history specimens, minerals and plants. For example, *Scranton Times*: Saturday, 8 June 1912, 6, col. 5; Monday, 4 November 1912, 13, col. 5; Thursday, 7 November 1912, 18, col. 1; Saturday, 28 June 1913, 6, col. 5; Saturday, 21 June 1913, 6, col. 5.

[138] For substantive discussion of Raught's life and work, see: Eric Jon Schruers, "John Willard Raught (1857–1931): A Pennsylvania Painter at Home and Abroad" (Master's Thesis, The Pennsylvania State University at University Park, 1992); Richard Stanislaus, "Pennsylvania Art and Industry: The Anthracite Coal Breaker Paintings of Pennsylvania Landscape Painter, John Willard Raught (1857–1931): 1911–1929" (Unpublished manuscript, University of Scranton, 1997), including unpaginated "chronology." Cf., also William Gerdts: *Art Across America: Two Centuries of Regional Painting 1710–1920* (New York: Abbeville Press, 1990), 1: 273; and Carl E. Ellis, *John Willard Raught, 1857–1931: A Retrospective Exhibition*, September 9–October 31, 1961 (Scranton: Everhart Museum, 1961).

[139] I thank Mindell Dubansky for sharing this document with me. Cf. below for more on Leah Heath.

[140] Schruers, 54ff.

[141] Stanislaus, "Chronology."

[142] Ibid. and Schruers, 67.

[143] Generally on Jennie Brownscombe, see: Willard and Livermore, *Woman of the Century*, 132-133.; Kent Ahrens, "Jennie Brownscombe: American History Painter," *Women's Art Journal*, 1 (Fall 1980–Winter 1981), 25–29; Peter H. Falk, ed., *Who Was Who in American Art 1564–1975: 400 Years of Artists in America* (Madison CT: Sound View Press, 1985), 1: 478; Florence W. Hazzard, "Brownscombe, Jennie Augusta," *Notable American Women* (Cambridge, Mass.: Belknap Press of Harvard University Press, 1971), 1: 258–259; Eleanor Tufts, *American Woman Artists 1830–1930* (Washington, D.C.: National Museum of Women in the Arts, 1987). On a local plane in 1913, suffragist Susan A. Dickinson (d. November 16, 1915) acknowledged Brownscombe's artistic stature in Northeastern Pennsylvania in "Advancement of Women," *Scranton Republican*, Monday, 16 June 1913, 7, col. 2–3. (Hereafter cited as *Tribune*). Many well-known American artists worked in and around the Northeast Mountains Region of Pennsylvania, but this essay is concerned with area natives. Cf. Gerdts, 1: 262–267.

[144] Brownscombe maintained a collection of historical costumes to assist her efforts. Dorothy S. Noble, "Jennie Brownscombe: Patriot with a Palette," *Daughters of the American Revolution Magazine*, 128, 9 (November 1994), 638.

[145] On Brownscombe and Morse: Willard and Livermore, respectively: 132–133 and 523.

[146] Jill K. McCormack, "Domesticity in the Progressive Era: The Woman's Institute of Domestic Arts and Sciences, Inc." (Master's Thesis: The Pennsylvania State University at Harrisburg, 1996).

[147] The Lackawanna Historical Society library holds a portfolio donated by David Allan (2000), comprising work by Farley-Allan and containing copies of pen-and-ink drawings, newspaper advertisements, and trade-journal covers. A selection of Farley-Allan's work was included by the author in the exhibition *Alive to the Call: Women and History in Northeastern Pennsylvania 1880–1935*, January 14–March 20, 2007, Hope Horn Gallery, University of Scranton, and published in the eponymous exhibition catalog (Scranton: University of Scranton, 2007), 7. Farley-Allan's sketches for John Bartlett's serialized novel *The Red Shadow* were published by the *Scranton Times*, Tuesday, 14 January 1913, 3, cols. 3–4).

[148] Darlene Miller-Lanning, Ph.D., *Ash Cans + Art Spirits: Amy Londoner and the Henri School*, Exhibition April 15 to May 11, 2007, Hope Horn Gallery (Scranton: University of Scranton, 2007). On Sandorhazi, see below n. 36; and on Evans, *Scranton Times*, Wednesday, 5 June 1912, 6, col. 4. P. W. Costello taught illustration at the American School of Art and Photography, a correspondence school established in Scranton in 1901 (*Scranton Times*, Tuesday, 28 May 1901, 6, col. 5).

[149] Cf., Gerdts, *Art Across America*, 1: 9.

[150] Tuesday, 5 November 1912, 15, col. 1; Wednesday, 18 June 1913, 5, col. 5; and *Scranton Tribune*, Thursday, 19 June 1913, 2, col. 3.

[151] Local patronage of the arts is under investigation by the author. Raught, for example, received financial backing from "anthracite coal-operator and art collector," John M. Robertson (1844–ca. 1918). See Stanislaus, 6; and Schruers, 25–26.

[152] *Scranton Times*, Tuesday, 21 January 1913, p. 9, cols. 2–3. Authenticity of the paintings in this collection and their current provenance are yet unstudied.

153 Schruers, 25.

154 *Scranton Times*, Tuesday, 28 May 1913, p. 1, col. 17. The Lackawanna Historical Society also benefited from this custom, which brought paintings by George Lafayette Clough (1824–1901) and John Willard Raught into the collection.

155 See Dubansky, above.

156 *Scranton Republican*, Thursday, 13 June 1912, 3, col. 3.

157 Ibid.

158 Progressive changes in the Scranton and Lackawanna School Districts during Morse's tenure were directed by a committed trio of leaders: County Superintendent Taylor; Superintendent of the Scranton School District George Howells; and Dr. Joseph H. Odell, school board president and pastor of the Second Presbyterian Church. Further study of their careers, school board decisions, state educational initiatives, county teachers' institutes, local teacher's organizations, and annual student art exhibitions may prove useful to clarifying Morse's initiatives and responsibilities as supervisor of drawing.

159 See Dubansky, above.

160 Hitchcock, 1: 342–343. Murphy, 1: 208 states that the school opened in October, but the Scranton High School Yearbook for 1896 reports a date of 2 September 1896. (I thank Mary Ann Moran, Lackawanna Historical Society, for the latter reference). The first high school of 1858 was razed to provide a site for the new building. Graduating classes were small, but Central graduated its largest class in 1901, 140 students. (*Scranton Times*, Wednesday, 12 June 1901, 6, col. 1.).

161 *Scranton Republican*, Thursday, 13 June 1912, 3, col. 3.

162 Murphy, 1: 204. Murphy reports that when Taylor assumed leadership of the county schools, he discovered that only 13 of his 238 teachers were Normal School graduates. One-year provisional certificates were held by 150 teachers, with the remaining 75 holding professional, permanent certificates.

163 *Scranton Times*, Wednesday, 12 June 1912, 11, col. 1.

164 Ibid.

165 Hitchcock, 1: 343.

166 See Dubansky, above.

167 *Scranton Times*, Wednesday, 19 June 1912, 4, col. 6.

168 *Scranton Times*, Thursday, 13 June 1912, 5, col. 4; and, Friday, 14 June 1912, 18, col. 2.

169 Hitchcock, 1: 345. Artistic work produced by Technical High School students is described by the *Scranton Times*, Tuesday, 11 June 1912, 10, cols. 4–6.

170 Hitchcock, 1: 344–345. Cf., Dubansky, above.

171 *The College Club, Scranton, PA, Directory 1919–1920*, 32. Morse was listed as an Associate Member residing at 320 Madison Avenue. Leah Heath, resident at 1024 Scranton Street, was documented as an Honorary Member in 1906–07; 1911–12; and 1913–14. *Constitution and By-Laws, The College Club of Scranton* (Scranton: Ye Kraft Printery, 1906), [14]; *The College Club of Scranton, Yearbook 1911–12*, 15; and "In Memoriam," *The College Club Yearbook 1913–1914*, 19. Leah Heath willed a painting to Katherine Winton Murray, friend and highly regarded clubwoman.

When Morse joined the College Club has not been determined, but the question begs research on local women's history, a topic until recently largely ignored by regional historians.

172 See the *Yearbook of the City Improvement Association of Scranton PA 1908–1909*, 10–23; and *Scranton and the City Improvement Association*, 15th Annual Meeting of the State Federation of Pennsylvania Women, Scranton, October 17–20, 1910 (*Scranton Republican*, [1910]), 3–15.

173 College Club Yearbooks: (1911–12) 11; (1913–14) 13. Scranton newspapers cite Sinn's name repeatedly in their coverage on city planning, parks, and playgrounds in 1912 and 1913.

174 *Scranton Times*, Saturday, 7 December 1940, 3, col. 2.

175 Clarke was recognized as a Distinguished Daughter of Pennsylvania in 1954. The author is currently researching Clarke's life and career as clubwoman, pioneering physician, and suffragist.

176 Sickler's biography is published in the State Federation of Pennsylvania Women's monthly newsletter, *The Messenger*, 15, 2 (January 1928), 28–29. (Pennsylvania Historical and Museum Commission, Bureau of Archives and History, MG 386).

177 Gullans and Espey (1979), 37–39; Gullans and Espey (1991), 38.

178 Elliott, 74.

179 Morse is likely to have seen numerous rare book exhibitions at the Grolier Club from 1884 (Winterich, 16–19). The Aldine Club also sponsored public exhibitions of rare books since 1890. *Constitution, Rules, Officers and Members, 1890–1891* (New York: Aldine Club, 1890); and *Catalogue of an Exhibition of Oil and Water-Color Paintings loaned by New-York Artists, also of Modern Cloth and Leather Book-Covers and Original Designs therefore, at The Aldine Club, from the twenty-fifth to the thirty-first of March, Inclusive.* (New York: Aldine Club, 1892).

180 Henri Bouchot, *Les Relieures D'Art à la Bibliotèque Nationale*, (Paris: Édouard Rouveyre, Ed., 1888); Henry B. Wheatley, *Remarkable Bindings in the British Museum: Selected for their Beauty or Historic Interest* (London: Sampson Low, Marston, Searle, and Rivington; and Paris: Gruel and Engleman, 1899); Owen Jones, *The Grammar of Ornament* (London: Bernard Quaritch, 1868); Minsky, 49.

181 Gullans and Espey (1979), 34–35.

182 Sydney M. Cockerell, *Bookbinding and the Care of Books: A Textbook for Bookbinders and Librarians*, Fifth Edition (London: Pitman and New York: Pentalic Corporation, 1953), 188–214.

183 Matt T. Roberts and Don Etherington, *Bookbinding and the Conservation of Books: A Dictionary of Descriptive Terminology* (Washington: Library of Congress, 1982), 96–97 (fanfare), 123 (Grolier), 252 (strapwork).

184 Ibid., 228 (semé).

185 Ibid., 11 (arabesque).

186 Willets, p. 119. Influenced by the Arts and Crafts and Art Nouveau movements, commercial publishers J. M. Dent and Osgood, McIlvaine published elegant books of poetry and literature.

187 Allen and Gullans, 55–75.

188 For example, Allen and Gullans, 65–72 shows examples of

Whitman's covers; in particular, the book covers illustrated in plate 16, Rodolfo Lanciani, *Ancient Rome in the Light of Recent Discoveries* (Boston: Houghton Mifflin, 1889) and Oliver Wendell Holmes, *Before the Curfew and Other Poems, Chiefly Occasional* (Boston and New York: Houghton, Mifflin and Company, 1888 [Minsky, 85]) most resemble Morse's cover on *Landscape Gardening*.

189 Respectively, Jewett (Boston and New York: Houghton Mifflin and Company, 1897) and Prince (Boston and New York: Houghton Mifflin and Company, 1898).

190 Allen and Gullans, 64, 94 (note 23).

191 Willets, 119.

192 A description of case binding is reviewed in Marshall Lee, *Bookmaking: The Illustrated Guide to Design and Production* (New York: R.R. Bowker, 1965).

193 Op. cit., 166–168. Gullans and Espey (1979), 34–35. Ibid., 166–168. Gullans and Espey (1979), 34–35.

194 Roberts and Etherington, 9 (aluminum leaf).

195 Ibid., 87–88.

196 Tomlinson, William and Richard Masters, *Bookcloth 1823–1980.* (Stockport, Cheshire: Dorothy Tomlinson, 1996), 43.

197 Op. cit., 46–48, 55, 93.

198 Op. cit., 45–46.

199 Op. cit., 54. "Vellum" cloth should not be confused with true vellum, an animal skin traditionally used in hand bookbinding.

200 Allen and Gullans, 62; Gullans and Espey (1979), 136.

201 Roberts and Etherington, 218.

NOTES TO THE READER ON DESIGN DESCRIPTIONS

ORDER OF CATEGORIES:

Designs are presented in this order: book covers known to have been designed by Morse, book covers attributed to Morse but not proven, and advertising posters for books.

CHRONOLOGICAL AND ALPHABETICAL ARRANGEMENT OF DESCRIPTIONS WITHIN CATEGORIES:

Book-cover designs are arranged chronologically, by year of publication, then alphabetically by publisher and author. Series entries are filed under author's name if all volumes in the series are by a single author, but under the series name, if the series has works by multiple authors.

Main entries also illustrate and describe the first use of a design in published form, if known.

PHOTOGRAPHS OF BOOK COVERS:

When multiple copies of a cover design have been available, the copy in the best condition has been photographed and described as the main entry. Supplemental photographs depict binding variants or adaptations. The photographs of Morse's designs come from three collections: the Metropolitan Museum of Art (MMA), the Dubansky Collection (MD) and the New York Public Library (NYPL). See illustration credits.

ENTRY NUMBERS:

Each design bears an entry number consisting of the last two digits of the year of publication, followed by a dash and number, i.e. (87-1). Entries within each year are numbered consecutively starting with 1. Following the category of dated book-cover designs (ending with entry 03-1) there are two undated book-cover designs (n. d. 1; and n. d. 2). These are publishers' proof covers in the MMA collection for which no published books could be found. In the category of book-cover designs attributed to Morse the entries begin with "Attrib." Following these are poster designs, also arranged chronologically by year of publication, with a "P" added, i.e. (95P-1).

BIBLIOGRAPHICAL DESCRIPTION:

The bibliographical description begins with the series name, if the design is for a publisher's series, or the author's name as found in the Library of Congress Name Authority database, followed by the title, publisher, and year of publication as transcribed from the title page. These are followed by measurements of height, width and depth, provided in millimeters. The width of each book or book cover has been taken from the top board, from the edge of the board at the joint to the fore-edge. When detached book covers are described, the depth measurement of a published book of the same design is included if it can be determined from a published book found in another collection.

Following this is information on printer, binder, illustrator, and identifying marks of the designer. The term "signed" confirms the presence of Morse's initials or monogram stamped on the cover.

DETAILS ON BINDING:

The first paragraph of each entry describes the color and texture of the covering material. Descriptive terms are used for colors, along with a number from the Pantone Matching System (matte colors). Some white cloths have no match in the Pantone matte color book. These are described in narrative terms. Color matching was done under controlled conditions in a daylight-balanced light booth. PMS colors are intended as a guide, rather than as an exact match, and are intended to assist the reader to identify binding variants or adaptations.

Descriptions of cloth textures come from two sources: ribbed cloths were identified using the system described in Andrea Krupp's "Bookcloth in England and America, 1823–50," *Papers of the Bibliographical Society of America* (New York: The Bibliographical Society of America, 2006); plain-weave cloths were identified from William Tomlinson and Richard Masters, *Bookcloth 1823–1980* (Stockport, Cheshire: Dorothy Tomlinson, 1996). Plain-weave cloths have not been specifically identified, as no close match was found in any available source. As previously stated, these appear to be "extra" plain-weave cloths in which colored starch has been applied to the front of the cloth and then finished in a variety of ways. Also as previously noted, many of these cloths are reversed. Covers with particularly coarse base cloths are noted, as is one example of satin-weave cloth.

Next is a description of the decoration on the front cover and spine. Back covers are described only if they are decorated. The lettering and design motif are described in quasi-facsimile transcription. Tiny dots printed within the lettering on several covers have been omitted from the descriptions. If a cover is stamped with Morse's initials or mono-

gram, its description and location are given. Only decorative edges, endleaves and headbands are described, as are endpapers designed by Morse, or attributed to her.

NOTES ON BINDING VARIANTS AND ADAPTATIONS, SERIES, ETC.:

The second paragraph includes notes on individual titles, series, and descriptions of binding variants and adaptations. Many of Morse's covers were designed for publisher's series. For some series, Morse is the designer for all titles; in others, only one title can be attributed to her. The series titles presented in this book have been identified from *The American Catalogue* and *The Publisher's Trade-List Annual* and from lists found in some of the volumes in the series. This paragraph also gives information on all known variants and adaptations. A variant is a book cover in which the same design with the same arrangement and spacing has been used, but with different colors of cloth or stamping (i.e. 89-2). An adaptation is a book cover in which elements of the original design have been reused with major changes; such as a design that has been adapted for use on another book (i.e. 97-1) or used for a later printing of the same book with elements changed (i.e. 91-10).

REFERENCES:

The third paragraph of each entry lists bibliographical references relating to the object described in the entry. Full citations for these are in the bibliography. Acronyms have been used for multi-volume reference sources. These are Am Cat (*American Catalogue*), BAL (*Bibliography of American Literature*), PTLA (*Publishers' Trade-list Annual*), and ALNY (*Architectural League of New York*).

MMA ACCESSION NUMBER, MORSE'S INSCRIPTIONS, TYPE OF COVER, COLLECTION KEY:

The fourth paragraph of each entry contains information about: 1) the owner and location of the object described in the main entry; and 2) descriptions of Morse's cover of the same design in the MMA. If 'MD' precedes 'MMA', the book illustrated and described is from the Dubansky Collection.

Collection Key: The object described and illustrated in the main entry is from the first collection listed in this paragraph.

MMA = The Metropolitan Museum of Art, Gift of Alice C. Morse, 1923, transferred from the library (followed by accession number and inscription)

MD = Dubansky Collection

NYPL = Art & Architecture Collection, Miriam and Ira D. Wallach Division of Art, Prints and Photographs, The New York Public Library, Astor, Lenox and Tilden Foundations

COVER DESCRIPTION:

Three types of Morse's MMA covers are described in this paragraph: "book cover" refers to a cover that has been cut off a published book; "publisher's production case" refers to a cover that was never attached to a book, but is identical to the cover on the book as published; and "publisher's proof" refers to a cover that was never put into production, and also exhibits missing elements of a published book, such as spine stamping. It can sometimes be difficult to determine whether a cover is a production case or a publisher's proof. Both terms are used when the design is complete, but the color has not been identified on a published copy. Morse's inscriptions on the covers vary, and some are not inscribed at all. All inscriptions have been transcribed. Some covers are numbered, but the meaning of these numbers has been lost.

I. BOOK COVERS

1887 Charles Scribner's Sons (New York)

87-1. Harold Frederic
Seth's Brother's Wife: A Study of Life in the Greater New York
195 x 124 x 32 mm
Printer: Press of J. J. Little & Co., Astor Place, New York

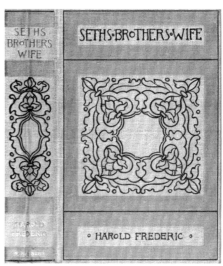

87-1

Gold (PMS 7509M) fine diagonal-rib reversed cloth (Krupp, Rib 10: "S" grain); front cover divided into three blind-stamped compartments, bordered by single brown-stamped rule; raised areas in the center of each compartment contain, in brown-stamping: at the top, 'SETHS BROTHERS WIFE'; in the center, a linear, square, symmetrical floral design; and at the bottom, 'HAROLD FREDERIC'; the spine is divided into three compartments by four blind-stamped bars; brown-stamped rules are at the top and bottom; 'SETHS | BROTHERS | WIFE' is gold-stamped in the top compartment; the center compartment has a linear floral design, stamped in brown; and 'HAROLD | FREDERIC' is gold-stamped in the bottom compartment; 'SCRIBNERS' is gold-stamped at the bottom; brown coated endleaves; cloth headbands, brown.

BAL notes two issues of this book and describes one binding variant. In issue A, the author's name is flanked by ornamental hollow dots; in issue B, the author's name is not flanked by ornamental hollow dots.

Am Cat 1884–1890, p. 184; BAL 6266; Gullans and Espey 1979, p. 39; Matthews 1896, p. 54; PTLA 1888, p. 11
MMA (56.522.74); book cover, with text block removed; inscribed "Alice C Morse"

1889 Harper & Brothers, Franklin Square (New York)

89-1. Theodore Child
Summer Holidays: Travelling Notes in Europe
190 x 120 x 30 mm

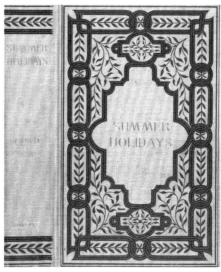

89-1

Tan (PMS 7508M), plain-weave reversed cloth; front cover stamped in the style of a sixteenth-century fanfare binding; edged with a green-stamped double line and filled with interlacing strapwork and brown- and green-stamped foliate sprays; a cartouche formed in the center of the design contains 'SUMMER | HOLIDAYS', gold-stamped; at the top and bottom of the spine are two decorative bars similar to the strapwork on the front cover; within these bars, gold-stamped, are at the top 'SUMMER | HOLIDAYS', in the center 'CHILD', and at the bottom 'HARPERS'; cloth headbands, white with black stripes.

Am Cat 1884–1890, p. 96; PTLA 1889, p. 9
MMA (56.522.48); book cover, with text block removed; inscribed "Harpers | 8 | Alice C. Morse"

89-2

89-2. Lafcadio Hearn
Chita: A Memory of Last Island
190 x 120 x 24 mm

Salmon (PMS 7523M) fine diagonal-rib cloth (Krupp, Rib 10: "S" grain); front cover divided into two compartments by a brown- and black-stamped ornamental border of intertwined seaweed; in the center of the top panel 'CHITA' is gold-stamped, outlined in black-stamping; within the lower compartment is a brown- and black-stamped circular seaweed and starfish motif; the spine is divided into two compartments by two brown- and black-stamped seaweed motif bands; in the top compartment 'CHITA' is gold-stamped, outlined in black-stamping; in the bottom compartment 'HEARN' black-stamped; cloth headbands, white with black stripes.

Chita was reprinted in turquoise plain-weave cloth (PMS 556M), the design stamped in green, outlined in red-brown; undated title page.

Am Cat 1884–1890, p. 232; BAL 7918; PTLA 1889, p. 20
MMA (56.522.82); book cover, text block removed; inscribed "To Lea M Heath | from | Alice C Morse"

89-3

89-3. Christine Terhune Herrick
Cradle and Nursery
167 x 110 x 25 mm

Green-tan (PMS 4515M) fine diagonal-rib cloth (Krupp, Rib 7); front cover dark green-stamped with a scrollwork border made up of two parallel lines; in the center is a square scrollwork easel-like stand that forms a cartouche which contains 'CRADLE | AND | NURSERY', gold-stamped; spine has two green-stamped scrollwork cartouches; the top cartouche contains 'CRADLE | AND | NURSERY' gold-stamped; the bottom cartouche contains 'H&B', gold-stamped; light brown endleaves; cloth headbands, white with black stripes.

Am Cat 1884–1890, p. 239; PTLA 1890, p. 19
MMA (56.522.63); book cover, text block removed with brown endleaves; inscribed "Alice C Morse"

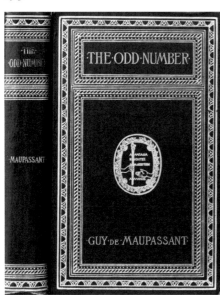

89-4

89-4. The Odd Number Series
Guy de Maupassant
The Odd Number: Thirteen Tales
Translation by Jonathan Sturges
180 x 113 x 25 mm

Dark blue (PMS 296M) plain-weave cloth; front cover edged with a silver-stamped, linear classical motif; the design creating two compartments, the upper contains 'THE ODD NUMBER', gold-stamped; the lower contains the Harper's insignia (a silver-stamped classical wreath with two hands passing a torch) and the author's name, gold-stamped; spine divided into two compartments by three wide silver-stamped bars, with 'THE ODD NUMBER', in the upper compartment and 'MAUPASSANT' in the lower, gold-stamped.

In an interview for *Art Interchange* in 1894, Morse states that *The Odd Number* was the first cover she designed for Harper's. All volumes in the Odd Number Series are bound the same, with three exceptions. *Pastels in Prose*, *Coppée's Tales* and *The Odd Number* (89-4A), were also issued in white cloth with gold stamping, in a boxed set, for $5.25 (PTLA 1899). The white volumes have gold top edges and decorative endleaves, printed with a small repeating floral pattern in green, gold and white.

Aldine 1892, p. 18; Art Interchange 1894, p. 119; Grolier 1894, p. 15; PTLA 1899, p.28; PTLA, p. 11 (and an advertisement on the back of the title page)

MD; MMA *(56.522.62); publisher's production case for* Tales of Two Countries, *1891; inscribed "[7] Morse | Alice C. Morse"*

89-4A. Color variant

1890 Dodd, Mead & Company (New York)

90-1. Giunta Series
Charles Reade
Peg Woffington
167 x 103 mm
Printer: University Press: John Wilson and Son, Cambridge
Illustrator: T. Johnson

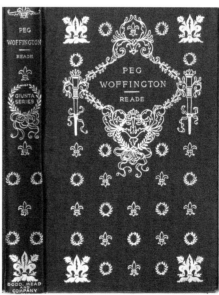

Green-blue (PMS 309M) plain-weave cloth; gold-stamped design, front cover stamped with a semé of wreaths and openwork fleur-de-lis, with four large fleur-de-lis ornaments in the corners; at the top of the front cover is an ornamental cartouche, made up of leafy garlands flanked by two torches, contains 'PEG | WOFFINGTON | — | READE'; the spine is stamped at the top with 'PEG | WOFFINGTON | — | READE'; contained within a wreath under the title is 'GIUNTA | SERIES', and at the far bottom, 'DODD, MEAD | AND | COMPANY'; the spine is evenly covered with the wreath and fleur-de-lis ornaments.

The Giunta Series of literary classics, published in twelve volumes between 1890 and 1894, was named for "the brothers Giunti," Florentine printers of the fifteenth century. Morse used the fleur-de-lis of the Giunta family in combination with other motifs for this design. The Giunta Series was initially issued in two styles of binding, one bound in green-blue cloth with uncut edges, and another bound in white cloth with the top edge gilt (91-1A [MD]). At least one title, *The Cloister and the Hearth* (in four volumes, 1898), was later reissued or reprinted, bound in dark green (PMS 567M) plain-weave cloth; the front cover design stamped in white, and the lettering in gold; the spine is stamped with the lettering in gold and the design in blind, the series title has been omitted (not shown).

90-1

THE GIUNTA SERIES:

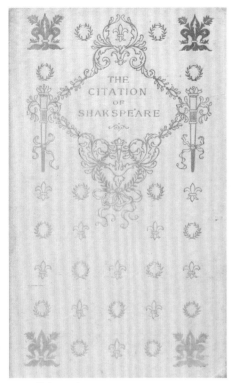

90-1A. Color variant

90-2

———. *Peg Woffington* (2 vols.), 1890

———. *The Cloister and the Hearth* (4 vols.), 1892

Claire de Durfort, duchesse de Duras. *Prison Journals During the French Revolution*, 1891

The Dramatic Essays of Charles Lamb. Edited by Brander Matthews, 1891

Journal of Maurice de Guerin: With a Biographical and Literary Memoir by Sainte-Beuve, 1891

Walter Savage Landor. *Citation and Examination of William Shakespeare*, 1891 (90-1A, in white cloth)

William Hazlitt. *Lectures on the English Poets*, 1892

Elizabeth Barrett *Browning. Aurora Leigh*, 1893

Selections from the Poetry of Robert Browning, 1893

Am Cat 1890–1895, p. 163; Art Interchange *1894, p. 119;* PTLA *1894, p. 9;* Publishers' Weekly, *Jan. 27, 1994, No. 1148, p. 209;* PTLA *1890, pp. 26–27*

MMA (56.522.60); publisher's production cover for Peg Woffington *(1890); inscribed "Alice C Morse." This title has not been seen in a published book; however, I believe it to be the first title in the Giunta Series.*

1890 Harper & Brothers, Franklin Square (New York)

90-2. Harper's Young People (New) Series

William Dean Howells
A Boy's Town: Described For "Harper's Young People"
191 x 122 x 31 mm

Dark blue-green (PMS 3302M) fine diagonal-rib cloth (Krupp, Rib 10: "S" grain); front cover silver-stamped with an illustrated border edged with a single rule and a bead of hollow dots; at the top of the border are two corner ornaments of filigree vines enclosing on the left a baseball bat, on the right a tennis racquet; at the bottom of the cover a large design of intertwining openwork vines wrap around a cricket bat and lacrosse stick; 'A BOYS TOWN' is gold-stamped at the top of the cover and a facsimile of the author's signature is gold-stamped at the lower right; the spine is made up of three panels separated by silver-stamped decorative filigree bars, made of ornaments similar to those on the front cover; 'A BOY'S | TOWN' is gold-stamped in the top panel, W. D. 'HOWELLS' is gold-stamped in the center panel, and 'HARPERS' is gold-stamped in the lower panel; cloth headbands, white with red stripes.

The same binding was used for all titles in the series.

THE HARPER'S YOUNG PEOPLE (NEW) SERIES:

William Dean Howells. *A Boy's Town: Described for "Harper's Young People,"* 1890

Lucy C[ecil]. Lillie. *Phil and the Baby and False Witness*, 1891

Kirk Munroe. *Campmates. A Story of the Plains*, 1891

———. *Dorymates: A Tale of the Fishing Banks,* [1890] (not seen)

———. *Canoemates: A Story of the Florida Reefs and Everglades*, 1893

———. *Raftmates: A Story of the Great River*, 1893

———. *Rick Dale: A Story of the Northwest Coast* [1896] (not seen)

———. *Snow-shoes and Sledges: A Sequel to the "Fur-seal's Tooth,"* 1895 (not seen)

John Russell Coryell. *Diego Pinzon and the Fearful Voyage He Took into the Unknown Ocean A.D. 1492*, 1892

Edward Howard House. *The Midnight Warning and Other Stories*, 1892

Sophie Miriam Swett. *Flying Hill Farm*, 1892 (not seen)

———. *The Mate of the "Mary Ann,"* 1894

Mary Eleanore Wilkins. *Young Lucretia and Other Stories*, 1892

Richard Kendall Munkittrick. *The Moon Prince and Other Nabobs*, 1893

William Drysdale. *The Mystery of Abel Forefinger*, 1894

Ellen Douglas Deland. *Oakleigh*, 1896 (not seen)

Am Cat 1890–1895, p. 207; Art Interchange 1894, *p. 119; BAL 9654; PTLA 1890, p. 20; Minsky 2006, p. 85; PTLA 1899, p. 17*

MMA (56.522.96); publisher's production case; inscribed "11 Morse | Alice C Morse"

90-3. Lafcadio Hearn

Two Years in the French West Indies

190 x 122 x 32 mm

Olive green (PMS 5773M) fine diagonal-rib cloth (Krupp, Rib 10: "S" grain); front cover fully covered in the style of a sixteenth-century French strapwork binding with a central oval panel; the strapwork is stamped in three tones of green, the oval panel contains an intertwining design of orange branches, green- and orange-stamping with a gold-stamped background; the spine has a green-stamped bar at the top, followed by 'TWO YEARS | IN THE | FRENCH | WEST INDIES | — | HEARN' in gold-stamping; the bottom half of the spine is filled with a condensed version of the front cover design; cloth headbands, white with brown stripes.

Am Cat 1884–1890, p. 232; BAL 7920; Matthews 1896, p. 203; PTLA 1890, p. 19

MMA (56.522.52); publisher's production case; inscribed "Alice C Morse | Morse 15"

90-3

90-4. Thomas Allibone Janvier

The Aztec Treasure-House: A Romance of Contemporaneous Antiquity

190 x 120 x 37 mm

Illustrator: Frederick Remington

Olive green (PMS 5615M) plain-weave cloth; front cover gold-stamped with an Aztec-style frieze across the top and a roundel in the center; the spine is gold-stamped with a continuation of the frieze; below the frieze is, 'The Aztec | Treasure-House | — | Janvier'; in the center, an ornament made up of a round shield and spears and, 'Harpers', at the bottom; cloth headbands, white with black stripes.

The Aztec Treasure-House was reprinted many times. Two additional binding variants have been seen on reprints and the design has become compromised with each variant, neither is dated; one variant is bound in green cloth (PMS 5743M), with the design stamped in black and the spine lettering in gold; another in red cloth (PMS 7427) with stamping on spine only, the design in black and lettering in gold.

Am Cat 1890–1895, p. 223; BAL 10841; PTLA 1890, p. 21

MMA (56.522.88); publisher's production case; inscribed "3 Morse"

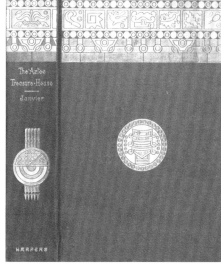

90-4

90-5

1890 G. P. Putnam's Sons (New York and London)

90-5. Edmondo de Amicis
Holland and its People (Vandyke Edition)
Translated from the Italian by Caroline Tilton
212 x 132 x 28 mm
Printer: The Knickerbocker Press, electrotyped, printed and bound
by G. P. Putnam's Sons

Dark blue (PMS 296M) plain-weave cloth; front cover gold-stamped in an armorial-style binding, with a classical-style border made up of two parallel lines flanking a repeat of openwork rectangles; in the center, the coat of arms of the Netherlands is surrounded by a leafy filigree design; spine is gold-stamped with a classical-style border at the top and bottom; between these two borders are, at the top, 'HOLLAND | and its People | —— | Amicis', in the middle, 'Illustrated', and in the lower part of the spine, a leafy filigree ornament; beveled boards; top edge gilt; cream endleaves, printed in gray with a repeating miniature floral spray pattern.

Am Cat 1890–1895, p. 11 ("new and revised edition, printed from new plates"); PTLA 1890, pp. 1; and 3
MMA (56.522.96); publisher's production case; inscribed on the outside back cover "For Lea M Heath | from | Alice | Morse | The designer"; and on the inside "Alice C Morse | 12 Morse"

90-6. Margaret Vere Farrington
Fra Lippo Lippi: A Romance
220 x 145 x 29 mm
Printer: The Knickerbocker Press, New York, electrotyped, printed, and bound
by G. P. Putnam's Sons
Illustrated

Gray-green (PMS 5545M) fine diagonal-rib cloth (Krupp, Rib 10: "S" grain); front cover gold-stamped, in the center is a white cloth onlay of a symmetrical eight-pointed design, edged with a leafy swag; in the center is an artist's palette, painting brushes and a painter's arm rest; spine gold-stamped with 'FRA | LIPPO | LIPPI | — | FARRINGTON' at the top and a symmetrical leafy motif in the center; 'PUTNAM' at the bottom; top edge gilt; endleaves printed in an overall pattern, with miniature bunches of grapes, in gray ink on cream paper.

Two of Morse's designs have onlays. The other design, featuring a paper onlay, is *A Rose of a Hundred Leaves* (91-1).

Am Cat 1890–1895, p. 151; PTLA 1890, p. 8
MMA (56.522.54); publisher's production case; inscribed "Alice C Morse [14 Morse]"

90-7. William Seward Webb
California and Alaska and Over the Canadian Pacific Railway
285 x 200 x 50 mm
Printer: The Knickerbocker Press, electrotyped, printed and bound
by G. P. Putnam's Sons
Illustrated

Dark brown (PMS Black 5M) full morocco binding; front cover gold-stamped in the style of a sixteenth-century French fanfare binding; spine is gold-stamped with 'CALIFORNIA | AND | ALASKA' surrounded with floral ornaments at the top; 'WEBB', in the center, and 'ILLUSTRATED', between two floral bar ornaments at the bottom; rear cov-

90-6

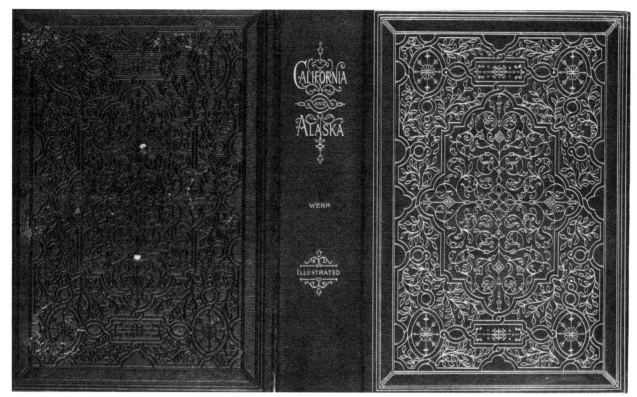

er is blind-stamped with a repeat of the front cover design; top edge gilt; endleaves print-
ed with tiny flowers in pale blue, gray and gold, on a paper that has a fine rib surface.

 This is one of five hundred copies bound in full morocco. It sold for the high price of $25.

Am Cat 1890–1895, p. 472; PTLA 1891, p. 13 (Section headed: "Supplement to the Trade List")
MMA (56.522.104); publisher's production case; inscribed "Alice C Morse"

1890 Charles Scribner's Sons (New York)

90-8. Robert Louis Stevenson
Ballads
182 x 117 x 15 mm
Printer: Trow Printing and Bookbinding Company, New York

Blue-green (PMS 7476M) plain-weave cloth; front cover gold-stamped, edged with a lin-
ear crenellated border; at the top, 'BALLADS' flanked by two circular ornaments; in the
center, a roundel surrounded by a wreath of strung discs tied with a bow with tassels on the
ends; at the bottom, 'ROBERT | LOUIS | STEVENSON'; spine gold-stamped at the top
with, 'BALLADS' | [a round ornament] | 'ROBERT | LOUIS | STEVENSON'; top edge gilt.

 This book has been seen in two additional cloth variants; one in brown plain-weave
cloth (PMS 7524M) and the other in bright green cloth (PMS 5825M), both with gold-
stamping. In P. G. Hubert's chapter "Occupations for Women" (*House and Home,* 1894; vol.
1, p. 9), *Ballads* is shown in the bright green binding next to a cover designed by Margaret
Armstrong, *Songs About Love and Death* (Anne Reeve Aldrich. New York: Charles Scribner's
Sons, 1892) (see fig. 3).

Am Cat 1890–1895, p. 422; Art Interchange 1894, p. 119; Grolier 1894, p. 15; Gullans and Espey 1979, p. 54; Hu-
bert 1894, p. 9; PTLA 1891, p. 39
MMA (56.522.89); publisher's production case or proof; inscribed "(Scribner's) | Alice C Morse | Alice C Morse |
12 Morse." I have not seen this binding variant on a published book.

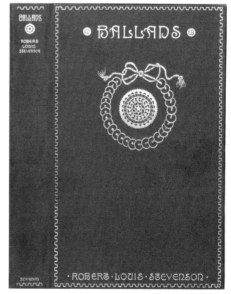

1891 Dodd, Mead & Company (New York)

91-1. Amelia Edith Huddleston Barr
A Rose of a Hundred Leaves: A Love Story
192 x 125 x 22 mm

Green (PMS 5773M) plain-weave cloth; front cover has an off-white paper onlay in the shape of a wreath, gold-stamped with an edging of four tied ribbons and a wreath of pink and green roses; these form a cartouche containing the gold-stamped lettering, 'A | ROSE | OF A | HUNDRED | LEAVES'; eight gold-stamped hearts fill in the spaces around the lettering; spine completely covered in gold-stamped ornamentation; from the top, a filigree bow, 'A | ROSE | OF A | HUNDRED | LEAVES', three gold-stamped hearts, 'AMELIA E. | BARR', three gold-stamped hearts and a long filigree motif of ribbons surrounding a rose branch, three more gold hearts and 'DODD, MEAD | & COMPANY'.

Two of Morse's designs have onlays. The other, on *Fra Lippo Lippi* (90-6), has a bookcloth onlay. The front cover design for *A Rose of a Hundred Leaves* was adapted for a "pocket" edition. For this smaller, less expensive edition, green cloth is used (PMS 371M) and silver-stamping replaces the gold-stamping of the original. The paper onlay has been replaced by dropout lettering on a white-stamped background and 'AMELIA E. BARR' appears at the bottom front cover in silver-stamping. The spine is silver-stamped with 'A | ROSE | OF A | HUNDRED | LEAVES', a heart ornament, 'BARR', and a filigree rose; and at the bottom, 'DODD MEAD | & COMPANY' (161 x 112 x 20 mm) (91-1A [MD]). Although there is no series name or date of publication on this book, it may be a part of the Phenix Series. *Far Above Rubies* (98-3) appears to be from the same series. Both covers have identical title page borders and are the same size.

Aldine 1892, p.16; Am Cat 1890–1895, p. 26 (Describes A Rose of a Hundred Leaves *as being "beautifully bound and illustrated in vignette-style … $1.50."); PTLA 1892, p. 2; PTLA 1899, p. 25*
MMA (56.522.73); publisher's production case; inscribed "22 Morse | Alice C. Morse"

91-1A. Adaptation of above for smaller format.

91-2. Portia Series
Mary Taylor Bissell
Physical Development and Exercise for Women
189 x 121 x 22 mm
Printer: University Press: John Wilson and Son, Cambridge

Dark blue (PMS 2965M) plain-weave cloth; front cover gold-stamped with a Rococo-style cartouche; with 'PORTIA | SERIES' in dropout lettering in the center, surrounded by an oval border of tiny dots; spine gold-stamped at the top with a flower and leaf ornament, 'PHYSICAL | DEVELOPMENT | AND | EXERCISE | FOR | WOMEN | — | BISSELL' in dropout lettering; in the center, a floral cartouche containing 'PORTIA | SERIES' and at the bottom, 'DODD, MEAD | AND | COMPANY'.

I have seen three additional variants of this design. All are bound in dark blue cloth and have variations of the original cartouche. In one, the cartouche is silver-stamped, but a centimeter larger than the others (9 cm tall, probably stamped from a larger die, seen on *Unmarried Woman*, 1892); in another, silver-stamping replaces the gold-stamping (seen on *Physical Development and Exercise for Women*, 1893); and in another, the title of the series has been replaced with the title of the book, silver-stamped on blue cloth background (seen on *Chats with Girls on Self-Culture*, 1900).

91-2

THE PORTIA SERIES:

> Mary Taylor Bissell. *Physical Development and Exercise for Women*, 1891
>
> Eliza Chester. *Chats with Girls on Self-Culture*, 1891
>
> ———. *Unmarried Woman*, 1892
>
> Harriet Elizabeth Prescott Spofford. *Engagement, Marriage and the Home*, 1891
>
> Mary Elizabeth Wilson Sherwood. *The Art of Entertaining*, 1892

The Portia Series sold for $1.25 per volume.

Am Cat 1890–1895, p. 352; PTLA 1891, p. 63; PTLA 1892, p. 14
MMA (56.522.64); publisher's production case; inscribed "Alice C Morse | 19 Mor[se]"

91-3. Harriet Elizabeth Prescott Spofford
House and Hearth
161 x 98 x 23 mm
Printer: University Press: John Wilson and Son, Cambridge

Straw (PMS 7502M) fine diagonal-rib reversed cloth (Krupp, Rib 10: "S" grain); front cover has a full-cover design with a brown-stamped linear border and two berried branches in the top corners; in the center, a large ribbon wreath with cascading ends, stamped in peach outlined in brown; gold-stamped in the center of the wreath, 'HOUSE | AND | HEARTH'; inside a cartouche at the bottom of the cover, stamped in peach and brown, 'HARRIET PRESCOTT SPOFFORD'; spine gold-stamped with a small crossed branch ornament at the top, followed by 'HOUSE | AND | HEARTH', a four-lobed flower ornament, 'SPOFFORD'; a filigree leafy branch ornament in the center, and 'DODD, MEAD | & COMPANY' at the bottom.

For this women's guidebook, Morse chose a wreath and laurel motif for her design, signifying the honor and recognition that so many women aspired to in the late nineteenth-century.

91-3

Aldine 1892, 15; Am Cat 1890–1895, p. 417 (Describes this as a book of helpful thoughts on home-making and house-keeping for women, sold for $1.); BAL 18502; PTLA 1892, p. 16
MMA (56.522.50); publisher's production case; inscribed "Alice C Morse | 21 Morse"

91-4. Oscar Wilde
Lord Arthur Savile's Crime & Other Stories
180 x 113 x 17 mm
Printer: R. & R. Clark, Edinburgh

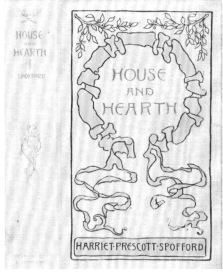

Rust (PMS 4655M) fine diagonal-rib reversed cloth (Krupp, Rib 10: "S" grain); front cover design, green-stamped at the top, 'LORD ARTHUR SAVILE'S | CRIME', flanked by two leaf ornaments, underscored with a horizontal band that carries over across the spine, the band is made up of two double lines filled in with vertical lines, green-stamped with a yellow-stamped background; at the bottom of the cover is a wide decorative band that carries over across the spine made up of a green-stamped horizontal double-line, followed by a decorative band filled with ribbons; the background in dark green- and yellow-stamping and the rust of the cloth showing through; spine is lettered at the top in green-stamping, with 'LORD | ARTHUR | SAVILE'S | CRIME | AND | OTHER STORIES', a two-leaf ornament, the decorative band, and 'OSCAR WILDE'.

Aldine 1892, p. 16; Am Cat 1890–1895, p. 482; PTLA 1892, p. 17
MMA (56.522.58); book cover, text block removed; inscribed "Alice C Morse."

91-4

1891 Harper & Brothers, Franklin Square (New York)

91-5

91-5. Alphonse Daudet
Port Tarascon: The Last Adventures of the Illustrious Tartarin
233 x 154 x 28 mm
Illustrators: Rossi, Myrbach, Montégut, de Bieler and Montenard

Dark blue (PMS 2955M) fine diagonal-rib cloth (Krupp, Rib 10: "S" grain); front cover silver-stamped with a classical-style border made up of a double rule with an interior motif of three repeating lines; all four corners are notched to encircle fleur-de-lis ornaments; inside the border is a cartouche, made up of a dot-and-line border punctuated with flower, leaf and fleur-de-lis ornaments; in the cartouche, gold-stamped is 'PORT TARASCON'; at both ends of the spine are silver-stamped decorative bars with a classical rule and leaf motifs; at the top, gold-stamped, 'PORT TARASCON | — | ALPHONSE DAUDET'; at the bottom a decorative, silver-stamped rule and three fleur-de-lis create a panel containing gold-stamped 'HARPERS'; top edge gilt.

Am Cat 1890–1895, p. 105; PTLA 1891, p. 11
MMA (56.522.99); book cover, text block removed

91-6. W[illiam]. Hamilton Gibson
Strolls by Starlight and Sunshine
253 x 168 x 27 mm
Illustrator: William Hamilton Gibson

Green (PMS 574M), fine diagonal-rib cloth (Krupp, Rib 10: "S" grain); front cover gold-stamped with a border and central cartouche of intertwined cornflowers drawn in a naturalistic manner; the cartouche contains 'STROLLS | BY | STARLIGHT | AND | SUNSHINE'; the spine is gold-stamped with cornflower motifs, and at the top, 'STROLLS | BY | STARLIGHT | AND | SUNSHINE' | — | 'W H GIBSON' | —; and at the bottom 'HARPERS'; cloth headbands, green.

Am Cat 1890–1895, p. 162; PTLA 1891, p. 15
MMA (56.522.98); publisher's production case; inscribed "Alice C Morse | Morse 2"

91-7 . Laurence Hutton
Curiosities of the American Stage
216 x 136 x 31 mm
Illustrated

Orange-red (PMS 186M), fine diagonal-rib cloth (Krupp, Rib 10: "S" grain); front cover is gold-stamped, divided into three horizontal panels outlined with single rules; a *dentelle* motif runs along the inside border of each panel, with ornaments and the letter 'H' (for Hutton) in each corner (in the style of French eighteenth-century bookbinding tools); the top panel contains 'CURIOSITIES | OF THE | AMERICAN STAGE'; centered in the middle panel is an illustrated roundel outlined with a *dentelle* design, depicting the masks of Comedy and Tragedy, tied together with a banner-like ribbon; 'LAURENCE HUTTON' is stamped in the center of the bottom panel; the spine is gold-stamped in a condensed version of the front cover design with 'CURIOSITIES | OF THE | AMERICAN | STAGE | — | HUTTON' in the top panel and 'HARPERS' bottom; top edge gilt.

Am Cat 1890–1895, p. 213; PTLA 1891, p. 20
MMA (56.522.78); publisher's production case; inscribed "Alice C Morse | Harpers | Alice C Morse"

91-8. Thomas Wallace Knox

The Boy Travellers in Great Britain and Ireland: Adventures of Two Youths in a Journey Through Ireland, Scotland, Wales and England, with Visits to the Hebrides and the Isle of Man

The Boy Travellers Series

231 x 163 x 37 mm

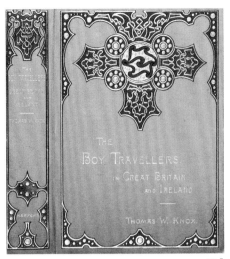

Green (PMS 5757M), fine diagonal-rib cloth (Krupp, Rib 10: "S" grain); front cover gold-, dark red- and black-stamped, with a Celtic motif border made up of lines, dots and a large three-pronged cross filled with interlacing strapwork and dotted roundels; in the lower part of the cover gold-stamped, 'THE | BOY TRAVELLERS | IN GREAT BRITAIN | AND IRELAND | — | THOMAS W. KNOX'; spine contains a condensed version of the cover design, with two panels; in the upper, 'THE | BOY TRAVELLERS | IN | GREAT BRITAIN | AND | IRELAND | — | THOMAS W. KNOX' and in the lower, 'HARPERS'; endleaves printed with maps of Ireland, Scotland, England and Wales; cloth headbands, white with red stripes.

Only this volume of The Boy Travellers Series, which consists of more than thirteen titles, can be attributed to Morse.

Am Cat 1890–1895, p. 241; PTLA 1891, p. 21
MMA (56.522.100); publisher's production case; inscribed "9 Morse | Alice C Morse | (Harpers) Alice C. Morse"

91-8

91-9. William Wordsworth

A Selection from the Sonnets of William Wordsworth with Numerous Illustrations by Alfred Parsons

276 x 205 x 19 mm

Illustrator: Alfred Parsons

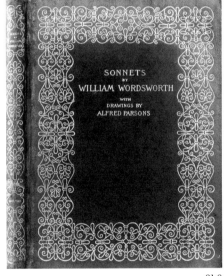

Dark green (PMS Black 3M) full-sheepskin binding; front cover gold-stamped with an open-work border made up of curling lines and stylized floral motifs; in the center of the cover, 'SONNETS | BY | WILLIAM WORDSWORTH | WITH | DRAWINGS BY | ALFRED PARSONS'; the gold-stamped spine is fully covered with a condensed version of the border motif; a small cartouche at the top contains 'SONNETS | BY WILLIAM | WORDSWORTH' and another at the bottom contains 'HARPERS'; back cover repeats the border from the front cover, but in blind-stamping; all edges gilt; cloth headbands, green.

ALNY 1890, p. 41; Am Cat 1890–1895, p. 492; Gullans and Espey 1979, pp. 52–54, 65; PTLA 1891, p. 37; Publishers' Weekly, December 20, 1890, p. 990
MD; MMA (56.522.105); publisher's production case; inscribed "Alice C Morse"

91-9

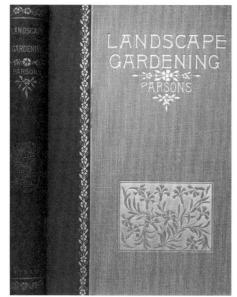

91-10

91-10A. Adaptation for 1904 reprint.

91-11

1891 G. P. Putnam's Sons (New York)

91-10. Samuel Parsons
Landscape Gardening...
258 x 175 x 28 mm
Printer: The Knickerbocker Press, New York. Electrotyped, Printed, and Bound by G. P. Putnam's Sons

Green (PMS 5615M) plain-weave cloth; spine and sides are of the same cloth; however, the cloth on the sides is reversed, appearing pale green; the edges of the spine-piece are gold-stamped along the edge with a single line and repeating flower motif; gold-stamped at the top of the front cover, 'LANDSCAPE | GARDENING | PARSONS', the title and author are separated with floral ornaments; gold-stamped lower on the cover is a rectangular dropout design of cornflowers; spine is gold-stamped with single line and flower borders at top and bottom; at the top, 'LANDSCAPE | GARDENING | PARSONS', with flower ornaments; in the center a filigree design of three leafy cornflowers; at the bottom 'PUT-NAM'; endleaves printed with a floral spray pattern, in brown on cream paper; top edge gilt; cloth headbands, white and red stripes.

Landscape Gardening was reprinted in 1904. Originally published in royal octavo with large margins, the reprint was trimmed to a smaller size (230 x 150 x 28 mm). It is bound in dark green (PMS 343M) fine-rib cloth (Krupp: Rib 2 [horizontal]) and gold-stamped. Morse's original cover design was adapted for the front cover; the spine is different from the original, probably not of Morse's design (91-10A). This design is in the style of some of Sarah Whitman's covers, for example, Oliver Wendell Holmes' *Before the Curfew and Other Poems, Chiefly Occasional* (1888). (See fig. 17).

Am Cat 1890–1895, p. 335; Am Cat 1900–1905, p. 820; Minsky 2006, p. 85; PTLA 1891, p. 9; PTLA 1904, p. 43 MD; MMA (56.522.97); publisher's production case; inscribed "Alice C. Morse | 13 Morse"

1891 Charles Scribner's Sons (New York)

91-11. Thomas Nelson Page
On Newfound River
186 x 119 x 23 mm
Printer: Typography by J. S. Cushing & Co., Boston. Presswork by Berwick & Smith, Boston

Light green (PMS 575M) plain-weave cloth; front cover stamped in light and dark green with a circular cartouche made up of intertwined dolphins, containing 'ON | NEW-FOUND | RIVER' and 'BY | THOMAS | NELSON | PAGE', separated by a dotted line ornament; spine is gold-stamped with 'ON | NEWFOUND | RIVER' at the top, followed by a dotted line ornament, and 'THOMAS | NELSON | PAGE'; lower on the spine is a motif of two intertwined dolphins and at the bottom, 'SCRIBNERS'.

Am Cat 1890–1895, p. 332 (only the "New Uniform Edition" mentioned, not believed to be this design); Aldine 1892, p. 28; BAL 15366; PTLA 1891, p. 32
MMA (56.522.57); publisher's production case; inscribed "Morse 25 | Alice C Morse | To Lea M Heath | from Alice C Morse"

1892 The Century Co. (New York)

92-1. Henry Blake Fuller
The Chatelaine of La Trinité
199 x 128 x 14 mm
Printer: De Vinne Press

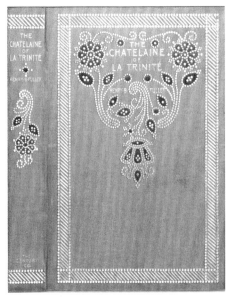

92-1

Gray-green (PMS 5783M) plain-weave cloth; front cover silver-stamped with a border made up of diagonal bars edged with parallel dotted-lines; within the border, a large cartouche made up of two edelweiss and an inverted crown, stamped with silver dots and filled in with orange-stamping; inside the cartouche, gold-stamped is 'THE | CHATELAINE | OF LA TRINITÉ | HENRY B. FULLER'; in the center of the rear cover is a blind-stamped, dotted, inverted edelweiss ornament; top edge silver.

An example of this book cover was included in Morse's exhibit at the Woman's Building of the World's Columbian Exposition (Elliott 1893, p. 75). In an interview of Alice Morse by Gilson Willets (*Art Interchange,* 1894), Morse states that as this book was a tale of travel dealing largely with the Tyrol, she used a Tyrolean belt (creating the look of a leatherwork object) for inspiration and the edelweiss, the national flower of Austria.

Am Cat 1890–1895, p. 155; BAL 6464; Gullans and Espey 1979, p. 54; Matthews 1896, p. 193; PTLA 1893, p. 1; Willets 1894, p. 119
MMA (56.522.72); publisher's production case; inscribed "Alice C Morse"

92-2. Henry Blake Fuller
The Chevalier of Pensieri-Vani (Fourth Edition, Revised)
199 x 130 x 16 mm
Printer: De Vinne Press

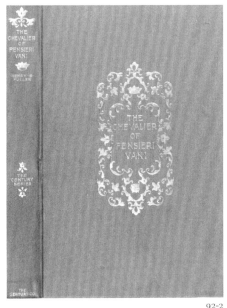

92-2

Green (PMS 5773M) plain-weave cloth; the same gold-stamped cartouche appears in the center of front and rear covers — an Italianate floral design with two small ornaments, a crown and a cooking pot; 'THE | CHEVALIER | OF | PENSIERI | VANI' is stamped in the center of each cartouche; the spine is gold-stamped with a small floral ornament at the top, followed by 'THE | CHEVALIER | OF | PENSIERI | VANI', a crown ornament and 'HENRY B FULLER'; slightly below the center of the spine, 'THE | CENTURY | SERIES', flanked by two small flowers; 'THE | CENTURY CO.' at the bottom; top edge gilt.

An example of this book cover was included in Morse's exhibit at the Woman's Building of the World's Columbian Exposition. References cite this as being the fourth edition, revised.

Am Cat 1890–1895, p. 155; BAL 6463; Elliott 1893, p. 74; PTLA 1893, p. 1
MMA (56.522.53); book cover, text block removed; inscribed "Alice C Morse"

92-3. Mrs. Burton Harrison
Belhaven Tales; Crow's Nest; Una and King David
199 x 128 x 19 mm
Printer: De Vinne Press

Gold (PMS 7509M) fine diagonal-rib reversed cloth (Krupp, Rib 10: "S" grain); front and rear covers stamped in olive green with a scrollwork border and central cartouche resembling ironwork; the cartouche contains 'CROWS NEST | AND | BELHAVEN TALES | MRS BURTON | HARRISON'; at the top of the olive green-stamped spine is a scrollwork cartouche with two panels, the top containing 'CROWS NEST | AND | BELHAVEN | TALES' and the lower 'MRS | BURTON | HARRISON'; at the bottom of the

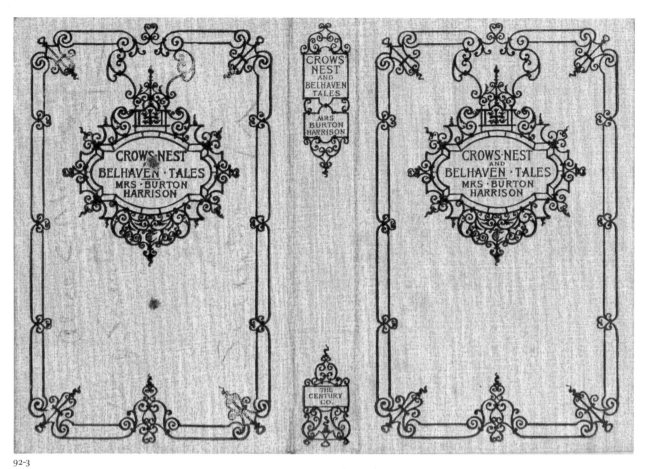

92-3

spine is a decorative scrollwork panel containing 'THE | CENTURY | CO.'; top edge gilt.

 In Gilson Willets' article, "The Designing of Book-Covers" (*Art Interchange*, 1894), this cover design is misattributed to Margaret Armstrong.

Am Cat 1890–1895, p. 185; Willets 1894, p. 118; BAL 7195; PTLA 1893, p. 1
MMA (56.522.81); publisher's production case; inscribed "Alice C. Morse (Scranton, Pa)"

92-4

92-4. Viola Roseboro'
Old Ways and New
199 x 128 x 13 mm
Printer: De Vinne Press

Pale tan-green (PMS 452M) fine diagonal-rib reversed cloth (Krupp, Rib 10: "S" grain); front and rear covers stamped in olive green with a large symmetrical panel with a foliate design; within the panel, four small cartouches are arranged in a diamond pattern; text contained in the cartouches is gold-stamped; in the upper 'OLD | WAYS'; in the left 'AND'; in the right, 'NEW' and in the bottom 'VIOLA | ROSEBORO'; the spine is covered in a foliate design with three small compartments of diminishing size; 'OLD | WAYS | AND | NEW' is gold-stamped in the top compartment, 'VIOLA | ROSE-BORO' in the middle and 'THE | CENTURY | CO.' in the bottom; top edge gilt.

 An example of this book cover was included in Morse's exhibit at the Woman's Building of the World's Columbian Exposition.

Am Cat 1890–1895, p. 378; Elliott 1893, p. 75; PTLA 1893, p. 1
MMA (56.522.68); book cover, text block removed; inscribed "Alice C. Morse"

1892 Harper & Brothers Publishers (New York and London)

92-5. William Dean Howells
Christmas Every Day and Other Stories Told for Children
191 x 122 x 18 mm

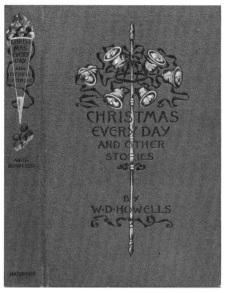

Brown-orange (PMS 7523M) fine diagonal-rib cloth (Krupp, Rib 10: "S" grain); front cover red- and gold-stamped with a design of a pole with six ringing bells tied together with ribbons; 'CHRISTMAS | EVERY DAY | AND OTHER | STORIES | BY | W. D. HOWELLS', underlined by a wavy ribbon, is overlaid on top of the staff and bell design, stamped in red; at the top of the spine is a large gold-stamped cone, wrapped with a ribbon and filled with popcorn in red- and gold-stamping; this forms a cartouche that contains in red-stamping, 'CHRIST | MAS | EVERY | DAY | AND | OTHER | STORIES', 'W. D. | HOWELLS', red-stamped in the center of the spine; and 'HARPERS', red-stamped at the bottom; cloth headbands, white with black stripes.

Christmas Every Day, was reprinted (no date on title page), bound in green plain-weave cloth (PMS 3435M) with the same design, stamped in red and silver.

Am Cat 1890–1895, p. 207; BAL 9671; PTLA 1893, p. 20
MMA (56.522.83); publisher's production case; inscribed "Morse | 4"

1892 Longmans, Green, and Co. (New York and London)

92-6. Owen Meredith
Marah
185 x 120 x 21 mm
Printer: Trow Directory, Printing and Bookbinding Company, New York

Dark blue (PMS 655M) plain-weave cloth; at the top of the front cover is a gray-stamped floral swag with ribbons, in the center of which is a gold- and gray-stamped winged harp, pierced by a lit torch, gray-stamped with gold smoke; the smoke forms a base for gold-stamped 'MARAH'; at the top of the spine gold-stamped, 'MARAH | BY | OWEN | MEREDITH'; at the center of the spine, a gray-stamped wreath and at the bottom, gold-stamped 'LONGMANS'; top edge gilt; cloth headbands, white.

AC 1890–1895, p. 60; Gullans and Espey 1979, p. 54; PTLA 1892, p. 11
MD

1892 G. P. Putnam's Sons (New York and London)

92-7. Jessica Cone
Scenes from the Life of Christ Pictured in Holy Word and Sacred Art
245 x 172 x 20 mm
Printer: The Knickerbocker Press

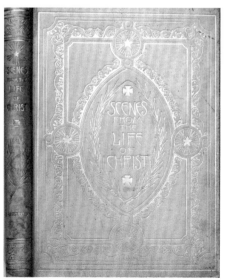

Warm white plain-weave cloth; front cover gold-stamped in the style of a sixteenth-century strapwork binding; edged with a single-line; the strapwork design is made up of lines edged with a leafy design; it forms four roundels, which contain shining stars; in the center, a large lozenge-shaped cartouche containing two crossed palm fronds, 'SCENES | FROM | THE | LIFE | OF | CHRIST', and two small cross ornaments; the spine is gold-

stamped with segments of the strapwork border at the top and bottom; from the top of the spine, a shining star ornament, 'SCENES | FROM THE | LIFE | OF | CHRIST', another shining star ornament, two crossed palm fronds, and 'ILLUSTRATED'; all edges red; cloth headbands, in white and tan.

Scenes from the Life of Christ was produced as a Christmas gift book. It has medieval-style page borders that may have been designed by Morse. This book cover was included in Morse's exhibit at the Woman's Building of the World's Columbian Exposition.

Elliott 1893, p. 70; PTLA 1892, p. 7 (Section headed: "First Announcements for the Autumn of 1892")
MD

92-8. Washington Irving
The Alhambra: Darro Edition; Author's Revised Edition (in two volumes)
226 x 149 x 35 mm
Printer: The Knickerbocker Press, New York, Electrotyped, Printed, and Bound by G. P. Putnam's Sons

White plain-weave cloth; designed in the style of a Moresque binding; front cover is bordered with a single blue- and gold-stamped line with corners notched with concave curves; decorative corner and side ornaments are green-, blue- and gold-stamped; in the center of the cover is a large decorative lozenge stamped in green, blue, and gold, which connects to the border at the top and bottom; spine is a condensed version of the front cover, with gold-stamped lettering, 'THE | ALHAMBRA' | [an ornament in blue-, green- and gold-stamping] | 'IRVING' | [a small ornament]; in the center of the spine, the lozenge is replaced with a cartouche containing 'DARRO | EDITION'; under the cartouche is 'VOL. I'; beveled boards; endpapers printed in Moresque pattern, in yellow on off-white paper; top edge gilt; cloth headbands in red and yellow.

92-8A. Endleaf for 92-8, possibly designed by Morse.

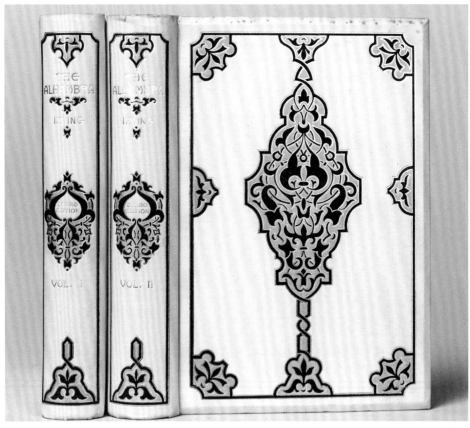

92-8

Putnam's companion gift books, *The Alhambra* and *The Conquest of Granada* (93-2) are two of Morse's most elaborate designs. Both have illustrated endleaves (92-8A) and ornamental page borders that may have been designed by Morse. All volumes were issued with chemises and each two-volume set was boxed in a slipcase. The Dubansky copy of *The Alhambra* has a dark blue plain-weave cloth chemise (PMS 2965) lined in off-white paper, gold-stamped on the spine with 'Irving's | Alhambra | 1 | Darro Edition'; the box is missing. It is possible that Morse may have looked to Owen Jones' The *Grammar of Ornament*, "Moresque Ornament from the Alhambra," No. 3, Pl. XLI (Lozenge Diapers), as an inspiration for this cover design. This book was included in Morse's exhibit at the Woman's Building of the World's Columbian Exposition.

Am Cat 1890–1895, p. 220, p. 122; Elliott 1893, p. 70; Gullans and Espey 1979, p. 54; Minsky 2006, p. 49; PTLA 1892, pp. 1 (Section headed: "First Announcements for the Autumn of 1892"), p. 10
MD; MMA (56.522.56); publisher's production case (on Vol. II); inscribed "To Lea M Heath | from the designer | Alice C Morse"

92-9. Ariel Edition of the Works of William Shakespeare
The Tempest
130 x 85 x 11 mm
Printer: The Knickerbocker Press, New York, U.S.A.
Illustrator: Frank Howard

92-9

Cordovan (PMS 4975M) leather, gold-stamped binding; front cover, with a Baroque-style oval cartouche with two flaming torches and three hanging Dramatic masks; the cartouche contains a small cross ornament, 'THE TEMPEST', two crossed quill pens, 'ARIEL | SHAKESPEARE', and a scroll; at the top of the spine is a Baroque-style cartouche pierced with a flaming torch, containing 'THE | TEMPEST', two waving banners hang from the cartouche, one containing 'SHAKESPEARE'; at the bottom 'PUTNAM'.

A second variant bound in maroon (PMS 7428) flexible morocco. This is the same design as Morse's cover, but the leather has a slightly different color and grain. The top edge is gilt and the endleaves are printed in an all-over floral pattern with flowers printed in dark green on cream paper.

This third variant is bound in maroon (PMS 7428), ribbed-morocco cloth (Krupp, Lea5: Horizontal ribbed morocco (vertical). In this variant, the design is blind-stamped and the lettering is gold-stamped.

The Ariel Edition was published from 1892 to 1894 in three groups, totaling forty volumes: comedies, historical plays and tragedies. *The Tempest* was the first comedy published, followed by *Much Ado About Nothing, The Merchant of Venice, As You Like It, Midsummer Night's Dream, Twelfth Night, Winter's Tale*. These were followed by seven historical plays—*King John, Richard the Second, Richard the Third, Henry the Fourth* (first part), *Henry the Fourth* (second part), *Henry the Fifth*, and *Henry the Eighth*. The third group, published in the fall of 1893, was the seven tragedies—*Hamlet, Macbeth, Othello, King Lear, Romeo and Juliet, Julius Caesar*, and *Anthony and Cleopatra*. A volume of *Shakespeare's Poems* followed.

In the *American Catalogue, 1890–95*, p. 399, this edition is described as: Ariel Edition, 1892–94, 40 volumes, illustrated T[itles]. 40, set $16 flexible leather. In PTLA July 1892–July 1893, p. 20, the Ariel Edition is described: "Ariel Edition" Each play in a separate volume, pocket size, large type, complete accurate text, illustrated with the celebrated designs of Frank Howard and bound in flexible morocco. Sold separately, 75 cents per volume, or in a box.

Am Cat 1890–1895, p. 399; PTLA 1892, p. 4; PTLA 1893, p. 5
MMA (56.522.101); publisher's production or proof case; inscribed "Alice C Morse | 20 Morse | 1024 Scranton St | Scranton Pa". The grained cordovan leather on the Museum's book cover has not been seen on a published book.

1892 Charles Scribner's Sons (New York)

92-10. Rebecca Harding Davis
Silhouettes of American Life
186 x 120 x 24 mm
Printer: Typography by J. S. Cushing & Co., U.S.A., presswork by Berwick & Smith, Boston, U.S.A.

Dark green (PMS 553M) plain-weave cloth; front cover silver-stamped with a floral cartouche divided into two panels containing, 'SILHOUETTES | OF | AMERICAN | LIFE | BY | REBECCA | HARDING | DAVIS'; the title lettering cascades down the spine, interspersed with foliate ornaments, 'SIL | HOU | ETTES | OF | AMER | ICAN | LIFE'; silver-stamped in the center of the spine, 'REBECCA | HARDING | DAVIS', and at the bottom, 'SCRIBNERS'.

Am Cat 1890–1895, p. 107; PTLA 1892, p. 11

MD; MMA (56.522.51); publisher's production or proof case; inscribed "Alice C Morse | Morse 15." This cover is bound in off-white (PMS 7501M) plain-weave cloth. This cloth variant has not been seen on a published book.

92-11. George Moore
Vain Fortune
186 x 117 x 25 mm
Printer: Press of J. J. Little & Co., Astor Place, New York

Brown (PMS 7505M) plain-weave cloth; front cover decorated with a four-lobed, circular cartouche, with foliate and beaded-line motifs, stamped in dark brown, outlined in black, containing 'VAIN | FORTUNE'; spine is gold-stamped and decorated with a leafy circular cartouche containing 'VAIN | FORTUNE' at the top; 'GEORGE | MOORE' in the center and 'SCRIBNERS' at the bottom.

Am Cat 1890–1895, p. 301; PTLA 1892, p. 29

MMA (56.522.69); publisher's production case; inscribed on the outside "Alice C Morse | 1024 Scranton St | Scranton Pa" and on the inside "Alice C Morse | Morse 27"

92-12. Thomas Nelson Page
Marse Chan: A Tale of Old Virginia
216 x 160 x 13 mm
Printer: Trow Directory, Printing and Bookbinding Company, New York
Illustrator: W. T. Smedley

Warm-white (PMS 4545M) plain-weave cloth; front cover border made up of a dark brown-stamped flower and leaf motif; in the center is a large trefoil center ornament of a similar flower and leaf motif; 'MARSE CHAN' is gold-stamped above the central ornament, and 'THOMAS NELSON PAGE' below it.

Marse Chan may be the first volume of a four-title set of Thomas Nelson Page's works. All are bound with a similar layout, with different motifs; none have stamping on the spines. The other, later titles are *Meh Lady: A Story of War*, 1894; *Polly: A Christmas Recollection*, 1894; and *Unc' Edinburg: A Plantation Echo*, 1895. These have not been attributed to Morse.

Am Cat 1890–1895, p. 332 ("new illustrated edition"); Art Interchange 1894, p. 119; BAL 15433; Grolier, p. 15; Minsky 2006, p. 92; PTLA 1892, p. 30

MD; MMA (56.522.79); publisher's production case; inscribed "Alice C Morse | Morse 17"

92-10

92-11

92-12

92-13. Robert Louis Stevenson and Lloyd Osbourne

The Wrecker

192 x 123 x 38 mm

Printer: Typography by J. S. Cushing & Co., Boston, U.S.A. and presswork by Berwick & Smith, Boston, U.S.A.

Illustrators: William Hole and W. L. Metcalf

92-13

Light rust (PMS 727M), fine diagonal-rib reversed cloth (Krupp, Rib 10: "S" grain); front cover fully decorated, stamped in green and green-black with a motif of intertwined dolphins and plant forms; the top of the design forms a cartouche that contains 'THE | WRECKER'; in the center of the design, a motif of two intertwined dolphins surround a monogram, 'RLS'; in the top half of the spine, green and black-stamped leafy ornaments separate 'THE | WRECKER'; 'ROBERT | LOUIS | STEVENSON | AND | LLOYD | OSBOURNE'; and 'ILLUSTRATED'; the bottom half of the spine is covered in an intertwining dolphin motif, similar to that on the front cover, stamped in green and green-black; at the bottom, 'SCRIBNERS' stamped in green-black.

Am Cat 1890–1895, p. 422; PTLA 1892, p. 38

MMA (56.522.67); publisher's production case; inscribed "Alice C Morse | Morse 26 | 1024 Scranton St | Scranton Pa"

92-14. Charles Warren Stoddard

South-Sea Idyls

185 x 12 x 30 mm

Printer: Trow Directory, Printing and Bookbinding Company, New York

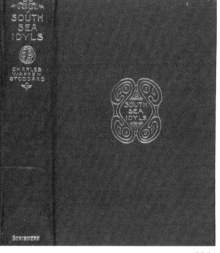

92-14

Dark green (PMS 553M) plain-weave cloth; front cover gold-stamped with a Malaysian-style, linear cartouche in the center, containing 'SOUTH | SEA | IDYLS'; spine gold-stamped at the top with a foliate linear ornament, followed by 'SOUTH | SEA | IDYLS', a small round ornament, 'CHARLES | WARREN | STODDARD', and another small flower-like ornament; 'SCRIBNERS' at the bottom.

Am Cat 1890–1895, p. 423; PTLA 1892, p. 39
MMA (56.522.59); publisher's production case; inscribed "Alice C Morse"

92-15. Richard Henry Stoddard

Under the Evening Lamp

190 x 121 x 25 mm

Printer: Trow Directory, Printing and Bookbinding Company, New York

92-15

Red-brown (PMS 4725M) plain-weave cloth; at the top of the silver-stamped front cover, 'UNDER THE EVENING | LAMP'; centered on the cover is a stylized scrollwork vignette of a lamp; at the bottom of the cover, 'RICHARD | HENRY STODDARD'; scrollwork motifs flank the words 'LAMP' and 'RICHARD'; the spine is decorated with a silver-stamped lamp design that forms a cartouche at the top containing 'UNDER | THE | EVENING | LAMP'; below this design is 'RICHARD | HENRY | STODDARD' and at the bottom, 'SCRIBNERS'.

Am Cat 1890–1895, p. 423; BAL 19219; PTLA 1892, p. 39; PTLA 1893, p. 40
MMA (56.522.75); publisher's production case; inscribed "Alice C Morse"

1893 The Century Co. (New York)

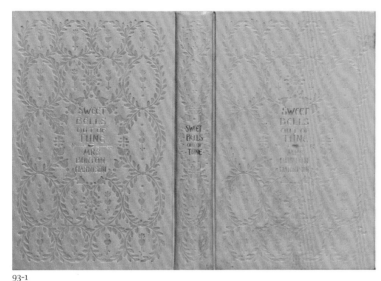

93-1

93-1. Mrs. Burton Harrison
Sweet Bells Out of Tune
196 x 125 x 21 mm
Printer: De Vinne Press
Illustrator: Charles Dana Gibson

Yellow-green (PMS 618M), plain-weave cloth; front and rear cover in the style of a French sixteenth-century bookbinding, covered in a blind-stamped symmetrical design of conjoined oval wreaths that enclose hearts pierced with arrows, and dots; the design forms a central cartouche that contains gold-stamped, 'SWEET | BELLS | OUT OF | TUNE' followed by a horizontal heart and arrow motif, then 'MRS | BURTON | HARRISON'; the spine is a continuation of the cover design; a cartouche contains 'SWEET | BELLS | OUT OF | TUNE', gold-stamped; top edge gilt.

The design is similar to a binding for Jacques-Auguste de Thou, Paris, before 1587 (Needham 1979, pp.294-295).

ALNY 1895, p. 58; Am Cat 1890–1895, p. 185; Art Interchange 1894, p. 119; *BAL 7202 (2nd printing); Grolier 1894, p. 14; PTLA 1893, p. 1*
MMA (56.522.77); book cover, text block removed; inscribed "Alice C Morse"

1893 G. P. Putnam's Sons (New York and London)

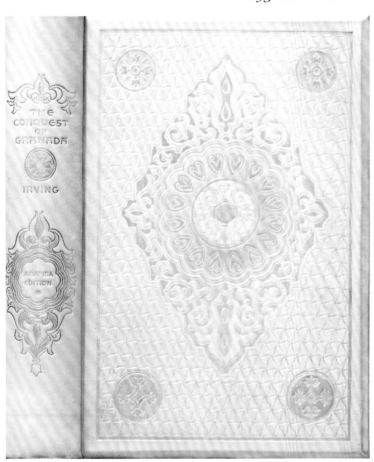

93-2

93-2. Washington Irving
Chronicle of the Conquest of Granada: Agapida Edition; Author's Revised Edition (in two volumes)
226 x 165 x 38 mm
Printer: The Knickerbocker Press, 1893

Warm white plain-weave cloth; front cover gold-stamped with a full-cover panel design that is a mixture of Arts and Crafts, Arabic, Moorish and Persian ornament, with a large lozenge in the center, four roundels in the corners and the background filled with repeating linear triangular forms; elements in the lozenge and corners are stamped in pale pink and pale green; at the top of the spine a gold- and green-stamped leafy motif, 'THE | CONQUEST | OF | GRANA-DA', a gold- and green-stamped round motif, 'IRVING', and then a gold-, green- and pink-stamped cartouche with 'AGAPIDA | EDITION |*' (indicating volume 1) gold-stamped; top edge gilt; beveled boards, printed endleaves in gray ink on cream paper; cloth headbands, tan and brown stripes.

Irving's *The Conquest of Granada* and *The Alhambra* (92-8) are two of the most elaborately produced gift books designed by Morse. They both have illustrated endleaves and ornamental page borders that were possibly designed by Morse. The same endleaves, printed in yellow ink, appear on *The Alhambra*. An

example of this book cover was included in Morse's exhibit at the Woman's Building of the World's Columbian Exposition. The Dubansky copy has a gray-blue (PMS 5415M) fine-rib cloth chemise, lined in paper, gold-stamped on the spine with the title, volume number and publisher; it most probably had a slipcase.

Am Cat 1890–1895, p. 220; Elliott, p.70; Gullans and Espey 1979, p. 54; Minsky 2006, p. 49; PTLA 1892, pp. 1 (Section headed: "First Announcements for the Autumn of 1892"), p. 10
MD; MMA (56.522.55), publisher's production or proof case, inscribed "Alice C Morse." In this cover, the coloring is extremely pale.

93-3. Gottfried Kinkel
Tanagra an Idyl of Greece . . .
Translated by Frances Hellman
202 x 132 x 15 mm
Printer: The Knickerbocker Press
Illustrator: Edwin Howland Blashfield

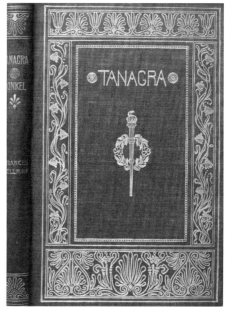

Green (PMS 574M) plain-weave cloth; front cover gold-stamped in a classical-style border with an anthemion-style design at the top and bottom, and floral designs on the sides; inside the border, at the top 'TANAGRA', flanked by two small roundels; in the center of the cover is a design of a flower wreath and a burning torch; gold-stamped spine has an anthemion ornament at both ends; at the top of the spine, 'TANAGRA' | a round ornament | 'KINKEL' | a fleuron motif; in the center of the spine, 'FRANCES | HELL-MAN'; top edge gilt; cloth headbands, white with brown stripes.

Am Cat 1890–1895, p. 238; PTLA 1893, p. 8
MD; MMA (56.522.65); book cover, text block removed

1893 Charles Scribner's Sons (New York)

93-4. New Edgewood Edition of the Works of Donald Grant Mitchell
Ik Marvel (pseud. of D. G. Mitchell)
Reveries of a Bachelor or A Book of the Heart
147 x 95 mm
Printer: Trow Directory, Printing and Bookbinding Company, New York

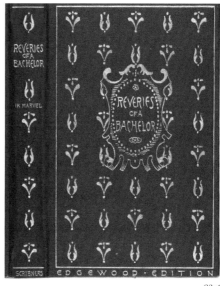

Dark blue-green (PMS 5535M) plain-weave cloth; gold-stamped front cover is bordered with a single-rule enclosing a semé of small flower and leaf ornaments and in the center, a frame-like cartouche with 'REVERIES | OF A | BACHELOR' is stamped along the far bottom edge of the cover; the spine is stamped with single rules at the top and bottom, and some of the small flower and leaf ornaments; 'REVERIES | OF A | BACHELOR' at the top, 'MARVEL' in the center and 'SCRIBNERS' at the bottom; top edge gilt.

Dream-Life is the only bound example of this design I have seen. I suspect that there are other titles in the New Edgewood Edition, but none have been found.

THE NEW EDGEWOOD EDITION:

Reveries of a Bachelor or A Book of the Heart, 1893
Dream Life, 1893
My Farm at Edgewood, 1894
Wet Days at Edgewood, 1894

Am Cat 1890–1895, p. 297; PTLA 1893, p. 29; PTLA 1894, p. 31
MMA (56.522.49); publisher's proof for Reveries of a Bachelor or A Book of the Heart; inscribed Morse 16 | Alice C Morse. This color variant has not been seen on a published book.

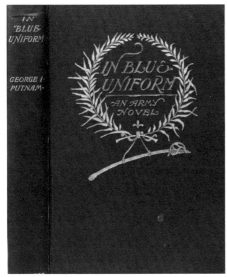

93-5

93-5. George Israel Putnam
In Blue Uniform: An Army Novel
185 x 120 x 26 mm
Printer: Norwood Press: J. S. Cushing & Co. – Berwick & Smith. Boston, Mass., U.S.A.

Blue (PMS 289M) plain-weave cloth; in the center of the front cover a silver-stamped wreath forms a cartouche that contains, in gold-stamping, 'IN BLUE | UNIFORM' | [a ragged horizontal line] | 'AN ARMY | NOVEL' | [a small fleuron ornament]; a gold-stamped sword hangs from the bottom of the wreath; spine is gold-stamped with 'IN | BLUE | UNIFORM' at the top, 'GEORGE I. | PUTNAM' in the center, and 'SCRIBNERS' at the bottom.

Am Cat 1890–1895, p. 358; Gullans and Espey 1979, p. 54; PTLA 1893, p. 34
MD

1894 The Century Co. (New York)

94-1. W[illiam]. H[enry]. Bishop
Writing to Rosina
130 x 68 x 11 mm
Printer: De Vinne Press

Brown (PMS 1615M) full-sheepskin cover; front and rear covers blind-stamped with a pattern of open-winged butterflies forming a cartouche at the top containing 'WRITING | TO | ROSINA'; spine blind-stamped with a repeating pattern of butterflies; top edge gilt; hand-marbled endleaves in a stone pattern in brown and red on a warm white paper; top edge gilt.

A book cover for *Writing to Rosina* (ALNY entry #226) and Morse's original design for the cover (ALNY entry #229) was lent by the Century Company to the Tenth Annual Exhibition of the Architectural League of New York in 1895. In the exhibition catalog, the design

94-1

was not described and designer is listed as "Miss Alice G. Morse." The "G" is assumed to be a typographic error. I have only seen the 1899 printing, illustrated and described here. However, *The Publishers Trade-List Annual* for 1894 describes the design of *Writing to Rosina* as "A dainty little volume, 5½ x 3 inches, 116 pp., in full stamped sheep binding." This convinces me that this is the design described and that Morse created this design in 1894.

ALNY 1895, p. 59; Am Cat 1890–1895, p. 292; PTLA 1894, p. 25
MD

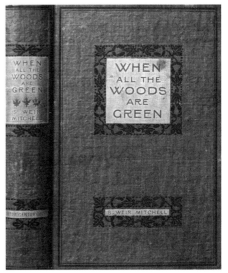

94-2

> 94-2. S[ilas]. Weir Mitchell
> *When All the Woods Are Green: A Novel*
> 196 x 128 x 35 mm
> Printer: De Vinne Press

Green (PMS 574M) plain-weave cloth; front cover with a green-stamped, double-line border, filled with a background pattern of small leaves, blind-stamped; in the center, a square cartouche with a green-stamped leaf and dot border encloses 'WHEN | ALL THE | WOODS | ARE | GREEN', in the dropout lettering, with a gold-stamped background; a smaller cartouche at the bottom of the cover contains 'S. WEIR MITCHELL' in dropout lettering; spine is a smaller version of the front cover, with green-stamped leafy bars bordering two lettering panels with dropout lettering in the upper panel, 'WHEN | ALL THE | WOODS | ARE | GREEN', [three maple leaf ornaments] | 'S. WEIR | MITCHELL'; in the lower panel, 'THE CENTURY CO.'; top edge gilt.

This design was obviously inspired by the designs of Sarah Whitman, in particular, *Balaam and His Master* (Boston: Houghton Mifflin and Company, 1891).

Am Cat 1890–1895, p. 297; BAL 14160; PTLA 1894, p. 2
MD; MMA (56.422.84); book cover, text block removed; inscribed "Alice C Morse"

1894 Dodd, Mead & Company (New York)

94-3

> 94-3. Sabine Baring-Gould
> *Kitty Alone: A Story of Three Fires*
> 190 x 123 x 32 mm

Brown plain-weave cloth (PMS 477M); gold-stamped front cover design with a cartouche made up of a heart-shaped motif, with a burning torch at the top, pendant bouquets and small dot and flower ornaments, containing 'KITTY | ALONE | S. BARING | GOULD'; at the bottom of the cover are two flaming torches tied with leafy flowers; at the top of the spine, a winged torch ornament | 'KITTY | ALONE' |, a small flower ornament | 'S. BARING | GOULD' |, a large heart and flower ornament; and at the bottom, 'DODD MEAD | AND COMPANY'.

Kitty Alone has been seen in a blue-green (PMS 330M) plain-weave cloth variant.

Am Cat 1890–1895, p.25; PTLA 1894, p. 10
MMA (56.522.61); publisher's proof; inscribed Alice C Morse [25]. I have not seen the brown cloth variant on a published book.

> 94-4. Jane Barlow
> *Kerrigan's Quality*
> 190 x 120 x 22 mm

Green (PMS 575M) coarse, plain-weave cloth; front cover with a swirling trefoil motif of silver-stamped clover and yellow-stamped ribbons; 'KERRIGAN'S | QUALITY' is sil-

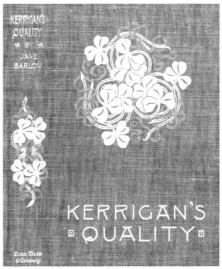

94-4

ver-stamped at the bottom with two square dotted ornaments on either side; spine silver-stamped with 'KERRIGAN'S | QUALITY | BY | JANE | BARLOW' with two small clovers on either side of 'BY'; in the center is a condensed version of the clover and ribbon design and 'DODD, MEAD | & COMPANY' silver-stamped at the bottom.

Am Cat 1890–1895, p. 25; PTLA 1895, p. 2
MMA (56.522.87); publisher's production case; inscribed "Alice C Morse"

94-5

94-5. At the Ghost Hour Series
Paul Heyse
Publisher's binding proof for *Mid-Day Magic* containing the text of *The Fair Abigail*
Translated from the German by Frances A. Van Santford
137 x 85 x 10 mm
Printer: The Caxton Press, New York
Illustrator: Alice C. Morse
signed

White (PMS 4545M) un-dyed, plain-weave cloth; underneath the cloth, the design has been printed on paper in red and black ink which shows through the translucent cloth and creates a ghost-like image; the design, a large symmetrical, foliate cartouche fills the front cover; 'AT THE GHOST HOUR' is at the top of the design and 'MID-DAY | MAGIC' is in the center; spine undecorated.

AT THE GHOST HOUR SERIES:

> *Fair Abigail,* 1894
> *Forest Laugh,* 1894
> *House of the Unbelieving Thomas,* 1894
> *Mid-Day Magic,* 1894

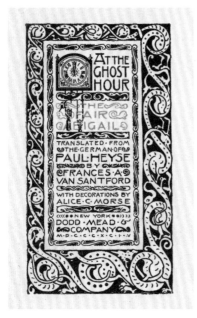

94-5A. Title page from Morse's proof copy of the At the Ghost Hour Series.

The volumes of the At the Ghost Hour Series include many small black-and-white illustrations by Alice C. Morse. These are the first books noted for which Morse received credit as designer (94-5A, title page). From the two complete volumes seen, it appears that the same illustrations were reused throughout the series; most of these were signed either "AM" or "Alice Morse." It is unclear whether the book cover is signed, because of the faded nature of the design and the poor condition of the copies examined. *The House of the Unbelieving Thomas* includes seventy of Morse's illustrations, *The Fair Abigail* (MMA 63.693.14) includes sixty-seven, most signed by Morse.

Am Cat 1890–1895, p.196; PTLA 1894, p. 10 ("… with decorations by Alice C. Morse, unique binding, sold in sets or separately per volume, .50")
MMA (56.522.103); publisher's production book. This is the only bound book in Morse's collection at the Metropolitan Museum of Art. Mid-Day Magic *is on the front cover; however, this binding proof contains three copies of the first thirty-six pages of* The Fair Abigail. *The front flyleaf is inscribed by Morse: To | Leä M. Heath | Xmas 1905 | from | Alice C. Morse. The Museum also owns a copy of* The Fair Abigail; *The Metropolitan Museum of Art, Gift of A. Hyatt Mayor (63.693.14). The poor condition of this book made it possible to describe the unusual technique used, in which the design is a pale, ghost image. This special effect was achieved through printing the design in strong colors on paper that was then covered with translucent, plain white cloth, so that the printed image appears subtly through it.*

94-6. The Secret of an Empire Series
Pierre de Lano
The Empress Eugénie: Translated from the French by Ethelred Taylor
192 x 122 x 26 mm
Printer: Typography and Electrotyping by C. J. Peters & Son, 145 High St.,
Boston, U. S. A.

94-6

Dark blue-green (PMS 3302M) ultra fine diagonal-rib cloth (Krupp, Rib 5); gold-stamped design; a Rococo-style cartouche on the front cover, made up of filigree and dots, containing 'THE | EMPRESS | EUGENIE | BY | PIERRE | DE LANO'; at the bottom, 'THE SECRET OF AN EMPIRE'; at the top of the spine, a Rococo-style filigree cartouche with two compartments; in the upper, 'THE | EMPRESS | EUGENIE' and in the lower, 'PIERRE | DE LANO; THE | SECRET | OF AN | EMPIRE' is stamped in the center of the spine; a Rococo-style ornament is at the bottom.

THE SECRET OF AN EMPIRE SERIES:

> *The Empress Eugénie*, 1894
> *Emperor Napoleon III*, 1895 (not seen)

Am Cat 1890–1895, p. 246; PTLA 1894, p. 5
MMA (56.522.66); publisher's production cover; inscribed "Alice C Morse"

94-7. Mrs. (Margaret) Oliphant
A House in Bloomsbury
190 x 122 x 26 mm

Tan (PMS 465M) coarse, plain-weave cloth; front cover with a full cover design in the Arts and Crafts style, made up of intertwined dark green-stamped ivy; the ivy motif creates two lettering panels, in the top panel gold-stamped, 'A | HOUSE IN | BLOOMSBURY'; in the bottom panel gold-stamped, 'MRS. OLIPHANT'; green-stamped ivy motifs form lettering panels on the spine; in the first panel gold-stamped, 'A | HOUSE | IN | BLOOMS | BURY'; in the second panel gold-stamped, 'MRS. | OLIPHANT'; in the bottom panel gold-stamped, 'DODD, MEAD | & COMPANY'.

94-7

Am Cat 1890–1895, p. 325; PTLA 1894, p. 16
MD; MMA (56.522.76); publisher's production or proof case; inscribed "Alice C Morse". This cover is bound in light gold (PMS 7508M) fine diagonal-rib reversed cloth (Krupp, Rib 10: "S" grain); the ivy is stamped in dark brown (94-7A). I have not seen this variant on a published book.

94-8. The Gypsy Series, New Edition
Elizabeth Stuart Phelps
Gypsy Breynton
205 x 132 x 25 mm
Printer: The Caxton Press, New York
Illustrator: Mary Fairman Clark

94-7A. Color variant of above from Morse's copy.

Gold (PMS 4515M) fine diagonal-rib reversed cloth (Krupp, Rib 10: "S" grain); front cover bordered by an orange-stamped dotted-line interspersed with brown-stamped hollow dots; the same line divides the cover into three compartments; a jester's stick extends from the top to the bottom compartments, where it is tied to an orange wheel with a brown jump rope; in the center compartment, 'GYPSY | BREYNTON'; at the bottom of the cover 'ELIZABETH STUART PHELPS'; spine with dotted line borders at the top and bottom; from the top, 'GYPSY | BREYNTON | BY | ELIZABETH | STUART | PHELPS'; author

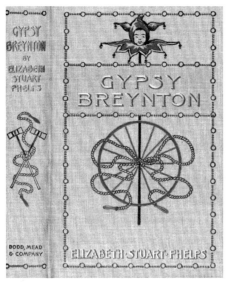

94-8

and titles stamped in gold-stamped with an orange drop-shadow; in the center, a vignette of two crossed croquet mallets tied with a jump rope, and at the far bottom, 'DODD MEAD | & COMPANY', brown-stamped; cloth headbands, white and red stripes.

THE GYPSY SERIES:

Gypsy Breynton, 1894
Gypsy's Cousin Joy, 1895
Gypsy's Sewing and Reaping, 1896
Gypsy's Year at the Golden Crescent, 1897

Am Cat 1890–1895, p. 343; PTLA 1894, p. 16 (PTLA states that this was "an entirely new edition from new plates, in cloth, ornamented from design by Miss Morse, $1.50.")
MMA (56.522.85); publisher's production case; inscribed "Alice C Morse"

1894 Harper & Brothers Publishers (New York)

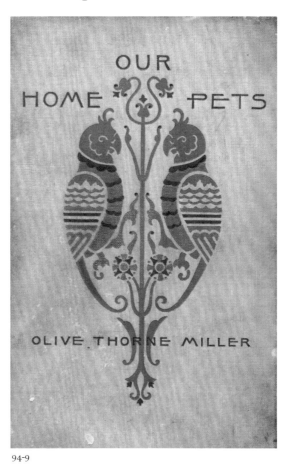

94-9

94-9. Olive Thorne Miller
Our Home Pets: How to Keep Them Well and Happy
173 x 106 x 28 mm

Yellow (PMS 7509M) plain-weave cloth; front cover green- and red-stamped with a large symmetrical motif made up of two facing parrots separated by a long flowering plant; all lettering is red-stamped; at the top of the motif, 'OUR | HOME PETS'; overlapping the lower part of the motif, 'OLIVE THORNE MILLER'; at the top of the spine, 'OUR | HOME | PETS' | [two horizontal parallel green-stamped lines] | 'MILLER', in the center of the spine is a vignette of a parrot on a stand, green- and red-stamped; at the bottom 'HARPERS'.

In an interview with Gilson Willets in *Art Interchange* (1894) Morse states, *Our Home Pets*, just published by Harper's, suggested parrots, so I conventionalized them thoroughly and covered the side with them." The spine of this book has not been photographed, as it is badly smoke-damaged.

Am Cat 1890–1895, p. 292; PTLA 1894, p. 25; Willets, p. 119
MD

1895

There are no covers for books published in 1895 in Morse's collection of book covers at the Metropolitan Museum of Art, and none have been found elsewhere.

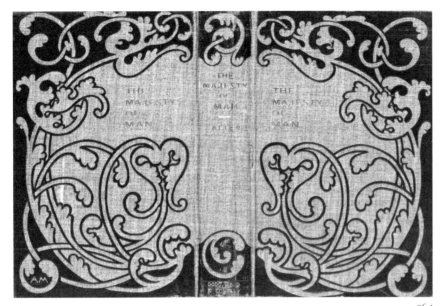

96-1

96-1. Alien. (Baker, Mrs. L. A.)
The Majesty of Man: A Novel
195 x 126 x 26 mm
signed

Light green (PMS 5575M) fine diagonal-rib reversed cloth (Krupp, Rib 10: "S" grain); front cover with a full-cover design of large symmetrical plant forms in the Art Nouveau style, stamped in dark-green; 'THE | MAJESTY | OF | MAN' gold-stamped on both covers; signed 'AM' in green-stamping at the bottom right corner of the rear cover; spine gold-stamped with 'THE | MAJESTY | OF | MAN | — | ALIEN' at the top and 'DODD MEAD | [AND] COMPANY' at the bottom.

Am Cat 1895–1900, p. 25; PTLA 1896, p. 2
This is Morse's most dramatic cover in the Art Nouveau style, and the only known cover in this style that fills both covers and spine.
MMA (56.522.95); book cover, where the text block has been removed; inscribed "Alice C Morse"

96-2. Amelia Edith Huddleston Barr
A Knight of the Nets
Printer: University Press: John Wilson and Son, Cambridge, U.S.A.
195 x 125 x 28 mm
signed

Tan (PMS 4655M) plain-weave cloth; on the front cover, a symmetrical design in the Art Nouveau style, of red- and green-stamped poppies forms two compartments; in the top, 'A | KNIGHT | OF THE | NETS', in the bottom, 'AMELIA E. BARR', both gold-stamped; signed 'AM' in green-stamping, within the design to the left of the author's name; spine decorated from the top, with a double-poppy bud in green-stamping, 'A | KNIGHT | OF THE | NETS' | [fleuron] | 'AMELIA | E | BARR', gold-stamped; the lower part of the spine is filled with a large red- and green-stamped poppy design, with a small cartouche at the bottom containing, 'DODD, MEAD | & COMPANY', gold-stamped.

Am Cat 1895–900, p. 30; PTLA 1896, p. 3
MD; MMA.(56.522.80); publisher's proof; spine undecorated but otherwise the same as the published cover; inscribed "Alice C Morse | #1a"

96-2

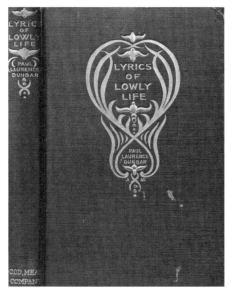

96-3

96-4

96-5

96-3. Paul Laurence Dunbar
Lyrics of Lowly Life
169 x 107 x 19 mm
Printer: University Press: John Wilson and Son, Cambridge, U.S.A. (1909 ed.)
signed

Olive green (PMS 133M) plain-weave cloth; gold-stamped and embossed design; front cover design made up of curving plant forms and small flower ornaments that form two cartouches; in the top, 'LYRICS | OF | LOWLY | LIFE'; in the bottom, 'PAUL | LAURENCE | DUNBAR'; signed 'AM' at the bottom part of the design; a vignette at the top of the spine contains, a flower ornament; 'LYRICS | OF | LOWLY | LIFE'; a larger flower ornament incorporating, 'PAUL | LAURENCE | DUNBAR'; at the bottom, 'DODD, MEAD | & COMPANY'; top edge gilt.

 Lyrics of Lowly Life is the first Dunbar title issued by Dodd, Mead and Company.

Am Cat 1895–1900, p. 139; BAL 4918; Minsky 2006, p. 45; PTLA 1897, p. 8
MD

96-4. Charles Godfrey Leland
A Manual of Mending and Repairing
17 x 123 x 22 mm
Printer: Burr Printing House, Frankfort and Jacob Sts., N. Y.
signed

Tan (PMS 465M) plain-weave cloth; in the center of the front cover is a dark green-stamped cartouche which resembles a mantlepiece with a shelf of decorative plates, flasks and pitchers; a floral swag tied with bows hangs from the shelf; the cartouche is edged with a double line border filled with dots; gold-stamped within it is 'MENDING | AND | REPAIRING | BY | CHARLES G LELAND'; signed 'AM', in dark green-stamping in the lower left corner within the cartouche; at the top of the spine, 'MENDING | AND | REPAIRING', gold-stamped; a paint brush and can, dark green-stamped; 'CHARLES G LELAND', gold-stamped; in the center of the spine is a vignette depicting decorative objects on a shelf, green-stamped; at the bottom, 'DODD, MEAD | & COMPANY', gold-stamped; top edge gilt.

Am Cat 1895–1900, p. 282; BAL 11680; PTLA 1896, p. 14
MD

96-5. Ian Maclaren
Beside the Bonnie Brier Bush (Illustrated Edition)
127 x 130 x 123 mm
Printer: University Press: John Wilson and Son, Cambridge, U. S. A.
Illustrator: George Wharton Edwards
signed

Gray-green (PMS 5815M) plain-weave cloth; front cover entirely covered in a thistle design, in the Art Nouveau style, stamped in light gray-green; the design forms a central cartouche that contains 'BESIDE | THE | BONNIE | BRIER | BUSH', bordered by a thistle motif, in gold; signed 'AM' in light gray-green, within the scrollwork of the thistle design at the bottom; two gray-green thistles form a panel for the gold-stamped lettering on the spine, 'BESIDE | THE | BONNIE | BRIER | BUSH | BY | IAN | MACLAREN'; at the bottom, 'DODD, MEAD & CO.'; top edge gilt.

This design was made for the illustrated holiday edition of this popular title. Another Maclaren title, stamped with the same design, is *The Days of Auld Lang Syne* (1896).

Am Cat 1895–1900, p. 528; Minsky 2006, p. 89
MD

96-6

96-6. Clement King Shorter
Charlotte Brontë and Her Circle
210 x 140 x 35 mm
Printer: University Press: John Wilson and Son, Cambridge, U.S.A.
signed

Brick-red (PMS 75254M) coarse, plain-weave cloth; in the center of the front cover is a decorative rectangular panel with intertwining stylized flowers in gold-stamping on a red-stamped background; in the center is an arabesque lozenge-shaped cartouche containing 'CHARLOTTE | BRONTE | AND HER | CIRCLE', gold-stamped; the blossoms of the flowers have been finely engraved with a granular texture making the gold appear matte; signed 'AM' in gold, within the design at the bottom; spine gold-stamped at the top with 'CHARLOTTE | BRONTE | AND HER | CIRCLE' | [a large fleuron ornament] | 'CLEMENT K | SHORTER'; at the bottom, 'DODD, MEAD & | COMPANY'; top edge gilt.

Am Cat 1895–1900, p. 448; PTLA 1896, p. 20
MD

1896 Charles Scribner's Sons (New York)

96-7. Marion Harland
Common Sense in the Household: A Manual of Practical Housewifery. Majority Edition.
194 x 121 x 34 mm

Pea-green (PMS 451M) plain-weave cloth; front and back cover stamped identically in the style of a sixteenth-century fanfare binding, with a single rule border in dark-green stamping, enclosing a strapwork design filled with black-stamped branches, green-stamped leaves and red-stamped fruits; a cartouche in the center contains 'COMMON | SENSE | IN THE | HOUSEHOLD | BY | MARION | HARLAND' in black-stamping; under it, a small horizontal, rectangular cartouche containing 'MAJORITY | EDITION', in black-stamping; spine stamped with a condensed version of the cover design, with the lettering gold-stamped; in the top cartouche, 'COMMON | SENSE | IN THE | HOUSEHOLD | — | MARION | HARLAND'; in the lower, 'MAJORITY | EDITION'; and at the bottom, 'SCRIBNERS'.

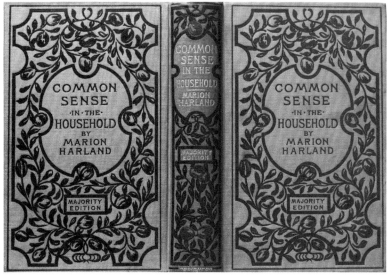

96-7

Am Cat 1895–1900, p. 489; PTLA 1896, p. 22

MD; MMA (56.522.71); publisher's proof, inscribed "Nov 18/9 | Alice C Morse – Morse [7]." The design on the back cover is unfinished and only the leaves have been stamped.

97-1

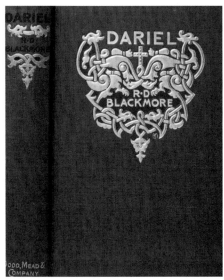

97-1A. A design variant with gold-stamping for a companion volume.

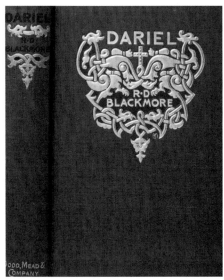

97-2

1897 The Century Co. (New York)

97-1 . Charles H[enry] Parkhurst
Talks to Young Men
Printer: De Vinne Press
179 x 111 x 20 mm
signed

Green (PMS 5825M) plain-weave cloth; design stamped in dark-green; front cover stamped with a large ornamental cartouche in the Italianate style, made up of plant motifs emerging from a sconce-like form; within the cartouche, 'TALKS | TO | YOUNG | MEN'; signed 'AM', within the design at the bottom; from the top of the spine, [fleuron] | 'TALKS | TO | YOUNG | MEN'| [a larger fleuron] | 'CHARLES H. | PARKHURST' | [a small fleuron] 'THE | CENTURY CO.'

The same design, with gold-stamped lettering, appears on Parkhurst's, *Talks to Young Women,* also published in 1897.

97-1A. Charles H[enry]. Parkhurst
Talks to Young Women
Printer: De Vinne Press
179 x 111 x 20 mm

An adaptation of this design also appears blind-stamped, on the cover of Arthur Christopher Benson's, *Escape and Other Essays* (1915), bound in green cloth.

Am Cat 1895–1900, p. 375; PTLA 1897, pp. 4 and 12
MD

1897 Dodd, Mead and Company (New York)

97-2. R[ichard]. D[oddridge]. Blackmore
Dariel: A Romance of Surrey
190 x 120 x 33 mm
Printer: University Press: John Wilson and Son, Cambridge, U.S.A.
Illustrator: Christopher Hammond
signed

Deep red (PMS 202M) plain-weave cloth; front cover with a gold-embossed and green-stamped symmetrical vignette of Celtic-style strapwork and grotesques, a dotted cross at the top and a grotesque head pendant at the bottom; the vignette forms two areas for lettering; at the top, gold-stamped, 'DARIEL'; in the bottom, gold-stamped on a green background, 'R · D | BLACKMORE'; signed with a conjoined 'AM' at the bottom right of the vignette; at the top of the spine, with the lettering in green-stamping and ornaments gold-embossed, 'DARIEL' | [ornament of two dolphins] | 'R · D | BLACKMORE' | [a grotesque ornament (gold-embossed with green stamping)]; 'DODD, MEAD &' | COMPANY'; gold-stamped at the bottom.

Am Cat 1895–1900, p. 47; PTLA 1897, p. 3
MMA (56.522.94); publisher's proof; spine undecorated; inscribed "From the designer | Alice Morse"

The three-dimensional design on *Dariel* was produced by the combination of stamping and embossing. This technique was also used on *My Study Fire* (99-3).

97-3. G[eorge]. E[dward]. Farrow

The Missing Prince

213 x 150 x 23 mm

Printer: University Press: John Wilson and Son, Cambridge, U.S.A.

Illustrators: Harry Furniss and Dorothy Furniss

signed

97-3

Tan (PMS 7503) coarse, plain-weave cloth; front cover design in the pictorial style, divided into three panels, each separated with a black-stamped line; in the top, red-stamped with dropout lettering, 'THE | MISSING PRINCE'; the large central panel contains an image of a prince and a magician standing within the castle wall, a path leading to a forest in the background, in red-, green- and black-stamping; the small bottom panel, green-stamped with 'G. E. FARROW' in dropout lettering; signed with a conjoined 'AM' in black-stamping, at the lower right corner of the center panel; the spine is separated into three panels separated with black-stamped lines; in the top, 'THE | MISSING | PRINCE' in dropout lettering on a red-stamped background; in the center, an image of a path leading to two soldiers at the castle gate, in green-, black- and red-stamping; in the bottom panel, 'FARROW' in dropout lettering on a green-stamped background; top edge stained brown.

Morse designed three pictorial covers, published between 1897 and 1898: *The Missing Prince*, *Yellow Pine Basin* (97-8) and *I, Thou, and the Other One* (98-1).

Am Cat 1895–1900, p. 156; PTLA 1897, p. 9 ("in handsome cloth binding, stained top")
MD; MMA (56.522.90); publisher's proof case; spine undecorated; inscribed "Alice C Morse | 1024 Scranton St | Scranton Pa"

97-4. Beatrice Harraden

Hilda Strafford: A California Story

175 x 116 x 25 mm

Printer: University Press: John Wilson and Son, Cambridge, U. S. A.

signed

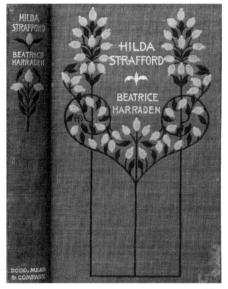

97-4

Green (PMS 5753M) plain-weave cloth; front cover design of three green- and yellow-stamped stylized lemon trees, forming a cartouche containing 'HILDA | STRAFFORD' | [a small flower ornament] | 'BEATRICE | HARRADEN', gold-stamped; signed with a conjoined 'AM', in green-stamping, within the left side of the design; at the top of the spine gold-stamped within a green- and gold-stamped lemon branch motif, 'HILDA | STRAFFORD | BEATRICE | HARRADEN' at the far bottom 'DODD, MEAD | & COMPANY', gold-stamped; top edge gilt.

Am Cat 1895–1900, p. 206; Gullans and Espey 1979, p. 54; PTLA 1897, p. 13
MD

97-5. George Macdonald

Salted With Fire: A Story of a Minister

Printer: University Press: John Wilson and Son, Cambridge, U.S.A.

195 x 125 x 28 mm

signed

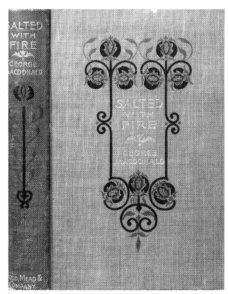

97-5

Light rust (PMS 7511M) coarse, plain-weave cloth; front cover brown- and red-stamped with a floral cartouche made up of leafy blossoms on long stems; within the cartouche, gold-stamped, 'SALTED | WITH | FIRE' | [a small fleuron] | 'GEORGE | MACDON-ALD'; signed with a conjoined 'AM' within the lower part of the design; at the top of the

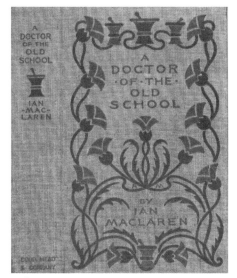

97-6

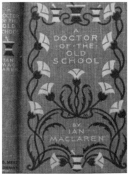

97-6A. Color variant of above.

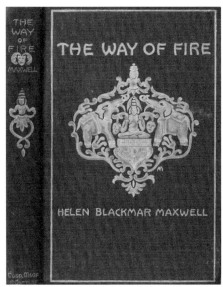

97-7

97-7A.
Preliminary proof
of above (note
misspelling of
author's name).

spine, 'SALTED | WITH | FIRE' | [fleuron] | 'GEORGE | MACDONALD', gold-stamped; below the lettering, is a tall stylized flower, brown- and red-stamped; at the bottom 'DODD, MEAD & | COMPANY', gold-stamped.

Am Cat 1895–1900, p. 304; PTLA 1897, p. 16
MD; MMA (56.522.93); publisher's proof; inscribed "Alice C Morse." This cover is bound in gray plain-weave cloth (PMS 7539M). I have not seen this binding variant on a published book.

97-6. Ian Maclaren
A Doctor of the Old School
162 x 100 x 24 mm
Illustrator: Frederick C. Gordon
signed

Green (PMS 5825M) plain-weave cloth; front cover stamped with a decorative panel of intertwining thistles and two apothecary's mortars and pestles; two cartouches are created by the design; in the top cartouche, purple-stamped, 'A | DOCTOR | OF THE | OLD | SCHOOL'; signed 'AM' in the center of the cover, green stamped; in the bottom cartouche, purple-stamped, 'BY | IAN | MACLAREN'; at the top of the spine, purple-stamped, 'A | DOCTOR | OF THE | OLD | SCHOOL' | [a mortar and pestle, green- and purple-stamped] | 'IAN | MAC- | LAREN', purple-stamped; at the bottom, 'DODD, MEAD | & COMPANY', green-stamped.

Two additional binding variants of *A Doctor of the Old School* have been seen, also published in 1897. One is bound in bright green (PMS 7496) plain-weave cloth with dark-green and yellow stamping (97-6A [MD]), the other in warm-gray (PMS warm gray 9M) plain-weave cloth with dark-green and lavender stamping.

Am Cat 1895–1900, p. 528; PTLA 1897, p. 17
MMA (56.522.91); publisher's production or proof cover; inscribed "Alice C Morse." The MMA variant has not been seen on a published book.

97-7. Helen Blackmar Maxwell
The Way of Fire
185 x 120 x 25 mm
Printer: University Press: John Wilson and Son, Cambridge, U. S. A.
signed

Brick red (PMS 5757M) plain-weave cloth; front cover bordered with a single gold-stamped line; at the top of the cover 'THE WAY OF FIRE' and at the bottom, 'HELEN BLACK-MAR MAXWELL' are tan-stamped; in the center, a tan-, gray- and gold-stamped vignette of two facing elephants with gold-stamped rings hanging on raised trunks, surrounded by a foliate border with small masks depicting Comedy and Tragedy; signed with a tan-stamped conjoined 'AM' at the lower right side of the vignette; spine gold-stamped at the top, with 'THE | WAY | OF | FIRE' and 'MAXWELL', separated by a mask with two feathers in tan- and gray-stamping; in the center of the spine is a tan-, gray- and gold-stamped figurative vignette; at the bottom 'DODD, MEAD | & COMPANY', tan-stamped; top edge gilt.

Am Cat 1895–1900, p. 321 (Morse's name is misrepresented "Maxwell, Helen Blackman"); PTLA 1897, p. 18
MD; MMA (56.522.92); publisher's proof, red-orange (PMS 181M) plain-weave cloth the spine and back cover are undecorated; inscribed and scratched out, "For Lea M Heath from Alice Morse." There are several differences between the proof and the published copy. In the proof, the author's name is misspelled 'ELLEN'; there is no single line border on the front cover; the title and author's name are gold-stamped; and brown-stamping replaces the gray-stamping (97-7A).

1897 George H. Richmond & Co. (New York)

97-8. Henry G. Catlin
Yellow Pine Basin: The Story of a Prospector
195 x 125 x 25 mm
Press of J. J. Little & Co. Astor Place, New York
signed

Blue-gray (PMS 5405M) fine diagonal-rib cloth (Krupp, Rib 10: "S" grain); the cover design is continued on the spine; both front cover and spine are bordered with a black-stamped single line border enclosing a pictorial design in deep perspective, with the image of a pine forest with a river running through it towards the mountains in the distance in red-, gold-, and black-stamping; breaking up the pictorial plane are two horizontal bands, gold-stamped within the bands, in the top, 'YELLOW PINE BASIN'; in the bottom, 'HENRY G CATLIN'; signed with a conjoined 'AM' in the bottom right corner in dropout; spine design is a continuation of the front cover, with gold-stamped 'YELLOW | PINE | BASIN' in the top band, and 'CATLIN' in the bottom; top edge gilt.

Morse designed three pictorial covers, published between 1897 and 1898: *Yellow Pine Basin*, *The Missing Prince* (97-3), and *I, Thou, and the Other One* (98-1).

Am Cat 1895–1900, p. 83
MD

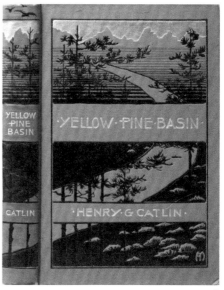

97-8

1898 Dodd, Mead (New York)

98-1. Amelia Edith Huddleston Barr
I, Thou, and the Other One: A Love Story
195 x 130 x 32 mm
signed

Gray-green (PMS 417M) plain-weave cloth; front cover edged with a black-stamped single line, surrounding a full-cover pictorial design drawn in deep perspective, with a tree and gatepost in the foreground and a path leading across a field to a castle in the background; stamped in green yellow-green, blue and black; breaking up the pictorial plane is a gold-stamped title panel, with a black-stamped linear border containing 'I | THOU | AND THE | OTHER | ONE | BY | AMELIA E | BARR', interspersed with leaf and dot ornaments; signed with a conjoined 'AM' in the bottom right corner; spine design is a continuation of the front cover, with a small version of the title panel; 'DODD, MEAD | & COMPANY' gold-stamped at the bottom.

This cover design also appears on the 1903 reprint.

Am Cat 1895–1900, p. 30; PTLA 1899, p. 5
MD

98-1

98-2. Paul Leicester Ford
Tattle-Tales of Cupid
188 x 117 x 27 mm
Printer: University Press: John Wilson and Son, Cambridge, U.S.A.
signed

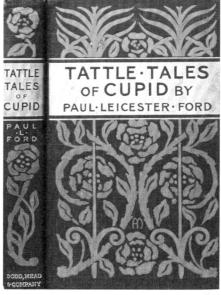

98-2

Dark green (PMS Black 2M) plain-weave cloth; front cover is fully covered in a symmetrical design of two yellow-gold stamped standing branches intertwined with scrolled stemmed roses, stamped in light-green and yellow-gold; a large gold-stamped band with 'TATTLE TALES | OF CUPID BY | PAUL LEICESTER FORD' in dropout lettering, runs across the cover; signed with a conjoined 'AM' in the lower-middle of the cover; spine is a condensed version of the rose motif; title panel gold-stamped with dropout lettering, 'TATTLE | TALES | OF | CUPID', under it, gold-stamped, 'PAUL | L | FORD'; at the bottom, gold-stamped, 'DODD, MEAD | & COMPANY'.

Am Cat 1895–1900, p. 166; BAL 6220 (first edition; describes cloth as gray-brown); Minsky, p. 82; PTLA 1898, p. 166
MD

98-3

98-3. George Macdonald
Far Above Rubies
162 x 100 x 20 mm
signed

Tan (PMS 7503M) plain-weave cloth; front cover stamped with a single black line border; in the center, a large cartouche framed with flowers and bows in red-, green- and black-stamping; in the center of the cartouche is an oval made up of a double green lines and red dots; within the oval, 'FAR ABOVE | RUBIES', black-stamped; at the bottom part of the design, 'GEORGE MACDONALD', black-stamped; signed with a black-stamped, conjoined 'AM', within the design; at the top of the spine, a flower ornament in red-, green- and black-stamping, 'FAR | ABOVE | RUBIES' in black-stamping, a red-stamped bow, 'GEORGE | MACDONALD' and a daisy ornament; at the bottom, 'DODD, MEAD | & COMPANY'.

 Although there is no series name or date of publication on *Far Above Rubies*, it appears to be from the same "pocket edition" as the adaptation of the original design for *A Rose of a Hundred Leaves* (91-1A) also designed by Morse. It is the same size and has the identical decorative title page border, possibly illustrated by Morse. The only reference in which *Far Above Rubies* appeared is *The Publisher's Trade-List Annual 1899*, as a volume in the Phenix Series.

PTLA 1899, pp. 20 and 25
MD

98-4

98-4. Esther Singleton
Turrets, Towers and Temples: The Great Buildings of the World, as Seen and Described by Famous Writers
212 x 135 x 35 mm
Printer: University Press: John Wilson and Son, Cambridge, U.S.A.
signed

Green (PMS 105M) fine-rib cloth (Krupp, Rib 2); front cover with a gold-stamped single rule border surrounding a full-cover symmetrical foliate window design in Gothic style; a cartouche is formed in the center with 'HISTORIC | BUILDINGS | DESCRIBED BY | GREAT WRITERS'; signed with a conjoined 'AM' at the bottom center; spine gold-stamped with a Gothic-style foliate design, with 'TURRETS | TOWERS | AND | TEMPLES' in a panel; top edge gilt

 Books by Esther Singleton with the same design:
 Great Pictures Described as Seen and Described by Great Writers, 1899
 Great Writers on Great Painting, 1899
 Guide to the Opera, 1899 (not seen)

Wonders of Nature, 1900

Modern Paintings Described by Great Writers, 1901

Romantic Castles and Palaces Described by Great Writers, 1901

Famous Paintings Described by Great Writers, 1902

Historic Buildings Described by Great Writers, 1903

Famous Women Described by Great Writers, 1904

Wonders of Nature as Seen and Described by Famous Writers. New York: Detmold, 1904

Great Portraits Described by Great Writers, 1905

Historic Landmarks of America . . . , 1907

Great Rivers Described by Great Writers, 1908

Famous Cathedrals Described by Great Writers, 1909

Famous Sculpture as Seen and Described by Great Writers, 1910

Wonders of the World, 1912

This is one of Morse's best-known designs. Two additional variants have been seen; one bound in light green (PMS 556M) vertical-ribbed cloth (Krupp, Rib 3: Rib) with the design blind-stamped, and title and author in gold on both cover and spine, published by Dodd Mead; and another bound in red (PMS 195M) plain-weave cloth with the front cover blind-stamped and the spine stamped in faux-gold, published by P. F. Collier and Son.

Am Cat 1895–1900, p. 451; Minsky 2006, p. 96; PTLA 1898, p. 26; PTLA 1905, p. 31
MD

98-5. Barbara Yechton
A Lovable Crank or More Leaves from the Roses
205 x 132 x 33 mm
Printer: University Press: John Wilson and Son, Cambridge, U.S.A.
Illustrator: Minna Brown
signed

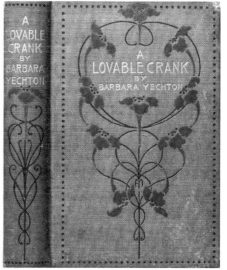

98-5

Yellow-brown (PMS 154M) coarse, plain-weave cloth; front cover has a dotted-line border, stamped in dark green; in the center is a symmetrical floral design in the Art Nouveau style, made up of orange-red and green-stamped flowers and dark green-stamped stems; the upper part of the design forms a cartouche containing 'A | LOVABLE | CRANK | BY | BARBARA YECHTON', gold-stamped; signed in dark green-stamping, with a conjoined 'AM', worked into the cover design; the spine has green-stamped dotted lines at the top and bottom, 'A | LOVABLE | CRANK | BY | BARBARA | YECHTON' is gold-stamped at the top; the balance of the spine is filled with a condensed version of the front cover design.

Minna Brown was a classmate of Morse's at Cooper Union. In 1891, Morse won the silver medal for life drawing and Minna Brown was one of three bronze medal winners in the same subject.

Am Cat 1895–1900, pp. 272 and 556; Cooper Union 1891, p. 76; PTLA 1898, p. 29
MD

1899 Dodd, Mead and Company (New York)

99-1. Paul Laurence Dunbar
Lyrics of the Hearthside
169 x 103 x 20 mm
Printer: University Press: John Wilson and Son, Cambridge, U.S.A.
signed

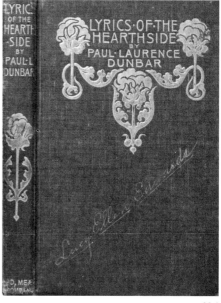

99-1

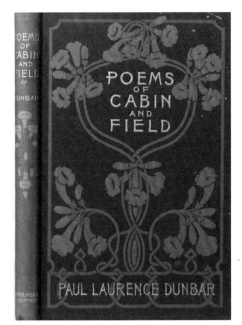

99-2

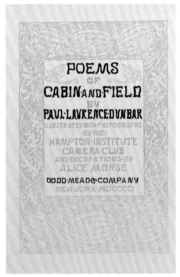

99 2A. Title page, of *Poems of Cabin and Field*, designed by Morse.

99-3

Dark, gray-green (PMS 448M) plain-weave cloth; gold-stamped and embossed design; front cover cartouche, open at the top, made up of three stylized cotton plants surrounding 'LYRICS OF THE | HEARTHSIDE | BY | PAUL LAURENCE | DUNBAR'; signed with a conjoined 'AM' within the center flower; from the top of the spine, 'LYRICS | OF | THE | HEARTHSIDE | BY | PAUL L | DUNBAR'; in the center of the spine, a large-stemmed cotton flower; at the bottom, 'DODD, MEAD | [AND] COMPANY'; top edge gilt.

Am Cat 1895–1900, p. 139; BAL 4925; Gullans and Espey, p. 54; Minsky 2006, p. 45; PTLA 1899, p. 11
MD

> 99-2. Paul Laurence Dunbar
> *Poems of Cabin and Field: Illustrated with Photographs by the Hampton Institute Camera Club and Decorations by Alice Morse*
> 225 x 142 x 165 mm
> Printer: University Press: John Wilson and Son, Cambridge, U.S.A.
> signed

Green (PMS 5743M) sized satin-weave cloth; front cover is a large symmetrical design in the Art Nouveau style, of intertwining trumpet vines in green- and orange-stamping; the top of the design forms a cartouche containing 'POEMS | OF | CABIN | AND | FIELD', gold-stamped; signed with a conjoined 'AM', green-stamped within the design at the bottom right; spine has green-stamped bars at the top and bottom; from the top, 'POEMS | OF | CABIN | AND | FIELD', a small green- and orange-stamped flower ornament, 'DUNBAR' in gold-stamping, followed by a trumpet flower motif and 'DODD, MEAD | & COMPANY', gold-stamped at the bottom; top edge gilt.

Published with an off-white paper dust-jacket; front cover with 'POEMS | OF | CABIN | AND | FIELD' at the top and 'PAUL LAURENCE DUNBAR' at the bottom, printed in green in the same style and format as the lettering on the binding.

Other than the At the Ghost Hour Series (94-5), this is the only book with "decorations" by Morse. These include an illustrated title page (99-2A), a cartouche for the imprint, depicting two crossed-banjos and intertwined leaves; as well as seven different page-border designs with watermelon, corn, peanut, tobacco, cotton, rabbit and raccoon motifs. The printing plates that make up the elements of the border designs were reused in different ways in the designs; all were printed in pale green and signed with a conjoined 'AM'. *Poems of Cabin and Field* is the first of a series of Dunbar's books with photographs by the Hampton Institute Camera Club, published by Dodd Mead, and is the only book in the series designed by Morse. Another, *Candle-Lightin' Time*, was designed by Margaret Armstrong (1901) (see fig. 5.) These books were widely used to publicize the work and educational principles of the Hampton Institute, founded in 1868, for the education of African-Americans.

Am Cat 1895–1900, p. 139; BAL 4927; Minsky 2006, p. 45; PTLA 1899, p. 11
MD

> 99-3. Hamilton Wright Mabie
> *My Study Fire*
> 210 x 133 x 30 mm
> Printer: University Press: John Wilson and Son, Cambridge, U.S.A.
> Illustrators: Maude Alice Cowles and Genevieve Cowles
> signed

Yellow-green (PMS 557M) fine diagonal-rib cloth (Krupp, Rib 10. "S" grain); front cover gold-stamped and embossed in matte and bright gold; in the center, a symmetrical rectangular panel with a design of curving leaves and flowers; a cartouche formed by the up-

per part of the panel contain; 'MY STUDY | FIRE | BY | HAMILTON | W | MABIE'; signed with a conjoined 'AM' at the bottom of the panel, right of center; spine gold-stamped with a leafy ornament at the top, 'MY | STUDY | FIRE', a different floral ornament, 'MABIE', a long-stemmed flower, and 'DODD, MEAD | & COMPANY' at the bottom; top edge gilt.

This new illustrated edition of *My Study Fire* was published in 1890 and 1893; Morse's design appears in the 1899, 1901 and 1904 printings (1899 and 1901 identified by Richard Minsky).

Am Cat 1895–1900, p. 301; Minsky 2006, p. 47; PTLA 1899, p. 20
MD

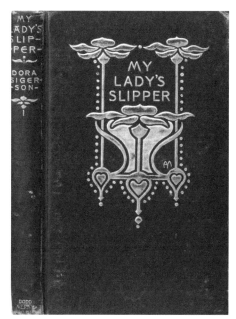

99-4

99-4. Dora Sigerson
My Lady's Slipper and Other Verses
174 x 105 x 18 mm
Printer: University Press: John Wilson and Son, Cambridge, U.S.A.
signed

Dark green (PMS 350M) plain-weave cloth; gold-stamped and embossed design in the Art Nouveau style; front cover gold-stamped with a cartouche made up of three stylized Lady's Slipper orchids with long stems forming the sides of the cartouche, containing 'MY | LADY'S | SLIPPER'; three hearts form the bottom of the design and a string of dots accentuate the edges of the cartouche; signed with a conjoined 'AM' in the bottom right of the cartouche; spine gold-stamped with 'MY | LADY'S | SLIP- | -PER' | [leafy flower ornament] | 'DORA | SIGER- | - SON-' | [leafy flower ornament]; 'DODD | MEAD & | COMPANY' at the bottom; top edge gilt.

This design reappears on Paul Laurence Dunbar's, *Lyrics of Love and Laughter*, Dodd, Mead, 1903 (03-1). Minsky points out Sarah Whitman's influence on Morse's work by comparing this design to Whitman's designs on Sarah Orne Jewett's, *The Country of the Pointed Firs* (1897) and Helen Choate Prince's, *At the Sign of the Silver Crescent* (1898) (figs. 18 and 19).

Am Cat 1895–1900, p. 448; Minsky 2006, p. 11, 93; PTLA 1899, p. 29
MD

1901 International Association of Newspapers and Authors (New York)

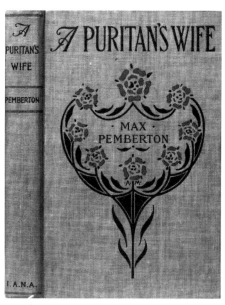

01-1

01-1. Max Pemberton
A Puritan's Wife
180 x 112 x 22 mm
Printer: Braunworth, Munn & Barber, Printers and Binders, Brooklyn, N.Y.
signed

Warm-gray (PMS warm gray 9M) plain-weave cloth; front cover stamped in black and red; at the top of the front cover, 'A PURITAN'S WIFE', black-stamped; in the center, a large cartouche made up of a black-stamped, split-stem with eight red-stamped flowers, containing 'MAX | PEMBERTON', signed 'AM' within the cartouche at the center, in black-stamping; at the top of the spine, three red-stamped lines create two panels containing 'A | PURITAN'S | WIFE', in the top, and 'PEMBERTON in the bottom; at the bottom of the spine, 'I.A.N.A.' is black-stamped with a red-stamped line below it.

Dodd, Mead & Company originally published *A Puritan's Wife* in 1896 (not seen).

Am Cat 1895–1900, p. 380
MD

1903 Dodd, Mead and Company (New York)

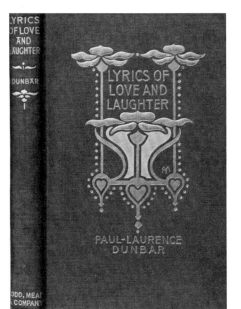

03-1

03-1. Paul Laurence Dunbar
Lyrics of Love and Laughter
170 x 106 x 19 mm
Printer: University Press: John Wilson and Son, Cambridge, U. S. A.
signed

Olive-green (PMS 455M) plain-weave cloth; gold-stamped and embossed design in the Art Nouveau style; front cover is stamped with a cartouche made up of three stylized lady's slipper orchids with long stems forming the sides of the cartouche, containing 'LYRICS OF | LOVE AND | LAUGHTER'; three hearts form the bottom of the design and a string of dots accentuate the edges of the cartouche; signed with a conjoined 'AM' in the bottom right of the cartouche; at the bottom of the cartouche, 'PAUL–LAU-RENCE | DUNBAR'; spine gold-stamped with 'LYRICS | OF LOVE | AND | LAUGH-TER' and 'DUNBAR', with leafy flower ornaments between the title and author and below the author's name; 'DODD | MEAD & | COMPANY' gold-stamped at the far bottom; top edge gilt.

The design of *Lyrics of Love and Laughter* is an adaptation of one originally created for Dora Sigerson's, *My Lady's Slipper*, Dodd Mead, 1899 (99-4). Minsky notes Sarah Whitman's influence on Morse's work by comparing this design to Whitman's designs on Sarah Orne Jewett's *The Country of the Pointed Firs* (1897) and Helen Choate Prince's *At the Sign of the Silver Crescent* (1898) (figs. 18 and 19).

AC 1895–1900, p. 314; BAL 4945; Minsky 2006, p. 11, 93; PTLA 1903, p. 10
MD

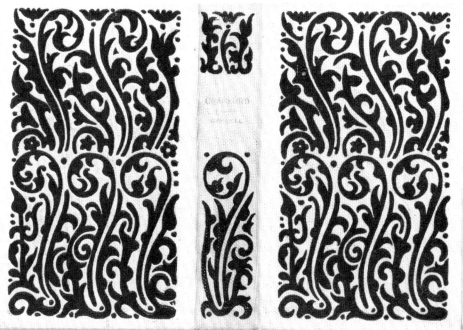

N. D. -1

N. D. -1. Elizabeth Cleghorn Gaskell
Cranford
142 x 90 mm

Cream (PMS 4565M) coarse plain-weave cloth; both covers brown-stamped with a large panel design in the Arts and Crafts style, made up of five stylized fiddlehead ferns, inter-

spersed with flowers and dots; at the top of the spine is a brown-stamped flower and leaf panel, followed by 'CRANFORD | — | GASKELL', gold-stamped; and a repeat of a single fern motif filling the balance of the spine panel.

MMA (56.522.70); book cover; inscribed "Alice C Morse." Although there are many contemporary editions of *Cranford*, I have not seen this cover on a published book. The fern motif is the same as that on n. d. -2.

N. D.-2. Untitled publishers' book cover design

165 x 103 mm

Brown plain-weave cloth (PMS 7500M); front cover brown-stamped with a large rectangular panel design made up of five stylized fiddlehead ferns interspersed with flowers and dots, in the Arts and Crafts style; spine without decoration.

The fern motif is the same as that on n. d.-1.

MMA (56.522.102), publisher's proof, inscribed "Alice C Morse | 1024 Scranton St | Scranton Pa"

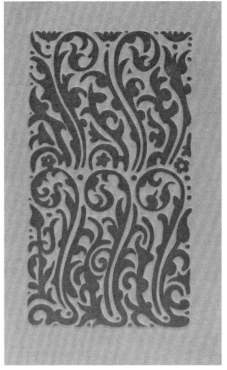

N. D.-2

II. BOOK COVERS ATTRIBUTED TO MORSE

ATTRIB. 83-1. George Edward Woodberry
A History of Wood Engraving
New York: Harper & Brothers, Franklin Square, 1883
230 x 162 x 25 mm

ATTRIB. 83-1

Green (PMS 5747M) ultra fine diagonal-rib cloth (Krupp, Rib 5); front cover gold-stamped with a wide illustrated frame that appears to be copied from an early woodcut style, that surrounds a lettering panel; within the panel gold-stamped at the upper left, 'A' [decorated initial] 'History | of | Wood- | Engraving | By | George E. Woodberry | Illustrated'; at the top of the spine gold-stamped, an engraved bar, a rectangular illustration of Christ on the cross; 'A | History | of | Wood- | Engraving | Woodberry'; a rectangular illustration of Christ being taken down from the cross; 'Harper's'; and a repeat of the engraved bar; mauve endleaves; cloth headbands, green.

Morse may not have designed this cover, as it precedes her earliest known cover by four years; however, Matthews attributes this design to her in *Bookbindings Old and New* (p. 203):

Some satisfaction there is in finding an old German woodcut border doing duty on the cover of Mr. Woodberry's "History of Wood Engraving" or in observing the apt use of the orange with it's full fruit and its green leaves as they are wreathed in the arabesques of the medallions which adorn the back and side of Mr. Lafcadio Hearn's "Two Years in the French West Indies," and which were designed by Miss Alice E. Morse, with a full understanding of the value of the colour on a book-cover, and an apt appreciation of the technical means where by it is best to be attained. (Morse's middle initial is a typographical error).

MD

ATTRIB. 93-1. Cyrus Fogg Brackett, et al.
Electricity in Daily Life: A Popular Account of the Applications of Electricity to Every Day Uses
New York: Charles Scribner's Sons, 1893
227 x 150 x 30 mm
Printer: Press of J. J. Little & Co., Astor Place, New York
Illustrated

ATTRIB. 93-1

Dark blue (PMS 282M) plain-weave cloth; silver-stamped bands of stylized electrical motifs run across the front cover and the spine at the top and bottom; in the center of the front cover 'ELECTRICITY | IN | DAILY LIFE' is gold-stamped in a lettering style that appears to be electrically charged; under the title is a silver-stamped vignette of three light bulbs tied with a bow of electrical current; at the top of the spine, 'ELECTRICITY | IN | DAILY LIFE | — | ILLUSTRATED', gold-stamped; in the center of the spine a flower-like ornament made up of alternating light bulbs and lines that may represent electrical current or wires is stamped in silver and gold; 'SCRIBNERS', gold-stamped at the bottom, within the decorative band; brown paper endleaves; cloth headbands, brown.

I remember once reading that Morse was the designer of this cover, but have not been able to relocate that reference. I believe it to be true.

Aldine 1892, p. 27; Am Cat 1890–1895, p. 49; PTLA 1893, p. 12
MD

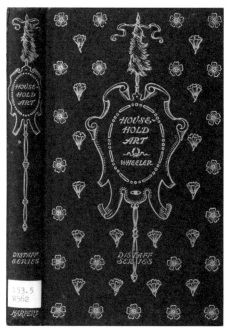

ATTRIB. 93-2. The Distaff Series
Candace Wheeler, ed.
Household Art
New York: Harper & Brothers Publishers, 1893
154 x 90 x 18 mm

Brown (PMS 462M) fine diagonal-rib cloth (Krupp, Rib 10: "S" grain) front cover gold-stamped in a semé of open and closed blossoms; in the center is a Baroque cartouche with a vertical staff with waving ribbons; at its center 'HOUSE- | HOLD | ART'; outside of the cartouche at the bottom of the staff is 'DISTAFF | SERIES'; at the top of the spine, a small repeat of the front cover cartouche, with 'HOUSE- | HOLD | ART' in the center, 'DISTAFF | SERIES' and 'HARPERS' at the bottom.

I believe that Morse may have been the cover designer for the Distaff Series. The style is similar to other covers, such as those on the titles in the Giunta Series (90-1); and it is mentioned in the introduction of *Household Art*, that a woman designed the cover. This attribution can be supported by the fact that Morse was well known by Wheeler, who, in addition to being the editor of this work, was Morse's supervisor at the Woman's Building at the Exposition and also the person responsible for promoting the Distaff Series to J. Henry Harper. The series consists of six volumes that were available for sale at the Women's Building Library. The series was a result of the efforts of the New York Board of Women Managers and others, who decided to represent the full scope of the achievements of women writers in the Woman's Building Library.

THE DISTAFF SERIES:

Anna C. Brackett, ed. *Woman and the Higher Education*, 1893
Alice Morse Earle and Emily Ellsworth Ford, ed. *Early Prose and Verse*, 1893
Frances A. Goodale, ed. *The Literature of Philanthropy*, 1893
Constance Cary Harrison (Mrs. Burton Harrison), ed. *Short Stories*, 1893
Candace Wheeler, ed. *Household Art*, 1893
Kate Douglas Wiggin, ed. *The Kindergarten*, 1893

Am Cat 1890–1895, p. 114; Peck and Irish, p. 70; PTLA 1893, p. 12
MMA, Jane E. Andrews Fund (Watson Library 153.5 W562)

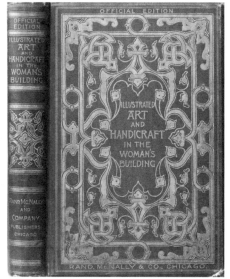

ATTRIB. 93-3. Maud Howe Elliott, ed.
Art and Handicraft in the Woman's Building of the World's Columbian Exposition
Chicago, 1893
Paris and New York: Goupil & Co. and Rand McNally Co., 1893
248 x 162 x 28 mm

Olive-green (PMS 1265M) plain-weave cloth; designed in the style of a sixteenth-century French Grolier strapwork binding with flower and leaf motifs; the strapwork on the front cover is outlined in silver and filled with gold-stamping; gold-stamped at the top 'OFFI-CIAL EDITION'; the strapwork forms a center cartouche that contains 'ILLUSTRATED | ART | AND | HANDICRAFT | IN THE | WOMAN'S | BUILDING' in gold; gold-stamped at the bottom 'RAND, Mc NALLY & CO, CHICAGO'; the spine is separated into panels by gold and silver-stamped bars, containing in the top panel, 'OFFICIAL | EDITION'; in the second panel, 'ILLUSTRATED | ART | AND | HANDICRAFT | IN THE | WOMAN'S | BUILDING'; in the center, two silver bars edged in gold are filled with a symmetrical Grolier-style ornament; in a lower panel, 'RAND Mc NALLY | AND | COMPANY | PUBLISHERS | CHICAGO'; beveled boards; all edges gilt; cloth head-

bands, white with black stripes; endleaves printed in a pattern of gold flowers over a light green leafy design, on off-white paper.

I have also seen a binding variant in dark blue cloth. In the blue copy, at the bottom of the front cover and on the spine, the publisher's name is gold-stamped 'GOUPIL & CO. PARIS & NEW YORK – BOUSSOD – VALADON & CO. SUCCESSORS'. It is logical to assume that Alice C. Morse may have been the designer of this cover, considering that she was chairman of the sub-committee for book covers for the Woman's Building at the World's Columbian Exposition, and was the author of the chapter on women illustrators for this publication, in which she expressed her respect for historic bindings. The design is very similar to a Grolier binding in Matthews' *Bookbindings Old and New* (1896).

Am Cat 1890–1895, p. 130; Matthews, p. 11
MD

ATTRIB. 95-1. Harper's American Essayists Series
Laurence Hutton
Other Times and Other Seasons
New York: Harper and Brothers, 1895
154 x 90 x 15 mm

ATTRIB. 95-1

Dark green (PMS 567M) plain-weave cloth, front cover gold-stamped in a semé of torches with bows; in the center is a Baroque cartouche; enclosing 'OTHER TIMES | AND | OTHER SEASONS | by | Laurence Hutton.'; spine gold-stamped with a circular cartouche with a torch and bow; inside cartouche is 'OTHER TIMES | AND | OTHER | SEASONS'; below it, 'Laurence Hutton'; and at the bottom, 'HARPERS'.

Morse may have designed the cover for Harper's American Essayists Series, which is very similar to that of the Distaff Series. The advertisement in the back of *Other Times and Other Seasons* lists fourteen titles in the series.

Am Cat 1895–1900, p. 239; PTLA 1895, p. 4
MD

ATTRIB. 05-1. Paul Laurence Dunbar
Lyrics of Sunshine and Shadow
New York: Dodd, Mead & Company, 1905
168 x 107 x 16 mm

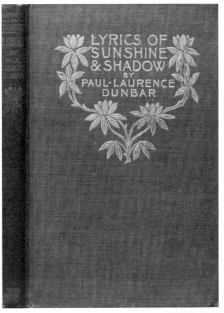

ATTRIB. 05-1

Olive green (PMS 133M) plain-weave cloth; front cover design of a gold-stamped double-stemmed magnolia branch which forms a cartouche for 'LYRICS OF | SUNSHINE | & SHADOW | BY | PAUL LAURENCE | DUNBAR'; spine gold-stamped with 'LYRICS OF | SUNSHINE | & SHADOW | BY | PAUL | LAURENCE | DUNBAR', with a single magnolia bloom ornament; at the far bottom, 'DODD | MEAD | COMPANY'; top edge gilt.

This cover is similar to those on two other books by Paul Dunbar designed by Morse, *Lyrics of Lowly Life* (96-3) and *Lyrics of the Hearthside* (99-1). It seems late for Morse and may be designed in imitation of her style for the other Dunbar books.

Am Cat 1905–1907, p. 314; BAL 4954; PTLA 1905, p. 12
MD

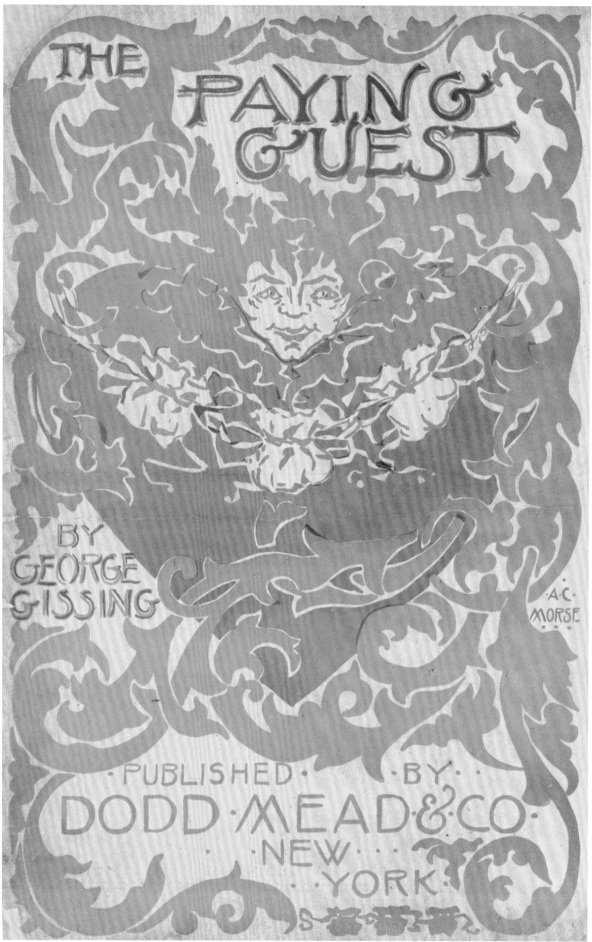

THE PAYING GUEST

BY GEORGE GISSING

A.C. MORSE

PUBLISHED · BY ·
DODD · MEAD & CO
· NEW ·
· YORK ·

95P-1. George Gissing
The Paying Guest
New York: Dodd, Mead & Company, 1895
462 x 300 mm (image size)
color lithographic print

Brandt 1994, p. 75.
MD

96P-1. Ian Maclaren
Kate Carnegie
New York: Dodd, Mead & Company, 1896
386 x 237 mm (image size)
color lithographic print

Brandt 1994, p. 75
NYPL

96P-2. M[ary]. M[artha]. Mears
Emma Lou: Her Book
New York: Henry Holt and Co., 1896
456 x 300 mm (image size)
color lithographic print

NYPL

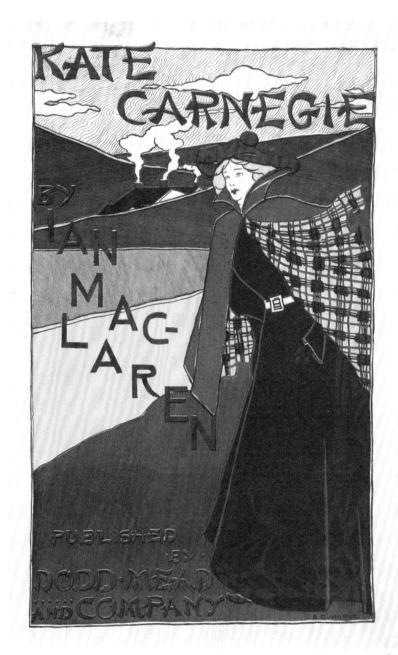

96P-1

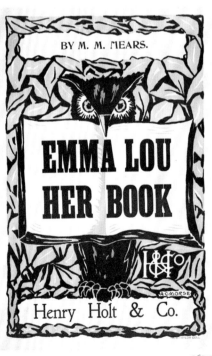

96P-2

1863

Alice Cordelia Morse is born to Joseph and Ruth Perkins Morse on June 1, in Hammondsville, Jefferson County, Ohio. Many sources state different years of birth for Morse. Willard and Livermore state Morse's birth year as 1862. Morse's Scranton Public Schools, Teacher's Record Card [1923?] states it as 1863. The birth year 1863 is supported by the federal census returns of 1880, 1910, and 1930.

1865

Two years after Alice C. Morse was born, her family moves from Ohio to Brooklyn, New York.

1868

Morse is sent to school at five years of age; she attends school in Brooklyn, New York for eight years.

1879–1883

Morse studies art at the Woman's Art School, Cooper Union for the Advancement of Science and Art, New York City.

1883

Morse studies art at the summer school at Alfred College, Alfred Centre, New York.

1884–1885

Morse studies art with John La Farge in New York City.

1885–1889

Morse designs stained glass for the Tiffany Glass Company in New York City. While there, she designs a notable window for the Beecher Memorial Church at 1325 Herkimer Street in Brownsville, Brooklyn.

1887

Morse's first known book cover appears on *Seth's Brother's Wife* for Scribner's (87-1).

1889

Morse is listed in the catalog of the Fifth Annual Exhibition of the Architectural League of New York as living at 88 Morton St., Brooklyn. A "Book Cover Sketch" and a "Scheme for a Book Cover" are exhibited.

1889–1891

Morse attends postgraduate art courses at the Woman's Art School, Cooper Union for the Advancement of Science and Art in New York City.

1890

Morse is listed in the catalog of the Sixth Annual Exhibition of the Architectural League of New York as living at 111 S. 9th St., Brooklyn. Harper & Brothers loan a "Cover for Wordsworth's Sonnets" and a "Book Cover Design" to the exhibition.

1891

In Morse's last year as a student at the Woman's Art School, Cooper Union for the Advancement of Science and Art, she wins a silver medal for life-drawing.

Morse is mentioned in *The Collector*, "Book-Cover Designing," vol. 2, no. 5 (1891).

1891–1892

Morse studies art at the Art Students League, New York City.

1892

Morse is appointed chairman of the sub-committee on book covers, wood engraving, and illustration of the New York State Board of Women Managers for the World's Columbian Exposition and prepares an exhibition of book covers in the Woman's Building of the Exposition.

Several of Morse's book-cover designs are exhibited at the Aldine Club, New York City (March 25-31). Titles included are *House and Hearth* (91-3), *A Rose of a Hundred Leaves* (91-1), *Lord Arthur Savile's Crime* (91-4), *The Odd Number* (89-4), *Pastels in Prose* (89-4), *Tales by Coppeé* (89-4), *Electricity in Daily Life* (Attrib. 93-1), *Seth's Brother's Wife* (87-1), *Vain Fortune* (92-11) and *On Newfound River* (91-11).

1893

Morse writes the chapter, "Women Illustrators" for *Illustrated Art and Handicraft in the Woman's Building of the World's Columbian Exposition,* Maude Howe Elliott, ed.

Morse receives diploma and medal, "the highest award possible," for a personal exhibit of book covers at the World Columbian Exposition.

Morse's biography appears in Frances Willard's and Mary Livermore's *A Woman of the Century: Fourteen Hundred-Seventy Biographical Sketches Accompanied by Portraits of Leading American Women in All Walks of Life* (Buffalo, Chicago and New York: Charles Wells Moulton).

In the catalog of the Ninth Annual Exhibition of the Architectural League of New York, Morse is listed as living at 111 South 9th Street, Brooklyn. Five book covers designed by Morse are included, two loaned by the Century Co.

1893–1895

Morse works as a designer for the New York Society of Decorative Art.

1894

Morse is first listed in *Lain's Brooklyn Directory* as a designer, living at 111 South 9th Street, Brooklyn (listed again in 1897 and 1898). Joseph Morse is listed at the same address, as a salesman. This indicates that Morse lives in her family's home until she relocated to Scranton in 1897.

(April 5-28) Morse's book covers appear in the exhibition Commercial Bookbindings, at the Grolier Club, New York City. She is mentioned in the catalog that accompanies the exhibition.

Morse is interviewed by Gilson Willets for "The Designing of Book-Covers: Women Artists in the Field" in *The Art Interchange* (November 1894). The article includes illustrations of *Crows Nest and Belhaven Tales* (92-3); and *The Chevalier of Pensieri-Vani* (92-2), which Willets misattributes to Margaret Armstrong.

1895

The covers and cover designs for *Sweet Bells Out of Tune* (93-1) and *Writing to Rosina* (94-1) lent by the Century Co., are exhibited at the Tenth Annual Exhibition of the Architectural League of New York.

Morse spends five months in France studying painting and French.

1896

Morse's work is included in *Bookbindings Old & New,* by Brander Matthews. *The Chatelaine of La Trinité* (92-1) is illustrated but her name is given as Alice E. Morse, instead of Alice C. Morse. In his text, Matthews favorably mentions *Two Years in the French West Indies* (90 3) and Woodbury's *History of Wood Engraving* (Attrib. 83-1), and attributes the Woodberry cover design to her.

1896–97
Morse attends a Management Training Course at the Normal School of Pratt Institute, Brooklyn, New York.

1897
Morse takes a position as supervisor of Art and Drawing for the elementary grade schools, Scranton public school system, Scranton, Pennsylvania, and relocates to Scranton.

Morse's designs are published in the Supplement of *Art Amateur*, vol. 36, no. 1 and no. 2.

Morse is mentioned with Margaret Armstrong and Sarah Whitman in "Women and Bookbinding", *House Beautiful,"* vol. 1, no. 3.

1898
Two of Morse's designs for embroidery are published in *Corticelli Home Needlework* (Florence, Mass.: Nonotuck Silk Co.), a quarterly periodical devoted to instruction in art needlework.

1899
Morse is first listed in the Scranton City Directory, with no address.

Morse is promoted to supervisor of Art and Drawing at the Central High School, Scranton, Pennsylvania.

1901–1912
Morse resides in Scranton, at the home of her companion, Leah M. Heath, at 1024 Scranton Avenue.

1903
Morse attends a summer course in Intermediate French at Harvard University.

1906
Morse spends the summer in Europe studying in art galleries in Holland, Belgium, and Paris.

1909
Morse attends a summer design course at Rhode Island School of Design, Providence, Rhode Island.

Morse receives a State Permanent Teaching Certificate (#4372), enabling her to teach "regular" subjects as well as Drawing in the Scranton Public Schools.

1912
Morse's companion, Leah M. Heath dies on June 13, leaving Morse as beneficiary and executor of her estate.

Morse moves to 917 Mulberry Street, Scranton.

1914–1917
Morse lives at 326 Monroe Avenue, Scranton.

1914
Morse spends the summer in Italy studying art.

1917
Morse is promoted to head of the Drawing Department for the entire Scranton school district.

1917–1923
Morse is employed as head of the Drawing Department at Central High School, Scranton, Pennsylvania. She retires in September 1923.

1918

Morse attends a course at the Atkinson Arts School, New York City.

1918–1919

Morse lives at 320 Madison Avenue, Scranton.

1920–1921

Morse lives at 1102 Green Ridge Street, Scranton.

1923

Morse lives at 739 Jefferson Avenue, Scranton. Morse retires from the Scranton Public School System in September. Either late in 1923 or early in 1924, she comes to live with her sister, Mary Fancher, at 606 West 116th Street, in New York City. Morse gives fifty-eight book covers to the library of the Metropolitan Museum of Art late in 1923. These are placed on exhibition in the Museum's library. The exhibition is announced in the Museum's *Bulletin* and *Annual Report*.

1937

Mary Fancher, Morse's sister, dies in Scranton about this time.

1939

Morse appears in the records of The Metropolitan Museum of Art Archive, as living at 606 West 116th Sreet, New York City.

1939–1961

Little is known of Morse after her return to New York City. In a deposition found in Morse's will, from a friend and neighbor, Augusta C. Wagner, it appears as though Morse continued living at 606 West 116th Street, and shared with Wagner and other friends, an interest in theater, opera and other cultural institutions. At the end of this period, Morse became a long-term patient at St. Barnabas Hospital, Bronx, New York.

1961

Morse dies on July 15 at St. Barnabas Hospital, Bronx, New York. Her will and related documents are on file at the Bronx County Surrogate's Court (File No. P1394).

adaptation An adaptation of an original book-cover design, in which elements of the original have been re-used with major changes in color, position, scale, or other elements.

Aesthetic movement A term referring to the period of design reform in England and America in the 1870s and 1880s, characterized by an emphasis on conventionalized natural ornamentation, often reduced to simplified patterns. Largely concerned with the decorative arts, it had affinities with Japanese, Gothic, and Classical art.

arabesque A traditional form of book decoration consisting of interlaced lines and curves arranged in a geometrical pattern, derived from Near Eastern art.

anthemion A term for a classical decorative border derived from the Greek for "flower," and often including honeysuckle, palmette and lotus motifs.

Art Nouveau An exaggeratedly asymmetrical decorative style, which spread throughout Europe in the last two decades of the nineteenth century and first decade of the twentieth; defined by the use of undulating natural forms.

Arts and Crafts A movement developed in the late-nineteenth century by John Ruskin and William Morris among others, promoting craftsmanship and reform of industrial design.

blind-stamped An impression made in a cover by an engraved brass stamp, with no addition of gold, silver, or color foil.

calendered A smooth surface or finish imparted by the use of metal rollers.

cartouche A plain or decorative frame, often decorated with scroll-like ornament, containing lettering, usually the name of the author, title or other information relating to a book.

case binding A bookbinding structure generally used for lightweight or commercial books, in which covers are made apart from text-blocks.

chemise An additional, loose cover that wraps around a book, usually used in conjunction with a slipcase.

dentelle (border) An eighteenth-century French style of book ornamentation, resembling lace.

diagonal-rib cloth Book cloth embossed with a diagonal parallel linear texture popular in the mid-nineteenth century. Used in reverse on many books designed by Morse to achieve a linen-like effect. Often referred to as "S grain".

dropout lettering A method of printing in which the background of a design or lettering panel is printed and the body of the letter is left blank (negative image). In the case of stamped book covers, the letter would appear to be the color of the background cloth.

embossing A process of creating a raised surface pattern by means of engraved plates, generally employing both heat and pressure.

endleaves Also called endpapers and flyleaves, the units of two or more leaves placed in the front and back of a book between its covers and text block.

"extra" cloth An obsolete term for a superior grade of book cloth, made of a base of cotton, starch-filled on the reverse side and color-filled rather than dyed. It was made in both a plain finish and in a variety of patterns, the heavy color coating concealing the weave of the fabric and giving a solid color effect.

fanfare-style binding An elaborate style of book decoration developed during the late sixteenth century and seventeenth century in France; features geometrically-shaped compartments of varying sizes, bordered by single and double lines, often with a large central compartment filled with floral ornament.

filigree Delicate ornamental openwork of an intricate design.

fleuron A small ornament resembling a flower or foliage, generally used to fill a space or compartment on a book cover.

frieze A design in relief, used decoratively in a long horizontal format.

Gothic-style A revival of Gothic ornament popular in England in the late-nineteenth century, associated with the work of John Ruskin and others.

grotesques Ornament derived by Renaissance architects and artists from ancient Roman decorations, consisting of distorted human, animal and monster-like motifs.

headbands Fabric bands at the head and tail of the book; originally headbands performed a structural function, but on nineteenth–century commercial books they are primarily ornamental.

lozenge A diamond-shaped stamp or design used in decorating bookbindings.

motif A single or repeated design, element or feature.

onlay A thin piece of leather, paper, or cloth that has been laid onto the surface of the book for decorative purposes.

openwork Any form of decoration which is perforated, or in which the design has created open spaces.

pictorial style An illustrative style in which the design is realistic and relates directly to the text of a book.

plain-weave cloth A type of bookcloth made from cotton with a straight warp and weft; it has been dyed and calendered but has no artificial surface texture; also referred to as "V grain."

publisher's production cover A book cover made as a sample, during the production of an edition that was never attached to a book but appears the same as the cover on the published book.

publisher's proof cover A cover made as a trial proof during the production of an edition that was never attached to a book, and is also unfinished, missing elements of the published book, such as spine stamping.

reversed cloth Bookcloth used with the unfinished side out; the use of reversed cloth began in the late 1880s when light-colored cloth became fashionable.

Rococo A decorative style of the early to mid-eighteenth century, primarily influencing the ornament in Europe, particularly France, typified by asymmetry, the use of curves and scrolls, and naturalistic motifs derived from rocks, shells and plants.

rule A single or multiple straight-line, used as a border or to create divisions on a book cover.

semé A traditional pattern used to decorate book covers, made up of small floral and dot motifs repeated at regular intervals; originally used by French binders in the mid-sixteenth and seventeenth centuries.

stamping A design impressed into a book cover, generally employing both heat and pressure by an engraved brass stamp pressed into the cover.

strapwork Ornamental style common in the sixteenth century, consisting of intertwining bands supposedly resembling leather straps.

variant A variation of an original book-cover design in which the same design and spacing is used, but the cover has different colors of cloth or stamping.

"Another among the designers of book-covers is Miss Alice C. Morse of Brooklyn, whose tasteful designs for "Sweet Bells Out of Tune," published by the Century Company, "Marse Chan" and Stevenson's "Ballads," by the Scribners, and the striking covers of the 'Odd Number Series' brought out by the Harpers has made her work known to the public."

"I was compelled to take up book cover work," said Miss Morse, through having competed with three other girls for some book-covers about five years ago. I won two out of three competitions. At that time I had been four years with the Tiffany Glass Co. designing windows; but growing tired of the long hours, and wishing to have time to myself for other work, I left them and turned my attention to book-covers, combining it with stained-glass work. My first cover was made for the Harper's for the 'Odd Number Series.' They wanted a series of French classics to be properly bound, and I was commissioned to try it. It was an apparently simple cover, but required a great deal of study, as the beauty of the design depended on the proper disposition of borders, and the balance of one set of lines with another. It was successful and was followed by enough more orders to induce me to think I could make a success of the work.

"There is not money enough in it to depend on that work alone as a means of livelihood. The qualifications necessary are, first, ingenuity because you must invent an idea from your manuscript capable of being converted into a fitting design; second, a strong sense of balance and composition; third, a knowledge of historic ornament. The cover ought to suggest the contents of the volume.

"The difficulties to be overcome are many. In the first place, the 'commercial book' must have a little on both sides and back, and the necessity of leaving a space in one's design to accommodate a title destroys the possibility of much originality. If publishers would realize this they would advance the cause of book-making tremendously. It isn't so much the necessity of having a title on the side as the determination on the part of the average publisher of having that title so large and legible that it is a regular signboard. For instance, they are not content with a modest and unobtrusive title such as the sixteenth century publishers used, nor will they countenance, yet, such work as you see on some of J. M. Dent's and Osgood, McIlvaine & Co.'s work—notably some poem of Oscar Wilde's, bound with a title on the side, but inserted in a design so as to form a part of it. But one must cut a large hole out of one's design so the lettering shall be seen first. Of course this is speaking generally; there are occasional exceptions among our publishers in New York.

"There are several ways of getting a design—the period in which the story is written sometimes suggests the style of ornament to be used. A love story should be dainty, as a rule. Essays require something dignified and severe. Then I get a hint from a flower, perhaps—a story of Holland, for example, naturally suggests tulips, and Scotland the thistle.

"In 'The Chatelaine of la Trinité,' I got the idea from a Tyrolean belt, it being a tale of travel dealing largely with the Tyrol. The design included a conventionalized edelweiss, the national flower. In the 'Giunta' series of classics, I used the fleur-de-lis of Giunta, combining it with other ornament; 'Our Home Pets', just published by Harpers, suggested parrots, so I conventionalized them thoroughly and covered the side with them. Book-covers are improving every year, I think.

"All the applied arts are more or less alike, but I think book-covers resemble glass (stained) more than, say, wall-paper or silks, in that you have a complete design in a given space, whereas wall-paper and silks repeat indefinitely.

"I usually submit two rough ideas containing lettering, general disposition of design and scheme of coloring first. Then I elaborate and complete the one chosen. The designer usually selects the color of the cloth. The material used depends largely on the amount the publisher is willing to expend on his edition."

ACKNOWLEDGMENTS

My discovery in 1997 of a group of Alice C. Morse's exhibition book covers in the collections of the Metropolitan Museum of Art inspired me to document the substantial contribution Morse made to nineteenth-century American book-cover design. This effort has resulted in a personal collection of books designed by Morse; this publication, *The Proper Decoration of Book Covers: The Life and Work of Alice C. Morse*; and two exhibitions of my collection, at the Grolier Club and at the University of Scranton, beginning in January 2008. The project would have been impossible without the advice and support of many knowledgeable, sympathetic and generous people, and I am delighted to have the opportunity to thank them here.

The details of Morse's life were gathered with the assistance of a number of historians, librarians and archivists. Alice Cooney Frelinghuysen, curator of American Decorative Arts at the Metropolitan Museum of Art, and binding historian Sue Allen were the first people I contacted after finding Morse's covers. Their initial support encouraged me to move forward, and I am grateful for Alice's continued interest in the form of an essay written for this volume. In establishing how Morse's covers came to the museum, I sought help from Barbara File of the museum's Archives, who provided important information on Alice C. Morse and Leah Heath.

The historians of Scranton have twice invited me to present lectures on Morse, visits which provided opportunities to resolve questions about Morse's life in Scranton and her relationship with Leah M. Heath. My earliest contact there was Michele Phillips Murphy, reference librarian at the Albright Memorial Library. Michele identified Morse's residences, and contacted the School Board for a copy of Morse's teaching record. Essentially a timeline, this document allowed me to reconstruct Morse's professional life. Mary Ann Moran and Alan Sweeny of the Lackawanna Historical Society (LHS) have maintained their enthusiasm for this project from the beginning. Among other things, they miraculously produced William Heath who shared information about his distant relative, Leah M. Heath, and her relationship with Alice C. Morse. Friend of the LHS, Gail Scaramuzzo, also assisted by giving me a tour of the Central High School building, where Morse had been on the faculty. More recently, Josephine Dunn joined the effort by offering an essay on Morse's life in Scranton, and helping to edit the book and support the author through a challenging process.

Many colleagues have taken an active role in this project by seeking out Morse's book covers in their collections. Barbara Hebard of the Boston Athenaeum and Barbara Blumenthal of Smith College identified several book covers that were not in Morse's collection or previously attributed to her. Vesta Gordon, Nora Lockshin and Richard Minsky also pointed the way to previously unidentified Morse designs, as did a number of generous and patient booksellers, many of whom sent photographs and information in support of this ongoing project of identification.

Finding designs by Morse for objects other than book covers has proved challenging. Although Morse created designs and artwork throughout her life, very few non-book items have surfaced. One of the most enjoyable days spent looking for traces of Morse's life I owe to the intrepid Mimi Schaer, who drove my partner John and me to Brownsville, Brooklyn, to look for a church that in 1893 was thought to have a stained-glass window designed by Morse.

The labor required to gather the threads of Morse's life into a book was immense. Although I was new to this type of work, my colleagues understood what was involved, and offered crucially important support and advice at every juncture. The catalog entries in particular were much improved by my editorial advisor, Michael Winship, Professor of English, University of Texas at Austin, who revised the organization and style of the descriptions. I cannot thank him enough for his contribution to this book, as well as for his patience and steadfast support throughout this long project.

Art book lovers know that it's all about the pictures, and the pictorial core of this book owes a great deal to the generosity of photographer Eileen Travell, who photographed Morse's covers in the Metropolitan Museum of Art and in my collection. Eileen's images will make it possible for others to identify Morse's work in the future. Barbara Bridgers and Julie Zeftel, also of the Metropolitan Museum of Art, most gra-

ciously provided additional support in the creation and use of the photographs. I would like to thank Richard Minsky for his generosity, by contributing his photographs of books designed by Whitman and Armstrong; and also Jerry Kelly, the designer of this publication, who used these images to superb advantage, creating a beautiful and lasting record of Morse's contribution to the field of design.

In addition to excellent work done by copy editor Frank Sypher, many friends and colleagues contributed to the text. Margaret Aspinwall made herself available for questions on style and grammar, while Nancy Mandel, Jae Carey, Josephine Dunn, Michael Winship, Shira Nichaman, Karol Pick, Stan Pinkwas, Monica Strauss and Eric Holzenberg all made valuable contributions to the editing process. Assistance in describing Morse's book covers and designs came from many sources. Andrea Krupp provided directions for identifying the textures of bookcloth, while Jae Carey and Talitha Wachtelborn used those instructions to help to identify the cloth textures. Yukari Hayashida and Georgia Southworth helped me to identify aesthetic consistencies in Morse's designs, while Clayton Kirking assisted me in describing Morse's posters at the New York Public Library.

The exhibition of my collection of Morse's book covers brings a significant portion of Morse's oeuvre into public view for the first time since 1924. The Grolier Club's offer to host this exhibition and publish the catalog has fulfilled my dream of bringing Morse and her work to an appreciative public. The Club mounted the landmark exhibition Commercial Bookbindings in 1894, in which Morse's book covers were shown. I thank my friends from the Grolier Club for their help and advice in producing the exhibition and its accompanying publication. Among these are Eric Holzenberg and George Ong of the Publications Committee, as well as two successive chairs of the Members' Exhibitions Committee, Mary Young and Szilvia Szmuk-Tanenbaum; exhibitions coordinator Megan Smith, and her team of volunteer exhibition workers. Metropolitan Museum colleagues, Ricky Luna, Geoff Taylor and Mary Arouni also contributed advice and assistance in exhibition design. I also thank Darlene Miller-Lanning and Josephine Dunn of the University of Scranton for planning the Morse exhibition in Scranton.

This record of Morse's life and work would not have been possible without substantial financial contributions from foundations and individuals. I especially want to thank the foundations and institutions that generously contributed funds towards the production costs for this book. These include Joan Davidson and Furthermore Grants in Publication (a division of the J. M. Kaplan Fund), the Peck Stacpoole Foundation, the Lackawanna Historical Society, and the Lackawanna Heritage Valley Authority. My appreciation also goes to the many friends who contributed not only funds and moral support, but also gave the gift of their confidence in Alice C. Morse, and my ability to do her justice. These generous souls are Mary Arouni and Tom Bodkin, Lisa Unger Baskin, Barbara Berkeley, Barbara Blumenthal, Candice, Ben, Jack and Annie Braun, William T. Buice III and Stuart U. Buice, Karen B. Cohen, Dan and Deane Dubansky, Richard Estes, Geraldine Garbaccio, Sue Gosin, Laura T. Harris, Priscilla Juvelis, Sophia Kramer, Deirdre Elizabeth Lawrence, Bruce McKittrick, Barbara Metz, Frederick W. Pattison, Robert J. Ruben, MD, Caroline F. Schimmel, Mary C. Schlosser, Arthur Schwarz, Kenneth Soehner, Dierdre Stam, Wendy Storch, Szilvia Szmuk-Tanenbaum, Mark and Nancy Tomasko, Charles P. Werner, Karen Williams, Wendy Wilson, Mary K. Young and several donors who wish to remain anonymous. I also thank Tammy Rubel, who has carefully managed the Morse Fund at the Grolier Club.

Lastly, my gratitude goes to two people who have provided support through this unexpectedly long and complex project—my supervisor at the museum, Ken Soehner, and also my dear, patient companion, John Cliett, who has experienced the heights and the depths of my relationship with Alice C. Morse for ten years. I am certain that before this book is in print, many other people will come forward to support this effort. Please forgive any omissions and know that your help will be appreciated.

BIBLIOGRAPHY

Aldine Club, New York. 1890. *Constitution, Rules, Officers and Members, 1890–1891.*

Aldine Club, New York. 1892. *Catalogue of an Exhibition of Oil and Water-Color Paintings Loaned by New-York Artists, Also of Modern Cloth and Leather Book-Covers and Original Designs Therefore, at The Aldine Club, from the Twenty-fifth to the Thirty-first of March, Inclusive.*

Allen, Sue and Charles Gullans. 1994. *Decorative Cloth in America: Publishers' Bindings 1840-1910.* Los Angeles: University of California, Los Angeles Center for 17th- and 18th-Century Studies, William Andrews Clark Memorial Library.

American Catalogue 1884–1890 (Am Cat) 1884–1890. Founded by F. Leypoldt. Edited by R. R. Bowker. New York: Peter Smith, 1941 (reprint edition). Also: 1895–1900; 1900–1905; 1905–1907.

Architectural League of New York (ALNY). 1889. *Catalogue of the Fifth Annual Exhibition of the Architectural League of New York.* Also: 1890; 1893–1894; 1895.

Art Amateur. 1897. Vol. 36, no. 1, pp. 16–17, 27. Also: no. 2, p. 46.

Bibliography of American Literature (BAL). 1959. Compiled by Jacob Blanck. New Haven: Yale University Press.

Borough of Brooklyn, City of New York. 1929. *Desk Atlas.* Volume 1.

Brandt, Frederick R. 1994. *Designed To Sell: Turn-of-the-Century American Posters in the Virginia Museum of Fine Arts.* Richmond, Va.: Virginia Museum of Fine Arts.

Burke, Doreen Bolger, Jonathan Freedman, Alice Cooney Frelinghuysen, et al., 1986. *In Pursuit of Beauty: Americans and the Aesthetic Movement.* New York: The Metropolitan Museum of Art.

City of New York. New York City Health Department. 1961. *Deaths and Fetal Deaths Reported in 1961.* Vol. 98, p. 276. (Entry for the death of Alice Morse).

Cockerell, Sydney M. 1953. *Bookbinding, and the Care of Books. A Text Book for Bookbinders and Librarians.* Fifth Edition. London: Pitman and New York: Pentalic Corp.

Cooper Union. 1879–1892. *Annual Reports of the Trustees of the Cooper Union, for the Advancement of Science and Art* New York: Cooper Union for the Advancement of Science and Art. New York: A. N. Whitehorn, Book and Job Printer.

Corticelli Home Needlework: A Manual of Art Needlework, Embroidery and Knitting. 1898. Mrs. L. Barton Wilson, Mrs. Emma Haywood, Miss Alice C. Morse, Miss Elizabeth Moore Hallowell, Mrs. Amalia Smith, eds. Florence, Mass.: Nonotuck Silk Company.

Dubansky, Mindell. 2001. "The Proper Decoration of Book Covers," *Gazette of the Grolier Club.* New York: Grolier Club.

Eidelberg, Martin, Nina Gray and Margaret K. Hofer. 2007. *A New Light on Tiffany: Clara Driscoll and the Tiffany Girls.* New York: The New-York Historical Society; and London: D Giles Limited.

Elliott, Maud Howe, ed. 1893. *Art and Handicraft in the Woman's Building of the World's Columbian Exposition.* Chicago: Goupil & Co. and New York: Rand McNally.

Grolier Club (anonymous). 1894. *Commercial Bookbindings: An Historical Sketch, with Some Mention of an Exhibition of Drawings, Covers, and Books, at the Grolier Club, April 5 to April 28, 1894.* New York: The Grolier Club.

Gullans, Charles and John Espey. 1979. "American Trade Bindings and Their Designers, 1880–1915," in *Collectible Books: Some New Paths*, pp. 33–67. New York and London: R. R. Bowker Company.

——. 1991. *Margaret Armstrong and American Trade Bindings.* Occasional Papers 6. Los Angeles: University of California, Los Angeles, Department of Special Collections.

Harris, Edna. 1899. "New Book Covers," *Brush and Pencil*, vol. 5, no. 3, pp. 118–124.

Hirshler, Erica E. 2001. *A Studio of Her Own: Women Artists in Boston, 1870–1940.* Boston: Museum of Fine Arts.

House and Home: A Practical Book. 1894. Vol. 1. New York: Charles Scribner's Sons.

House Beautiful. 1897. Vol. 1, no. 3 (February). "Women and Bookbinding," p. 63.

Krupp, Andrea. 2006. "Bookcloth in England and America, 1823–50," *Papers of the Bibliographical Society of America.* New York: The Bibliographical Society of America, vol. 100, no.1, March, pp. 25–88.

Lain's Brooklyn Directory. 1894, 1897, 1898. New York: Lain and Healy.

Lee, Marshall. 1965. *Bookmaking. The Illustrated Guide to Design and Production.* New York: R. R. Bowker.

Lucie-Smith, Edward. 1984. *The Thames and Hudson Dictionary of Art Terms.* London: Thames and Hudson.

Matthews, Brander. 1896. *Bookbindings, Old and New. Notes of a Book-lover, with an Account of the Grolier Club, New York.* London: George Bell & Sons, York Street, Covent Garden, & New York.

Minsky, Richard. 2006. *American Decorated Publishers' Bindings 1872–1929.* Limited edition of 25. Stockport: Richard Minsky.

Morris, Ellen K. and Edward S. Levin. 2000. *The Art of Publishers' Bookbindings 1815–1915.* Los Angeles: William Dailey Rare Books Ltd.

Needham, Paul. 1979. *Twelve Centuries of Bookbinding 400–1600.* New York: The Pierpont Morgan Library; London: Oxford University Press.

Peck, Amelia and Carol Irish. 2001. *Candace Wheeler: The Art and Enterprise of American Design, 1875–1900.* New York: The Metropolitan Museum of Art and Yale University Press.

Publisher's Trade-List Annual (PTLA). New York: Office of the Publishers' Weekly, 1887–1905.

Publishers' Weekly. 1894. No. 1160 (April 21) p. 620.

Report of the Board of General Managers of the Exhibit of the State of New York, at the World's Columbian Exposition. Albany: J. P. Lyon, 1892.

Roberts, Matt T. and Don Etherington. 1982. *Bookbinding and the Conservation of Books: A Dictionary of Descriptive Terminology.* Washington: Library of Congress.

Scranton Public Schools. Teacher's Record Card [1923?] (for Alice C. Morse).

Tomlinson, William and Richard Masters. 1996. *Bookcloth 1823–1980.* Stockport, Cheshire: Dorothy Tomlinson.

Weimann, Jeanne Madeline. 1981. *The Fair Women.* Chicago: Academy Chicago.

Will of Alice C. Morse. 1961. Surrogate's Court, Bronx County, New York. File No. P1394.

Willard, Frances Elizabeth and Mary A. Livermore. 1893. *A Woman of the Century: Fourteen Hundred-Seventy Biographical Sketches Accompanied by Portraits of Leading American Women in All Walks of Life.* Buffalo: Charles Wells Moulton.

Willets, Gilson. 1894. "The Designing of Book-Covers," *The Art Interchange.* November, pp. 118–119.

Winterich, John T. 1967. *The Grolier Club, 1884–1967.* New York: The Grolier Club.

INDEXES

I. AUTHOR AND SERIES NAME INDEX

II. BOOK ILLUSTRATOR INDEX

III. PUBLISHER INDEX

IV. NUMBER OF DESIGNS BY PUBLISHER (79 designs by Morse)

V. CONCORDANCE OF METROPOLITAN MUSEUM OF ART ACCESSION NUMBERS AND ENTRY NUMBERS

Accession No.	Entry No.	Accession No.	Entry No.	Accession No.	Entry No.	Accession No.	Entry No.
56.522.48	89-1	56.522.62	89-4	56.522.76	94-7	56.522.91	97-6
56.522.49	93-4	56.522.63	89-3	56.522.77	93-1	56.522.92	97-7
56.522.50	91-3	56.522.64	91-2	56.522.78	91-7	56.522.93	97-5
56.522.51	92-10	56.522.65	93-3	56.522.79	92-12	56.522.94	97-2
56.522.52	90-3	56.522.66	94-6	56.522.80	96-2	56.522.95	96-1
56.522.53	92-2	56.522.67	92-13	56.522.81	92-3	56.522.96	90-5
56.522.54	90-6	56.522.68	92-4	56.522.82	89-2	56.522.97	91-10
56.522.55	93-2	56.522.69	92-11	56.522.83	92-5	56.522.98	91-6
56.522.56	92-8	56.522.70	n. d.-1	56.422.84	94-2	56.522.99	91-5
56.522.57	91-11	56.522.71	96-7	56.522.85	94-8	56.522.100	91-8
56.522.58	91-4	56.522.72	92-1	56.522.86	90-5	56.522.101	92-9
56.522.59	92-14	56.522.73	91-1	56.522.87	94-4	56.522.102	n. d.-2
56.522.60	90-1	56.522.74	87-1	56.522.88	90-4	56.522.103	94-5
56.522.61	94-3	56.522.75	92-15	56.522.89	90-8	56.522.104	90-7
				56.522.90	97-3	56.522.105	91-9

ILLUSTRATION CREDITS (with figure and entry numbers):

Images © Mindell Dubansky, Eileen Travell, photographer: Figs. 2, 3, 4, 8A, 8B; entries 89-4A, 90-1A, 91-1A, 91-9, 91-10, 91-10A, 92-6, 92-7, 92-8, 92-8A, 92-10, 92-12, 93-2, 93-3, 93-5, 94-1, 94-2, 94-7, 94-9, 96-2, 96-3, 96-4, 96-5, 96-6, 96-7, 97-1, 97-1A, 97-3, 97-4, 97-5, 97-6A, 97-7, 97-8, 98-1, 98-2, 98-3, 98-4, 98-5, 99-1, 99-2, 99-2A, 99-3, 99-4, 01-1, 03-1, Attrib. 83-1, Attrib. 93-1, Attrib. 93-3, Attrib. 95-1, Attrib. 05-1, 95P-1

Images © The Metropolitan Museum of Art, Eileen Travell, photographer: Figs. 1, 6; entries 87-1, 89-1, 89-2, 89-3, 90-1, 90-2, 90-3, 90-4, 90-5, 90-6, 90-7, 90-8, 91-1, 91-2, 91-3, 91-4, 91-5, 91-6, 91-7, 91-8, 91-11, 92-1, 92-2, 92-3, 92-4, 92-5, 92-9, 92-11, 92-13, 92-14, 92-15, 93-1, 93-4, 94-3, 94-4, 94-5, 94-5A, 94-6, 94-7A, 94-8, 96-1, 97-2, 97-6, 97-7A, n. d. 1, n. d. 2, Attrib. 93-2

Images © 2006 Richard Minsky, used with permission: Figs. 5, 7, 11, 13, 17, 18, 19

Images © Morgan Library & Museum, New York (MLM), used with permission: Figs. 14, 15, 16

Images © The New York Public Library, Astor, Lenox and Tilden Foundations, used with permission: Entries 96P-1, 96P-2

Image © University of Wisconsin Digital Collections/Publishers' Bindings Online, used with permission: Fig. 9

Image © Groton Scholl, Vaughn Winchell, photographer: Fig. 10

Image © St. Margaret's Episcopal Church, Willard Kennedy, photographer: Fig. 12

THE PROPER DECORATION OF BOOK COVERS:
THE LIFE AND WORK OF ALICE C. MORSE

has been set in Rilke types from the Nonpareil Typefoundry
and printed by Capital Offset Company.
Designed by Jerry Kelly.